FINDING AUGUSTA

INTERFACES: STUDIES IN VISUAL CULTURE

Editors Mark J. Williams and
Adrian W. B. Randolph, Dartmouth College

This series, sponsored by Dartmouth College Press, develops and promotes the study of visual culture from a variety of critical and methodological perspectives. Its impetus derives from the increasing importance of visual signs in everyday life, and from the rapid expansion of what are termed "new media." The broad cultural and social dynamics attendant to these developments present new challenges and opportunities across and within the disciplines. These have resulted in a trans-disciplinary fascination with all things visual, from "high" to "low," and from esoteric to popular. This series brings together approaches to visual culture—broadly conceived—that assess these dynamics critically and that break new ground in understanding their effects and implications.

For a complete list of books that are available in the series,
visit www.upne.com

Finding

Dartmouth College Press Hanover, New Hampshire

HEIDI RAE COOLEY

Augusta

HABITS OF MOBILITY

AND GOVERNANCE

IN THE DIGITAL ERA

Dartmouth College Press
An imprint of
University Press of New England
www.upne.com
© 2014 Trustees of
Dartmouth College
Manufactured in the United States of
America
Designed by Mindy Basinger Hill
Typeset in Garamond Premier Pro

University Press of New England
is a member of the Green Press Initiative.
The paper used in this book meets their
minimum requirement for recycled paper.

For permission to reproduce any of the
material in this book, contact Permis-
sions, University Press of New England,
One Court Street, Suite 250, Lebanon NH
03766; or visit www.upne.com

Library of Congress Cataloging-in-
Publication Data

Cooley, Heidi Rae.
Finding Augusta : habits of mobility
and governance in the digital era /
Heidi Rae Cooley.
 pages cm — (Interfaces :
studies in visual culture)
Includes still images from the film *The
Augustas* as an entry point into the discussion.
Includes bibliographical references and index.
ISBN 978–1–61168–521–3 (cloth : alk. paper)
— ISBN 978–1–61168–522–0 (pbk. : alk
paper) — ISBN 978–1–61168–523–7 (ebook)
1. Information technology—Psychological
aspects. 2. Information technology—Health
aspects. 3. Information technology—
Social aspects. 4. Mobile communication
systems—Psychological aspects. 5. Mobile
communication systems—Health aspects.
6. Mobile communication systems—Social
aspects. 7. Self—Social aspects. 8. Augustus
(Motion picture) I. Title.
BF637.C45C686 2014
303.48'33—dc23 2013031786

5 4 3 2 1

FRONTISPIECE: "West Virginia." From Scott Nixon's *The Augustas*. Scott Nixon Home
Movies. Moving Image Research Collections. University of South Carolina.

CONTENTS

ACKNOWLEDGMENTS

Many have encouraged and supported this project during its gestation and writing.

I thank the University of South Carolina's College of Arts and Sciences for a semester's teaching leave, which afforded me time to find the book's current shape, and its Provost's Office, for a Humanities Grant that funded development of Augusta App, the book's digital supplement.

The university would have found less to value in my work had I not been trained by some exceptional teachers. Principal among these is Anne Friedberg, whose penchant for rigorous theorization and intricately nuanced prose challenge me to think and write more sharply, even as she herself cannot. I feel most fortunate to have studied with Michael Renov, whose generosity and poise inspire me and whose gentle reminders regarding my "first Visible Evidence" keep me on track. I thank John Carlos Rowe, who early on encouraged me to "try my hand" at graduate school. And I thank Anne Balsamo for cultivating my sense of the collaborative nature of interdisciplinary projects.

Susan Mary Mellender Wilke supported this work in its very earliest phases, joining me at my first conferences as a graduate student, accompanying me on research trips and reviewing my prose. Kay Potocki (and Tom) encouraged me to pursue my intellectual interests. Jon Wilke helped me learn the language of biomechanics, which became crucial to my investigations of design and expressivity. And I thank Curtis Wilke, whose recent illness has made me understand more fully the importance of an autobiographical self.

I thank my colleagues: Susan Courtney, for so deftly mentoring me throughout the writing process; Laura Kissel, whose conversations asked me to speak more precisely about the project; and Simon Tarr, who shared his incisive artistic talent. I also thank Greg Wilsbacher, who introduced me to *The Augustas*; Gordon Humphries, who helped me prepare the photographic images that appear in the book; and Jeremy Greenberger, who spent hundreds of hours programming the book's digital supplement.

In its penultimate instantiation, the book benefitted from two readers for the press. I thank Steve Anderson and Nanna Verhoeff; their generous insights have made this a better book.

Duncan Buell has made the book's digital supplement possible. Through him, I have learned how to describe the computational mathematics that manage our mobile present. Our work together for the NEH-funded Humanities Gaming Institute (2010) and serious game Desperate Fishwives (2011–12), as well as our work on Ghosts of the Horseshoe (2012–present) have inspired me to be a more agile, interdisciplinary thinker. If I am a digital humanist, I learned how to be one from him. I look forward to our continued collaboration.

Mark Garrett Cooper: you have shared your intellect, your experience, and your family. You have read every word that

comprises the book—several times. Thank you for believing in me.

Marmalade of the handlebar whiskers and curly calico furs: a fabulous feline—and my girl. Thank you for seeing me through.

All image stills are from Scott Nixon, *The Augustas* [16mm color film], Scott Nixon Home Movies, University of South Carolina, graciously provided by the Moving Image Research Collections, University of South Carolina.

Keyword

"AUGUSTA"

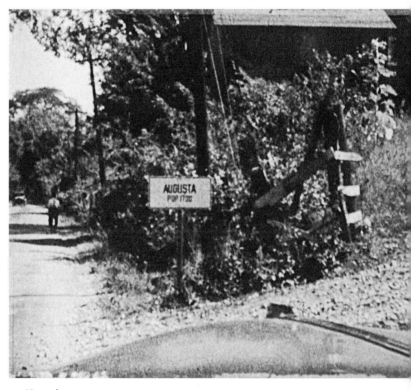

Kentucky

"Augusta" is a proper noun. It names a unique instance of a person, place, or some other entity. Capitalization indicates as much, although failure to capitalize would not necessarily invalidate its status as a proper noun. On occasion, this proper noun assumes the plural form, "Augustas," in which case it refers to a group of entities deemed unique. Adjectival declensions exist, as in Augustan Rome. Importantly, any one proper noun might very well signify any number of possible referents.[1]

For the purposes of this preamble, let's assume that "Augusta" names a city in the state of Georgia, in the United States. And let's take as a point of departure the independent insurance agent, amateur filmmaker, and Augusta native Scott Nixon (b. 1901–d. 1980), who from the 1930s through the 1950s, documented no fewer than thirty-six Augustas. These disparate Augustas Nixon compiled into a home movie of approximately sixteen minutes. The resulting reel is called *The Augustas*, and it represents various Augustas that Nixon encountered as he traveled the United States. During the course of the film, we discover that "Augusta" specifies a township, a plantation, a military academy, a fort, a street, and a flower, called the Hardy Phlox Augusta.

The flower's name repays investigation. The Augusta is a member of the Rubiaceae plant family. Four species comprise the genus, in which "A." abbreviates "Augusta": A. longifolia (native to Brazil), A. Rivalis (native to Central America), A. vitiensis (native to the Fiji Islands), and A. austro-caladonica (native to New Caledonia). This tidy classification scheme is a relatively recent achievement. Apparently, the number and names of the species belonging to the genus had long been a matter in dispute. In a 1997 article, Piero G. Delprete of the Institute of Systematic Botany at the New York Botanical Garden explains that for over a century "most herbarium specimens still bear annotation of a confused assortment of scientific names."[2] After conducting extensive studies of "about 500 herbarium specimens," Delprete concludes, "Augusta (with the inclusion of Lindenia) is represented by four species of rheophytic shrubs."[3] While there is "high morphological variation" among species of the Augusta, which probably accounts for the long-standing question regarding species typification, Delprete grounds his findings on molecular data that prove conclusive.

The complex history of the genus's nomenclature originates in an 1828/29 publication by Johann Emanuel Pohl titled *Plantarum Brasiliae*. As Delprete recounts, the Austrian botanist and mineralogist joined a group of scientists on expedition to Brazil, where he first described five species of the plant. The trip was arranged as "part of the nuptial celebrations" honoring the marriage of Archduchess Leopoldina, daughter of Emperor Franz I of Austria (also king of Hungary and Bohemia), to Dom Pedro (later Pedro I of Brazil). At the time of the expedition, Caroline Augusta, formerly Princess of Bavaria, was wife to Emperor Francis I. Pohl dedicated his then newly discovered plant to the Empress of Austria (Caroline Augusta). Delprete quotes Pohl's dedication: "This new name, witness of reverence and gratitude, is derived from that of Her Majesty Caroline Augusta, Empress of Austria,

who, most holy priestess of Flora, with her whole heart does everything to strew flowers in the path of her most august spouse [the Emperor]."[4] In this tribute to "Her Majesty," Pohl links wife/empress and husband/emperor etymologically: she, Caroline Augusta, who inspires "reverence and gratitude" and he who is most revered, that is, "most august."[5]

It should not come as a surprise that "Augusta" is "a feminine form of the name of the Roman Emperor Augustus" (Wikipedia), sharing roots with "august," from the classical Latin, augustus, meaning "consecrated, venerable," and by extension, "revered" (*Oxford English Dictionary* [OED] online). The same Latin root underpins "August," the eighth month of the Julian and Gregorian calendars, which supplanted the sixth month of the ancient Roman calendar. In 8 BC, "Sextilis" (or "sixth month") was renamed "August" in honor of Caesar Augustus. The renaming served to commemorate the most significant achievements that secured the emperor's rise to power—events that occurred in the month we call August.

Even this very schematic etymological tour—from town to amateur home movie to flower to the feminine declension of a masculine noun—suffices to make a simple, and foundational, point: in addition to naming its "proper" referent, any specific "Augusta" also points to rather too many histories altogether. I am interested in the indeterminacy of reference opened by this constellation of Augustas, especially because such indeterminacy seems no rare phenomenon but rather a defining feature of daily life. When Nixon's home movie invites us to consider the perhaps haphazard but certainly curious string of associations leading from town to phlox, it challenges us to continue the experiment that seems to find Augusta everywhere one looks. What would be involved in finding and keeping track of Augustas of all varieties? Fortunately, our digital present provides tools ready to hand.

Introduction

BODIES, MOBILITIES, TECHNOLOGIES

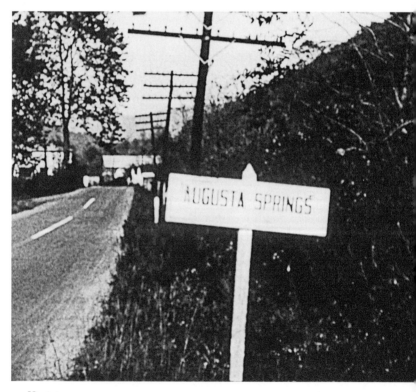

Virginia

Finding Augusta: Habits of Mobility and Governance in the Digital Era is interested in routine practices that define the mobile present. When digital technologies set places, persons, things, and information in constant motion, habits of navigation assume decisive social and political importance. While most discussions of mobile media treat them as tracking devices, freedom machines, or both, I argue that we should attend to the everyday habits of finding places, persons, and information that mobile media encourage and discourage. In this regard, I make three claims. First, mobile media encourage population managers to think less in terms of surveillance and more in terms of tracking. I suggest that this shift is less a revolutionary change brought about by new technologies than a change in emphasis whereby mobile handheld devices supplement long-standing, even ancient, techniques of governance. Second, I argue that the handheld quality of mobile technologies requires a threefold understanding of human individuals as biological beings, expressive (e.g., cognitive) subjects, and members of populations. Third, I propose that acknowledging how we inhabit bodies tracked through mobile, networked, visual media offers possibilities for intervening in the techniques of governance that define and manage persons within

populations. In this way, I consider how biopolitical modes of governance work as well as how they might change.

ONCE UPON A TRAVELING SALESMAN

From the 1930s through the 1950s, independent insurance agent and amateur filmmaker Scott Nixon documented the various Augustas he encountered during his travels throughout the United States.[1] He filmed towns, streets, and schools called Augusta and subsequently edited the sequences together into a sixteen-and-a-half-minute compilation film.[2] Called *The Augustas*, the film can be understood as a record of his travels to various Augustas—but this is only one, if perhaps the most common, interpretation. There are no fewer than thirty-six instances edited into a montage of disparate locations and scenes all identified as "Augusta" or some variant thereof, for example, "Augustaville" or "The Augusta." The Augustas are identified by signage, intertitles, labeled still images, train schedules, or maps. In this way, the film confronts its spectator with the question of how to interpret "Augusta." For example, the fifth "Augusta" appears in black caps on a simple white rectangular board. The name "Augusta" is underscored by a solidly painted arrow pointing screen left, indicating that Augusta is located in that direction. Presumably one need only turn left and one will find Augusta some distance offscreen, even as one has encountered "Augusta" framed within the shot. If by habit we assume Augusta to be a place so named, the arrow and related strategies in the film also inspire speculation: there may be other options once our attention shifts to the name itself.

While the inspiration behind this work may lie in the fact that Nixon himself lived in Augusta, Georgia, the principle or "key" governing his cinematic tour is not known. The assembled film follows neither chronology nor geography. The lack of a readily

decodable order prompts us to consider that "Augusta" may be its own key, that one point may be simply to celebrate "Augusta" as a keyword label qua search term. The signifier plays Mobius-like across three registers of interpretation. It may appear painted on a road sign; it may be the indexical trace of a place once visited; it may function symbolically as a word signifying a referent, place, or otherwise. It matters whether one sees a filmed image of a road sign specifying "Augusta" or sees the word in an intertitle; one's interpretation depends on such differences. For example, the appearance of a road sign calls to mind the social habit of navigating to a place of destination, while the intertitle bespeaks

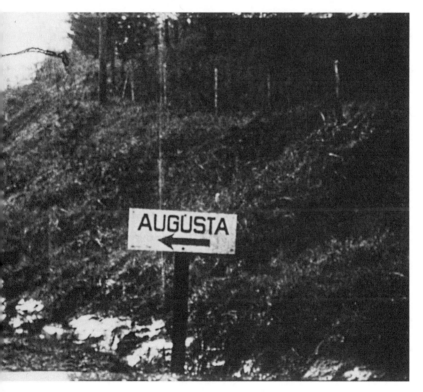

Missouri

the filmmaker's guiding hand in structuring interpretation. Either image, however, can name a place we might be seeing in the surrounding or a subsequent mise-en-scène. Similarly, the inclusion of any image whatsoever in this context suggests that we are looking at an "Augusta" even if we cannot immediately determine which one.

By the reel's conclusion, Augusta is revealed to designate a county in Virginia, a high school and a military academy in Ohio, a fort in Pennsylvania, and streets in both Georgia and South Carolina. The Hardy Phlox Augusta concludes the show. On one hand, the indexical image of signage naming Augusta as "Augusta" produces a kind of certainty of reference: there is an Augusta being photographed or filmed in each instance of Augusta. On the other hand, the very multiplication of Augusta dismantles assumptions regarding the stability of any single Augusta as referent. We discover that "finding" Augusta is a problem, even as our desire for and expectation of doing so is facilitated by the film's strategy of organization. Moreover, insofar as we learn that Augusta may not be a place at all, we must contend with the prospect that it might very well be a state of mind: a way of seeing and ordering the world. The word label "Augusta" turns out to be powerful in its organizing capabilities and feeble in its designating abilities. Its slippery operations are made doubly slippery by the fact of being filmed and arranged in the film, given the medium's indexical and iconic qualities. In all of these various dimensions, we might understand *The Augustas* to demonstrate a concern for information retrieval and, more specifically, how the process of recording, storing, and arranging information relates to the project of finding information, persons, places, and things. In this regard, despite the fact that it is a decidedly analog artifact, the film alludes to computational processes that characterize our mobile present.

The puzzle that is Nixon's *The Augustas* has an unexpected

counterpart in computational mathematics and computer science: the Traveling Salesman Problem, or TSP.[3] The TSP is a problem of determining optimal paths through a given number of specified points. In its paradigmatic form, the TSP asks, What is the best route for traveling round-trip to some number of cities? This is precisely the type of problem companies employing traveling salesmen—or in more current vernacular, sales representatives—confront.[4] The idiom "time is money" applies. Out of fiscal necessity, one must minimize travel costs by spending less time "on the road" or in the air. The most efficient itinerary is critical. But how to identify such an itinerary turns out to be surprisingly difficult. As computer scientist and mathematician William J. Cook explains, the traveling salesman is "foremost among the route planers [*sic*]."[5] In support of this claim, Cook cites correspondence between a 1920s traveling salesman and the company for which he works.[6] In a letter criticizing his employer's routing of his tour, he announces that he has changed his itinerary for a more suitable one, one that does not have him "jumping all over the map."[7] Since presumably his employer also desires an efficient itinerary, this is a contest not of aims but of expertise.

Solutions to the TSP are "optimal" routes, but finding these routes is a complex problem. In fact, the TSP still stands among the "impossible" problems in computational mathematics, one among several problems no "efficient" algorithm is known to solve. The TSP has many variations, including such challenges as scheduling FedEx delivery routes, coordinating airline flight schedules, and routing mobile phone calls.[8] Nonetheless, computer scientists regard the TSP as "impossible" because one cannot determine efficiently a singular "key," that is, a plan or search term, for sorting various stops, or "nodes," into a fail-safe route or "tour."[9] Even if we specify a point of departure and return, a variety of potential paths always exist. Any number of factors—for example, ice, accident,

traffic, and roadblock—might potentially impede or alter any one designated route. Without a reliable principle of organization to govern the order of travel, effectively sequencing a series of stops proves contingent on a wide array of variables. Moreover, the number of possible routes (i.e., tours) increases exponentially with any increase in the number of stops.[10]

Scott Nixon traveled the United States during the same years that mathematicians in the United States began focusing more concertedly on the TSP. This is a coincidence insofar as the person, Scott Nixon, his profession, and his film had (so far as I have been able to determine) no direct involvement with formulating the TSP as an academic problem. It is not at all a coincidence that both Nixon and the mathematicians who defined the TSP inhabited a particular moment in the history of mobility and information, a moment when profit, travel, navigation, information retrieval and manipulation, and pleasurable expertise were closely associated. That moment gives birth to our mobile, digital present. Despite obvious differences, Nixon's version of the TSP and the version officially named by the RAND Corporation in 1949 are equally relevant when it comes to figuring out what it means to manage persons, vehicles, goods, currency, ideas, and information. They teach comparable lessons. In both cases, a potential for failure shadows the project of "mapping" any single best or optimal itinerary. I am referring to a failure not only to find the best route but also to discover the principle (or logic) by which any particular itinerary has been decided. For planners and administrators, this means that problems of routing and locating are never "solved" so much as "managed." For individuals, this condition of uncertainty encourages patterns decided as much by habit as by careful preparation. At the same time, the ever-present possibility that habitual patterns will fail in a particular case opens onto new possibilities—whether these be alternative routes (TSP) or

alternative interpretations (Scott Nixon). And so, similar FedEx routes may or may not result in similar delivery schedules. And we, with mobile technologies in hand, may or may not connect with a desired contact. We submit ourselves daily to the volatility of the Traveling Salesman Problem, to the fact that small changes in the costs and connections that define a particular problem can result in large changes in the optimal solution. We only notice this when habit, or routine, fails.

Read in tandem, the Traveling Salesman Problem and Nixon's *The Augustas* invite us to consider both the pervasiveness and the inherent instability involved in the routine work of finding and tracking. Such consideration, moreover, casts new light on the administrative logic that requires these operations. By approaching the topic of new media's role in relation to biopower through this "old" Traveling Salesman Problem, this book contributes to an understanding of the relationship between bodies and technologies of administration in the digital era. Mobility, its organization and potentiality, is the defining problem of this present.

MOBILE, CONNECTED, ON GRID

Both Scott Nixon, independent insurance agent, and the Traveling Salesman Problem allow us to consider the increasing significance of mobility in the digital age. As early as 2000, sociologist John Urry argued that to study society one must address the problem of mobilities.[11] Here, mobilities refers to various "bodies" in motion, including not only people, objects, and images but also money, information, and waste. Indeed, "mobilities" applies to the diversity of movements, circulations, fluctuations, transactions, and exchanges—both "natural and artificial"—that comprise what Michel Foucault in *Security, Territory, Population* calls the milieu.[12] Like Urry, I am interested in how mobilities of all sorts

shape habits of living in, thinking about, and engaging the world. Productive for such consideration is the increasing prominence of what Mimi Sheller terms the "transdisciplinary" scholarship of critical mobilities research (also called mobility studies, critical mobilities thinking, and mobilities theory).[13] Such scholarship, Sheller suggests, "brings together" insights from the social sciences, cultural, visual, and media studies, as well as geography. In the process, it generates new possibilities for thinking relations among bodies and technologies.

Critical mobilities research encourages thinking that complicates conceptions of what mobility is and how it functions in the world. It acknowledges that mobility operates across a number of domains and according to a horizontal dispersal. In *Mobilities*, John Urry identifies five interdependent mobilities that comprise sociality (and management thereof): corporeal travel (for leisure, work, migration, and escape), physical movement of objects (purchases, exchanges, and transfers), imaginative travel (e.g., visual and print media), virtual travel (e.g., electronic media), and communicative travel (e.g., person-to-person messages via telephone and text message, etc.). These transpire as complex and ever-shifting circulations. Thus, questions central to mobilities research emphasize interconnections among various mobilities and not movement in the abstract (e.g., from point A to point B).

Furthermore, mobilities theorists recognize that mobility systems involve pauses, lapses, stasis, interferences, and turbulence—that is, various immobilities. Sheller characterizes immobilities citing Urry, stating that the conditions that produce "multiple fixities and moorings often [depend on] a substantial physical scale."[14] For example, "Walls, borders, check-points and gated zones" stabilize, even if only temporarily, flows of all sorts. Likewise, immobile platforms and infrastructures, including "transmitters, roads, stations, satellite dishes, airports, docks,

factories," reshape the landscape in very concrete ways but ways that simultaneously facilitate continued circulations.[15] This line of thinking emphasizes the tension between "a spatialized ordering principle" and "a sense of fluidity and mobility." The former seeks to "fix" or "to place" and thereby "locate" and render legible that which is mobile. It is compelled to do so by the latter sense, which entails both the personal possibility of movement and the anxiety of become unmoored, lost.[16]

In its inquiry into the nature and function of "textured rhythms" constitutive of contemporary mobility systems, critical mobilities research revises how we think about movement, people, and place.[17] In the process, it readily acknowledges the fact that technologies, mobile devices included, factor largely in facilitating mobilities of all sorts. As Tim Cresswell points out, the historical specificity of the technologies that produce mobilities necessarily inform understandings of oneself, one's surroundings, and one's movements.[18] In the mobile present, data trails map us in relation to physical locations; location awareness proves increasingly essential to understanding subjectivity. While place has always mattered, Eric Gordon and Adriana de Souza e Silva explain that our mobile technologies foster a particular concern for and attention to location. They refer to this kind of awareness as "networked locality," which they attribute to the fact that "virtually everything is located or locatable."[19] As they indicate, this condition of existence necessarily alters how institutions and communities function and interact.

Here, Paul Dourish and Genevieve Bell's discussion of mobility and technology proves useful. Approaching questions of mobility from the perspective of ubiquitous computing (ubicomp), they draw attention to the ways that technological infrastructures determine the organization and meaning of space. When we begin to think the "portability of practice" as enabled or denied by the

kind of connectivity we enjoy, we necessarily understand our relation to our surroundings differently.[20] For example, thinking in terms of cellular network access, Wi-Fi service provider, range of signal, and proximity to power outlets informs our conceptions and interpretations of and movements through our surroundings. But also, such thinking is suggestive of how mobilities of various sorts are facilitated, hindered, and (re)directed. As Dourish and Bell indicate, the massive technological infrastructure enabling these new forms of concern with location imply "power geometries" that define patterns of access and shape how, when, and where people, things, information, and so forth, move. If one has cell phone coverage here but not there, it is likely due to some combination of corporate profit calculation and local regulation.

Not surprisingly, scholars interested in mobilities have increasingly turned their attention to portable (not simply transportable[21]) networked devices. Notably, Gerard Goggin and Ilpo Koskinen offer compelling cultural interpretations of mobile technologies.[22] Mizuko Ito, Daisuke Okabe, and Misa Matsuda provide a pioneering account of mobile phones in Japanese youth culture.[23] And we are beginning to see a number of edited collections addressing cultural effects of mobile technologies.[24] In a more theoretical vein, Jason Farman has posited the "'sensory-inscribed' body" in order to account for how we engage mobile interfaces and how we inhabit space while on the move.[25] Drawing on phenomenology, he makes a case for understanding embodied experience as a being-in-the-world that is perceptually grounded, intersubjectively informed, and culturally specific—even as it is simultaneously dispersed across digital networks. Complementarily, Nanna Verhoeff has coined the term "performative cartography" as a means of conceptualizing how the mobile microscreen functions as a Foucauldian "dispositif,"[26] facilitating a "procedural experience" particular to what she terms

the "visual regime of navigation."[27] "Navigation," here, refers to an active and creative process, a "making-in-motion" that is not a "result" of cartography per se but a practice or action of moving toward a destination. In the context of mobile devices, navigating to a "there" frequently involves touch (e.g., index finger upon or across a touch screen).[28]

Read alongside critical mobilities and related research, work in media studies and theory helps us to develop an account of how and to what end mobilities are regulated. In taking a Foucauldian approach, I aim to extend lines of inquiry developed by Wendy Chun, Alex Galloway, Richard Grusin, Lisa Parks, and Eugene Thacker.[29] Both Chun and Galloway with Thacker approach the question of governance from the perspective of computer technologies. Chun theorizes the fiber optics of Internet technology in terms of a mutually informing relation between control and freedom; she questions the distinction between hardware and software in order to focus our attention on the problem of sociocultural programmability. Galloway takes up programming protocols and gaming algorithms in order to consider how code conditions possibilities for behavior. And Lisa Parks examines the ways in which satellite footprints map populations according to signal reach and coverage, as well as how aerial imagery, as produced by U.S. satellite reconnaissance systems and global media platforms (e.g., Google Earth), articulate visual, military, and corporate economies of power in order to manage flows of information, its representation, and its interpretation.

While Parks, Chun, and Galloway focus on media technologies and infrastructure, Richard Grusin discusses how post-9/11 media practices along with governmental techniques have served to "premediate," that is, manage in anticipatory fashion, the "public's collective moods and perceptions." In particular, he considers how premediation operates at the level of affectivity, wherein

the body responds to events prior to any conscious recognition or interpretation of them. Eugene Thacker, too, understands populations as biological entities. In addition to coauthoring with Galloway on the "protocological control" of networks, he demonstrates how biological networks are implicated in managing populations. Referring to the twin threats of bioterrorism and emerging infectious diseases (such as swine and avian flues, and SARS), he observes that the transmission of biological contaminants is both facilitated and secured by means of managing transportation (e.g., air travel) and communications (e.g., postal service) networks. For him, the turn to biodefense as a tactical response to such risks links information networks and epidemic networks in a way that epitomizes biopolitics in the twenty-first century.[30]

In pursuing an argument about how governance works on populations, *Finding Augusta* develops these precedents in understanding individuals as members of populations, whereby they are socially networked, studied, tracked, and defined by and through the pervasive programs of productive regulation that have been theorized by Michel Foucault as governmentality. Moving beyond cultural studies interpretations of devices of mobility, such as the Sony Walkman, this book also intervenes in more recent discussions of visual and media studies that tend to position mobile devices of connectivity in terms of prosthetic extensions or cyborgian incorporations. Informed by research in mobilities, the book addresses the proliferation and sprawl of the sundry dispersals, disseminations, distributions, and so forth, that exemplify our digital present. In the following chapters, I focus on questions about the changing meanings of location and "locatability," about investments in "where-ness," and about legibility (as opposed to visibility). I likewise consider how notions of "findability" inform biopolitical techniques of population management, or governance.[31] Finally, I engage the question of

what it means for regulatory habits to change. Theoretically, I invoke the philosophy of Charles Sanders Peirce; practically, I offer readers an opportunity experimentally to change habits through this book's digital supplement Augusta App.

CREATURES OF HABIT

We are creatures of habit. Frequently progressing through our days on "autopilot," we can accomplish familiar tasks without any explicit thought whatsoever. We often overlook the routines of everyday life and take their completion for granted. For example, we might travel a familiar route and arrive at our destination unable to recall much of anything about the particular journey. We might pause to notice the hazardous peculiarity of speeding down the highway while preoccupied with some vexation or impending deadline, but miraculously we more frequently arrive alive and distracted. This normalcy born of repetition and familiarity has been explained in different ways. For the purposes of my argument, (bio)philosophy, semiotics, and neurophysiology may usefully be read together to provide an account of habit as an interrelated and ongoing process. In this process, habit is always habit-in-formation and habit-as-change. Such an approach allows us to think of populations in terms that recognize that individual persons are simultaneously vital, that is, nonconscious, meaning-making, and social entities.

Beginning in chapter 2, I turn to Henri Bergson, who offered an early philosophical account of how habit and habit change might transpire, and to pragmatist Charles Sanders Peirce, who posited a semiotic account of habit and habit change. My understanding of these early twentieth-century humanists has been informed by more recent work in neurophysiology, particularly that of Antonio Damasio. Damasio explains, "On many occasions, the

execution of our actions is controlled by nonconscious processes."[32] Such processes are trained by the conscious intention of repeated practice. And in the normal-functioning brain, this means that they serve to amplify the "reach of consciousness."[33] "Outsourcing expertise to the nonconscious space is what we do when we hone a skill so finely that we are no longer aware of the technical steps needed to be skillful."[34] And so we arrive home from work each day without ever really thinking about it; we negotiate familiar surroundings on foot while texting friends or posting mobile updates; and we aim, frame, and snap images on the fly. In short, we tend toward absentmindedness.

And it's a good thing, too. Without the capacity for absentmindedness, which Damasio refers to as the "cognitive unconscious,"[35] our conscious processes would not be "free for creative use"[36]—for analysis, problem solving, and planning. The "submerged operations" of general knowledge and reasoning make possible the completion of simple tasks without concentrated deliberation or planning. In fact, studies have shown that nonconscious processes are actually capable of beneficial spur-of-the-moment decision making. This is because nonconscious space "is wide open" and "can hold and manipulate many variables."[37] As such, it has the potential to produce "the best choice in a small window of time,"[38] and this is because it has learned from various instances of prior conscious deliberation and, therefore, "operates according to conscious intentions and goals."[39] That is, cognitive unconscious processes do not exist of their own accord without external influences. They are informed by biases "connected to previously learned emotional-feeling factors."[40] While these may be biologically set or culturally acquired, they make only certain options available.

Damasio admits that for some the prospect that a number of our everyday behaviors are influenced or even accomplished by

nonconscious processes raises questions about individual agency and, more to the point, responsibility. But such concern mistakes the relationship between consciousness and the nonconscious processes that support conscious, deliberative action. Ultimately, the cooperative interplay between conscious and nonconscious processes develops over time, as habit, with repetition and practice. Moreover, the conventions and rules by which we may initially acquire particular cognitive unconscious tendencies do not necessarily result in permanent patterns of influence. We can modify nonconscious procedures and action in ways that alter how we perform the rituals and routines of everyday life. In fact, health and social behavior can be revised with "intense conscious rehearsal of procedures and actions we wish to see nonconsciously realized."[41] Simply put, habitual actions and understandings can and do change. This is so, in part, because conscious alternations of the cognitive unconscious are possible.

THE BOOK: AN ITINERARY

Finding Augusta: Habits of Mobility and Governance in the Digital Era endeavors to put into practice the theory it engages. It does so by means of a digital supplement called Augusta App, a mobile application designed for iPhone. In *Tactical Media*, Rita Raley explains that tactical media deploy interventionist media art practices in order to disrupt or trouble the "dominant semiotic regime."[42] Like these "tactical media" practices, Augusta App aims "to provoke and to reveal."[43] It is not designed, however, to circulate as an artistic practice in the manner of Raley's privileged examples: the Critical Art Ensemble, the Yes Men, and the Carbon Defense League. In contrast, my efforts toward a scholarship based in theory and practice strive to work within, through, and against the very technologies and related habits that serve to ensure biopo-

litical governance in the digital present. As chapter 1 explains, Augusta App serves as a kind of laboratory for exploring the book's argument. Titled "Making Tracks: Augusta App Would Like to Use Your Location," it introduces the app's use of QR codes (printed in book), mapping, Twitter-like feeds and updates, and semantic visualization that, in combination, function to engage and track the book's participants. The chapter elaborates the twofold figure of the traveling salesman: (1) Scott Nixon, the historical independent insurance agent, whose Augustas provide content and thematic for the application; and (2) the Traveling Salesman Problem (TSP), the computational model that informs the technical processes that make the application functional. I survey computer science and, by extension, computational mathematics; discuss search engine functionality (specifically, Google's PageRank algorithm); and explain data management techniques, such as latent semantic indexing (LSI) and singular value decomposition (SVD)—both of which are central to the mobile app. The chapter explains the various TSP-informed processes that ensure findability (broadly speaking) and demonstrates how reader participants might begin to explore how they themselves are tracked. In this way, the chapter draws attention to the intensity of tracking built into our mobile devices and our habits of using them.

Chapter 2, "In Hand and On the Go: Design, Neuroscience, and Habits of Perception Handheld," turns to discourses of industrial design (ID), neurophysiology, and biophilosophy to explain how manufacturers like Apple succeed in placing mobile devices in hand. I contend that only by recognizing that mobile devices are designed to be integral—in relation—to the persons using them can we understand the importance of texting, mobile imaging, and other kinds of mobile updates. I argue that we might more fully understand how populations come to embrace our mobile devices if we consider our attachment to them as a nonconscious

bodily process. Biophilosopher Henri Bergson, neurophysiologist Antonio Damasio, and pragmatist philosopher Charles Sanders Peirce help me to explain how industrial design keeps devices in hand—which facilitates tracking but also affords new habits of self-expression (texts, mobile-imaging thumbnails, and updates of all sorts). Neurophysiology and the biophilosophy of Bergson help us to understand this at the level of the organism where habit formation, as Peirce theorizes it, transpires.

"'Location, Location, Location': Placing Persons, Accessing Information, and Expressing Self," chapter 3, considers habits of self-documentation as afforded by mobile technologies. Here, Scott Nixon and *The Augustas* return as a case study for thinking about the particularities of contemporary practices. I argue that because mobile devices are almost always in hand, they encourage spontaneous and pervasive recording of routine transactions. Texts, mobile-image sharing, updates, posts, and so forth, produce streams of data that provide a continuous account of where a person is and what the person is doing. Rhythm and pacing of abbreviations, acronyms, keyword tags, and canted and blurred images that punctuate our routines provide evidence of a different kind of expressivity. No longer the province of self-aware intentionality, the artifacts generated by mobile devices being in hand and "on" are indexes of an impulse to document. I contend that such practice occurs at the level of the organism and, therefore, at the level of habit and habit formation. But also, we must consider the mediation of such self-record by algorithms designed to parse data for similarity, regularity, and popularity, as well as to assign GPS coordinates and time stamps to strings of digital artifacts. Together, our habit of announcing where-ness and our devices' capacities for locating us in real time allow us to consider how self-expression interacts with "calculability" and findability to facilitate contemporary governance.

Chapter 4, "Secured Mobilities: How to Think about Populations," demonstrates that we should think of governance in terms of tracking rather than surveillance. Following Michel Foucault's lead, I trace contemporary biopolitics back to Augustan Rome. This longer view encourages me to recontextualize the revolutionary potential Howard Rheingold attributed to "smart mobs" in his influential 2002 book of that title. I cite a number of recent global events, including the 2011 Arab Spring, and popular happenings, such as flash mob performances, to show that the range of sociocultural practices enabled by mobile networked devices continue the genealogy of biopolitical governance limned by Foucault. The very infrastructures that power our mobile devices so that we can be newly connected also ensure our locatability. We rarely think about this and are surprised when confronted with, for example, dropped calls or inadequate cellular service. The example of Augustan Rome underscores that fact that securing mobilities (of all sorts) by making their locations predictable has been an objective of governance for millennia. I emphasize that in the twenty-first century location preempts privacy, mobility trumps democracy, and being connected matters more than being smart. That we are in the habit of overlooking these defining characteristics of our mobile present demonstrates a complicity with forms of governance we might better understand. As a response, this chapter works to bring the previous three chapters into relief in order to make explicit how real-time tracking might also afford possibilities for real-time intervention.

In the conclusion, I posit habit change as a mode of intervention in biopolitical governance. I cite Augusta App as an experiment in developing the means of such intervention. This app aspires to make apparent the processes of tracking that typify contemporary governance by enlisting a select, but potentially limitless, community of participants. In the process, it seeks to concretize a

pervasive sociocultural blindness: we are encouraged to overlook the myriad ways movement and connection entail being "on" grid and therefore trackable. The digital present inherits this condition of existence in part from earlier photographic practices, including those apparent in Scott Nixon's *The Augustas*.

In addition to numerous places, persons, and things, Augusta also names an experimental space designed to investigate the conditions of possibility for any habit change whatsoever. This makes Augusta App unlike other mobile locative artworks, such as Rafael Lozano-Hemmer's *Amodal Suspension* (2003) and John Craig Freeman and Mark Skwarek's more recent *Border Memorial: Frontera de los Muertos* (2012), that pursue explicitly political engagements. Rather, Augusta App seeks to encourage attentiveness to the various ways our technologies map us and our activities. While other theorists have proposed, for example, an "affirmative biopolitics" (Roberto Esposito), or take up Foucault's later interest in ethics (John Protevi, Jeffrey T. Nealon), I prefer Charles Sanders Peirce's conception of habit change for its more concrete engagement with daily semiotic activity. In doing so, I endeavor to limn a politics that might be more pervasive, if less conventionally oppositional, in order to intimate how such mundane intervention might take place.

FINDING AUGUSTA

Making Tracks

AUGUSTA APP WOULD LIKE

TO USE YOUR LOCATION

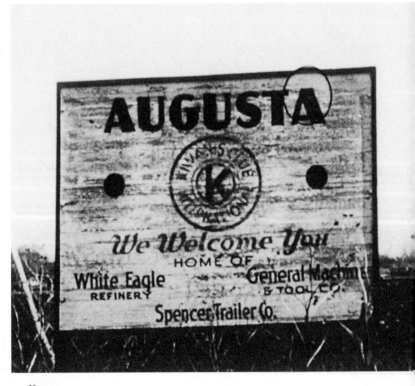

Kansas

Quick Response (QR) codes, like the one here, address a need for increased data storage and take advantage of the fact that many of us have mobile networked devices ready at hand. Invented in Japan in 1994 for the purposes of tracking vehicles during automobile manufacturing, the QR code may carry numeric, alphanumeric, and binary information and accommodates special characters, such as Japanese kanji.[1] This technology dramatically extends the information-carrying capacity of conventional barcodes, which are limited to twenty digits. QR codes have a data capacity hundreds of times greater because they store information in both vertical and horizontal directions. Moreover, the "position detection patterns" defining three of the four corners of the symbol allow them to be "read" in any orientation. In addition to displaying information, QR codes can be configured to connect to wireless networks and to open web pages. While barcodes could perform these functions in theory, in practice they lack the storage capacity to facilitate website access.

QR codes belong to a large family of relatively recent technologies designed to increase dramatically the speed, accuracy, availability, and sophistication of object-to-information matching. These

technologies include information-retrieval (IR) models, such as latent semantic indexing (LSI). As I will explain in the next section, LSI deploys a concept-based approach to managing "objects" (textual, audio, etc.) and returning results to a search query. Singular value decomposition (SVD) is one of the techniques for accomplishing this task of identifying associations and patterns among sets of objects.[2] Along with technologies like GPS that locate individual persons, sourcing and parsing techniques make management of persons, places, information, and things a mathematical problem. They intensify management techniques identified by Michel Foucault—theorist of the biopolitical milieu—and Henri Lefebvre—theorist of the social space of the urban revolution—as directed toward ensuring a population's complicity (Foucault) and complacency (Lefebvre) with governance.

The QR codes that populate this book provide entry points to a virtual tour of the book's argument. Scanning the QR code that heads this section directs readers to www.findaugusta.com, which invites them to download the book's digital supplement Augusta App (from Apple's App Store).[3] Once downloaded, an initial splash screen appears that reads, "Register."[4] Accepting the invitation and registering will initialize Augusta App's four distinct but articulated functionalities: Augusta Map, Augusta Feed, Augusta Ledger, and Augusta Photobox. Thereafter, the app returns the following statement to the newly subscribed participant's device: "Augusta App would like to use your location." Selecting "No" results in a significantly diminished experience of Augusta App's functionality. But upon selecting "Yes," three things happen: (1) Augusta Feed pings users periodically with updates, announcements, selected excerpts, and so forth; (2) the application's tracking function tracks users' locations, which is subsequently mapped against Scott Nixon's Augustas and in relation to the broader Augusta App community;[5] and (3) Augusta App presents participants with a visual interface that features the image of a magnifying loupe at center

screen, which allows them to access data regarding others' and their engagements with the book (via QR codes in the text) and the app. In combination, these dimensions provide users with an experience that proposes to illuminate the book's central claim: because handheld networked technologies create habits that regulate populations, those habits may be revised by communities of participants who are themselves counted as members of a population.[6]

A magnifying loupe organizes the Augusta App interface, allowing a participant to navigate fields of interaction and review.[7] The "lens" of the loupe offers two kinds of interaction depending on whether it is "transparent" or opaque. In transparent mode, the loupe opens onto the device's camera view. In this mode, one can scan QR codes dispersed throughout the book, as well as take images for posting to Augusta Feed—which is the app's most interactive feature.[8] The opaque mode allows one to explore Augusta App–related content. By rotating the loupe, one cycles through the four channels that define varying degrees of interactivity. Augusta Map makes tracking obvious by visualizing the heuristic of the Traveling Salesman Problem. Requiring no active input from the participant, it simply harvests participants' location coordinates, if they allow their GPS-enabled device to transmit them. Traces of their movements then display against thirty distinct, readily identifiable, and still locatable Augustas that Nixon documented across twenty-three states. The application maps participants not only against an established itinerary of Nixon's Augustas but also against additional Augustas registered over time by the broader Augusta App community. Participants can be monitored by the application in real time. In addition to location coordinates, participants' scans of QR codes are recorded, and their various contributions to Augusta Feed are archived. When a user of the application physically passes through one of Nixon's Augustas or "levels up," the app pushes to the Augusta Photobox a related image of a single frame of the preserved film or another relevant (i.e., to Nixon)

image.[9] These are filed along with images that Augusta App pushes in response to participants finding and scanning QR codes. These souvenir images remind recipients that they are tracked by the application in geographical space, just as images pushed by means of QR code scans remind them of and track their placement in the terrain of the book.

In the meantime, Augusta Ledger maintains statistics regarding individual participants' "progress" as they traverse the book, scan QR codes, contribute to the Augusta Feed, and encounter physical locations called "Augusta." It offers information of comparison and contrast across the Augusta App community based on participants' habits of interaction, contribution, and mobility. Moreover, it parses these transactions, merges resulting data with the data that is the book (i.e., the prose that comprises the book), and produces an ever-shifting semantic visualization that serves to map what Augusta is—or signifies—at any given moment.[10] Participants can check their progress and statistics regarding the rate and degree of their participation as these compare with other reader participants. Augusta Ledger calculates and provides measures of these various transactions.

You who scan this book's QR codes and join Augusta's experimental community will gain awareness of increasingly ubiquitous but often unnoticed regulatory practices. As you engage in "finding augusta," Augusta App, like so many other apps, will be tracking you—registering you as locatable and legible. Documented by every QR code scanned, participants' traversals of these pages will add to the application's database. This data will be interpreted analytically and mapped in real time across a diverse range of Augustas, which have been accumulating since before the book's publication.[11] Different instances of engagement with the application will generate differently navigable Augusta-oriented objects. For example, posting an image or comment to

Augusta Feed, or tagging a digital artifact already posted, will affect the semantic visualization in Augusta Ledger and, subsequently, revise how "Augusta" signifies. At any given moment, Augusta might acquire valences, connotations, or associations unanticipated by me, by persons who might readily assume Augusta to be a place, or by those who have logged on as members of the Augusta community.[12] As a digital supplement,[13] then, Augusta App provides an opportunity to consider how a community might develop around this book's concerns regarding tracking, "findability," and the management of populations. My hope is that Augusta App will evoke critical awareness about and engagement with the infrastructures and technologies that make governance possible in the twenty-first century, as opposed to motivating paranoid action against them.

AUGUSTA LEDGER

The Augusta Ledger employs semantic visualization, that is, a network representation of patterns and relations among keywords. Its initial interface presents a participant with a visual rendering of the original or root data set strictly based on the book's contents. Following the conventions of network visualization as described by Manuel Lima in *Visual Complexity: Mapping Patterns of Information*, words function as vertices, while lines indicate interconnections.[14] Sparsely used terms and terms of negligible significance (e.g., prepositions, articles, pronouns, and similar "stop words") do not appear in the application's depiction of the book's network of keywords. As might be expected, terms calculated to have high degrees of relevance initially appear more boldly and in the foreground of the screen. Varying thickness and length of lines defines strength of relatedness between terms. But because the application is explicitly interested in each participant's interac-

tions, the visualization is potentially ever shifting. As participants interact with and contribute to the application's content data, the SVD algorithm is used to recompute the relations among keywords and valences of particular terms. This iterative procedure registers shifts in semantic variations and clusters in real time. This results in the redistribution of keywords and their degrees of relation. In this way, individual reader participants have the capability to alter the image of what the book is "about." Insofar as the application's software "interprets" participation, it reveals those aspects of the book the community of participants finds most compelling. How individual participants engage affects what the book means and how it has meaning. That the program, as authored by computer scientists, tracks multiple participants, means that collective acts might very well relegate to the background aspects of the argument I, the author, consider central. In this sense, the book-app system aspires to enact an ongoing procedural rhetoric—that is, a participation in and performance of a system of rules governing particular conditions of being and relation—more than execute a singular persuasive act.[15]

Certainly, one could argue that the application recognizes participants as individuals of agency, or that it democratizes the book. But the fact that Augusta Ledger—along with Augusta App's other features—responds to participant inputs also registers the fact of surveillance—or more aptly, tracking. The original LSI-based rendering of the book only exists at the launch of the 2.0 version of the application. After the launch and as would-be participants interact, the visualization metamorphoses over time and in relation to the book's readership and their experimentation with it. Participants' interactions with the book are captured, registered, processed, and displayed. In this context, personal choice to experiment with the app—that is, should a reader opt to do so—provides the grounds for thinking about a mutually constitutive relation between choice

and governance—which, according to Michel Foucault, are indexes of a well-managed milieu. Governance involves both willingness to engage in the experiment encouraged by the book and app and willingness to have one's motions and reading habits tracked to enable that experimentation. (Again, willingness to participate is key—and not at all guaranteed.) Through their engagement, participants might very well refine the texture of the book's argument. They will likely also test it. But they do so by means of the very biopolitical techniques that function to manage the various flows and mobilities that typify contemporary life.

Internet and database search tools offer an expedient example. Google Search sets the paradigm through what Astrid Mager calls its "'service-for-profile' model."[16] As Google users well know, Google keeps track of their query histories and link selections in exchange for free use of its service. This is, in part, how Google's search engine streamlines online searching and swiftly provides access to information that aptly reflects "users' interests, locations and desires."[17] Its efficient return of statistically relevant links to an inordinate number of possible queries makes it appealing and useful. And while it is possible to disable certain features (e.g., cookies) and clear browser cache and search history, many Google users "opt out," and others never think to do so. Even if one practices these kinds of self-protective (or privacy) measures, Google cashes in on each user's search habits precisely because it can constitute that very refusal as a valuable data point. As Christian Fuchs notes, citing Nicholas Carr, Google tracks "people's everyday behavior online"; it sources "valuable intelligence from the patterns the behavior reveals."[18] As a consequence, the structure of Google's index shifts: our clicks manifest—in some small degree and at some point in time (iteratively)—a reconfiguration of the Google index, which facilitates "improved" future searches for ourselves and others. But because the processes that reconfigure Google's returns routinely

go unquestioned, they facilitate techniques of governance that we experience every day.

Google's continuous surveilling of its users generates profit for the conglomerate. It also serves to ensure the "visibility"—and by extension manageability—of those who take advantage, even rely, on its services. Google is able to track user interests (e.g., queries) and preferences (e.g., link selections). This allows the company to develop "profiles" that "place" users, in part by IP address. This is crucial for the targeted advertisements that appear at the margins of one's search windows.[19] When such tracking of user data becomes mundane, it can likewise seem benign. Insofar as Google is a disciplinary technology, it helps make routine or habitual the biopolitical enterprise of managing populations. Such management aims to ensure health, safety, and productivity. We need not mistrust these aims; however, we might very well question our lack of participation in making them concrete.

Searching the web or "surfing the net," suggestive of a mobility connotative of liberty, provides Google with the means to enable an accounting of such mobility by registering each user's engagement with its service. Every search query and link selection—which are moves within and across a network of information (e.g., web pages, documents, files, etc.)—is registered; each user gets mapped. Google's foray into smartphones by means of its investment in the Android operating system makes this even more literally the case: Google can track data in time to a user's movements in space.[20] That we rarely question or even notice this state of affairs speaks to its efficacy as a means of regulating conduct. Even as we (may) fear identity theft, we do not cease our credit card purchases, let alone our Google searches, which often find us at sites that culminate in our inputting billing information. Our participation in processes of tracking is precisely what good management is about in the biopolitical sense. We are governed best when

practices like googling stabilize into routine, when we ourselves habitually participate in the techniques that make it possible to predict and therefore anticipate and manage our conduct—most frequently by offering us results, products, services, and destinations that seem to be what we wanted all along.

Augusta App attempts to intervene. Mathematically speaking, the transformations that the application visualizes on mobile microscreen indicate something fundamental about the content of *Finding Augusta*: not only does its meaning change over time but also nonhuman actors play a role in changing it. Augusta App and, in particular, the Augusta Ledger functionality, illustrates the vitality of information and the malleability of its representation. It underscores that information can acquire differently weighted significance according to quantity and distribution as determined by an algorithm's interpretation of a community of participants whose individual inputs soon become integral to defining the aggregate. In tracking participant interactions and representing them, Augusta App makes the logic of biopolitics visible. It encourages awareness of the kinds of processes that structure and secure our present. It does so by inviting participants experimentally to engage the sorts of processes that Google Search, for example, seeks to make transparent.

TSP, LSI, AND SVD

Computationally, Augusta App takes advantage of the heuristic of the Traveling Salesman Problem (TSP), a mathematical optimization problem of calculating the shortest trip through a specified set of cities. To provide the necessary ground against which a participant's progress might be charted, the application identifies all the possible itineraries Nixon might have taken. In this framework, Nixon's editing of discrete film elements provides only one—the

first—tour instance. Starting with Augusta, Georgia, home of the Nixon family, this component of the application deploys a T S P-informed algorithm to map Nixon's original itinerary as indicated by the film's sequence of Augustas: Georgia (point of origin), Kansas, New Jersey, Indiana, Missouri, Maryland, Arkansas, Maine, Kentucky, Michigan, Illinois, Virginia, Ohio, West Virginia, Minnesota, Pennsylvania, Iowa, Oklahoma, Texas, South Carolina, Mississippi, Louisiana, Montana, and back to the tour's originating Augusta in Georgia. Actually, Nixon's film offers thirty-six instances of Augusta, including a military academy and a number of streets in multiple states, not to mention the Hardy Phlox flower.[21] While the application's instance of a T S P that maps Nixon's travels ignores these noncity instances of Augusta, it will acknowledge these and similarly designated Augustas as pertinent to T S P-related computational techniques in the ever-evolving semantic visualization located in the Augusta Ledger facet of Augusta App.

While Augusta App uses one of the basic formulae of the T S P to map Nixon's possible tours, the ultimate goal of T S P solutions is to find the optimal route through a given set of cities (or nodes). Typically, optimal means shortest. Less travel time and less expense equal a more direct accumulation of profit. As a problem, though, the T S P can be used to reframe other problems. A variety of tasks we take for granted every day can be converted into a T S P, for which an efficient heuristically appropriate solution can be calculated. Usually, a successfully efficient solution obscures the underpinning T S P framework. As William J. Cook notes in his *In Pursuit of the Traveling Salesman: Mathematics at the Limits of Computation*, we are more likely to notice this type of problem solving in inadequacies or outright failure of its application.[22] For example, we may be inconvenienced when a particular Amazon delivery fails to arrive as specified, or we might become frustrated when a delay causes us to miss a connecting flight.

The TSP heuristic has many applications in addition to delivery schedules and transit routes. It has been used to map genomes, to determine the most efficient way to drill and solder circuit boards, and to design computer chips. The approach has been essential to developing the algorithms that support basic mobile phone functionality. The TSP underpins approaches to ensuring the continuity of mobile phone connectivity when a call needs to cross from one cellular tower to another. It helps to optimize e-mail transmission, as well as text- and picture-message delivery. And it informs approaches to maintaining the accuracy and reliability of GPS-based mobile navigational applications (and related vehicular systems). Considered with the TSP in mind, it becomes clear that the central concern of mobile networked communications is the routing of audio, textual, and video data.

Routing is similar to arranging, and TSP solutions have proved instrumental in designing methods for organizing vast quantities of data as well.[23] In an earlier information age, retrieval systems could overlook the problem posed by multiple versions of the same data set. This is no longer the case when it is important to keep track of rapidly accumulating software variants, wiki updates, file modifications, photo uploads, and so on.[24] TSP-informed methods allow for constant updating to track the accumulation of variants. Whereas previous information-retrieval protocols proceeded according to hierarchical specification, current practices work according to computational approximation. For example, Library of Congress (LC) subject headings develop granularity through the addition of modifiers, as in "Augusta (Ga.)—Description and travel," and relational databases typically define a parent-child structure to organize records. In contrast, methods that treat organization as a TSP seek efficient ways to associate individual objects globally within relatively unstructured and evolving sets of data, where "object" might designate individual terms or entire docu-

ments.[25] The TSP is a useful means for identifying groups of data elements bearing similarity values, that is, likenesses among data elements. "Similarity," in the language of the TSP, measures "travel cost." Representationally, "similarity" appears as a line (an edge or arc), and the terms whose similarities are being evaluated appear as points (called nodes or vertices). A node marks the terminus of an edge designating similarity. The closer the nodes, the more similar they are and the less "costly" it is to travel from one to the other. This closeness can be represented as closeness, by relative size, by difference of color, or in any other way one might devise.

Behind the scenes, TSP-oriented math can employ a vector-space model. Representational systems such as perspective map three-dimensional space onto a flat surface according to a relation among a vanishing point and $x-y$ axes. In contrast, a vector-space model represents patterns and densities of relation occurring in multidimensional space (or, k dimensions). Here, the number of properties under consideration comprise the number of dimensions defining a field. "Properties," in this context, might be unique keyword terms or categories relevant to a text or other object, or a series of discrete texts or files. Moreover, the number of dimensions fluctuates with the addition or deletion of properties. Since the complexity of an algorithm or computation often depends on the number of dimensions, it is common to find that an algorithm begins by attempting to reduce the number of dimensions by determining the least useful or more negligible data points. Keywords or terms comprising a book's index are what's left after the negligible data is removed.

To identify the properties that relate to its objects, Augusta App employs singular value decomposition (SVD). SVD spatializes data.[26] It transforms into numbers words, documents, or other material that can be treated as if they were words or documents. These numbers designate points (nodes or vertices) within a mul-

tidimensional space, where lines (edges or arcs) link nodes deemed similar (as opposed to those considered [spatially] close). The goal is to identify both points of greatest variation and clusters of strongly related points in order to arrive at a best approximation of the original configuration—and then iterative configurations thereafter. "Best approximation," here, refers to a representation of the original data using fewer points. In this way, SVD reduces the dimensionality (from k to $k-p$—where p can be thought of as the number of keyword terms that mathematically have little value in discriminating among documents or parts of documents) of a text in order to bring strong relationships to the foreground as well as expose otherwise not readily discernible substructures that make a particular document unique. Reduction eliminates noise by eliminating statistical outliers. The key feature of SVD is that it extracts algorithmically identified significant terms and their relationships based on the computational processing of the data itself, not on a Library of Congress–like imposition from the top. Rather than have a preconfigured or predetermined "expert" template match a document to a predefined template (as is the case with Google's content score as described above), which would be overly costly, SVD—and latent semantic indexing (LSI), more broadly—allow the description of any document to be defined in a mathematically sound way based on the data of the document itself. In the process, it distills a text to its component keyword terms. As such, SVD establishes a root "dictionary" according to which similarities (not physical proximities) among various accruing documents might be identified, ordered, and visualized.[27]

In Augusta App, my colleagues in computer science have used a standard method for reducing dimensionality by trimming away those properties and dimensions that contribute little to semantic content and computational efficiency. The number indicating dimensionality is represented by the variable k. What appears

on-screen, then, is not a static planar (i.e., photographic) "view through a window," as we might see in perspectival representation. Rather, vertices designating properties populate a field according to degrees of proximity (i.e., similarity). Properties mapped by Augusta App include the book's initial list of index terms, keywords derived from participant-contributed content, as well as participant interaction with the semantic visualization (e.g., touching a keyword node). Similarities—travel time—between terms and objects containing terms, such as "Augusta" and "Hardy Phlox," are interpreted as angular, as opposed to linear, distances between two points.[28] Each point exists along an axis in some multidimensional space. In more familiar two-dimensional plots the proximity of one point to another is calculated according to the logic of "as the crow flies." In vector-space models, however, the proximity of any number of points is measured by degrees of separation. Instead of being interested in the spatial distance between A and B, the vector-space model considers the (potentially) various relations among A, B, C . . . Z, as these might be determined by a number of occurrences. In the case of Augusta App, objects that share more of the same keyword occurrences cluster more closely together.

Conceptually, this is how Internet search engines, such as Google, return results in response to queries composed of keyword strings.[29] Google does not use SVD but rather a ranking system that uses complex link-structure algorithms. Any Google Search return involves adding together a content score and a PageRank popularity, or importance, score.[30] The content score incorporates data regarding previous user hyperlinking in relation to a priori keywords, while the importance score is based on the web's hyperlink structure. Suppose a Google user submits the string "augusta flower." In processing the request, the query module of the search engine automatically assumes the existence of the Boolean "and": "augusta" *and* "flower." It accesses precomputed

indexes such as the content index.[31] Web pages that contain both query terms are identified as relevant pages. This list, however, likely boasts a vast number of pages (many of which might very well specify florists in Augusta, Georgia). Because of the number of possible returns, the list of relevant pages is passed on to the ranking module where popularity rankings "are imposed on the pages" comprising the relevant set and, thereby, "make the list of retrieved pages more manageable."[32]

What appears on-screen in response to this type of query might strike one as completely off the mark. For example, a Hardy Phlox seeker might well be disappointed by the above search. This is a consequence of the mathematics responsible for content and popularity scores. Nevertheless, most of us find the odd return only a minor inconvenience, and perhaps even a delightfully quirky surprise. Typically, though, Google returns at least one good link, and users tend to be quite facile at filtering out less useful ones. Users have also been shown to be comfortable with and rely heavily on relevance feedback; having found one good response to a query, a common and comfortable user action is to ask for "more [stuff] like this." The problem with this search logic is that "popularity" equates to "reliability." Thus, alternatives that might be "better" are not recognized as such because of how principles of likeness and reliability are defined within the preexisting abstraction of computational mathematics.

On a significantly less rigorous and less expansive scale than Google's web page ranking model, Augusta App employs a simple vector-space information-retrieval (IR) model to parse the book's prose and to return a graphical representation of its keywords to the Augusta Ledger facet.[33] Semantic visualization is configured, not alphabetically as one would find at the end of a book (where, in the case of *Finding Augusta*, a traditional index may indeed be found), but visually according to representational signifiers: font

size for frequency, color for importance, and word placement for degree of similarity, and so forth. Moreover, unlike a conventional book index, which is static and fixed, Augusta App's keyword visualization is dynamic and multidimensional. It responds to reader-participant inputs.

LSI reassesses keyword significance based on participant interaction. As participants select words, by touching them with their fingers, it expands, assuming a more pronounced orientation on-screen. As it expands, the node opens onto data about the term: for example, number of hits the term has accrued over time and across the community of participants, as well as related content uploaded to the application's database by participants. Simultaneously, lines of connection acquire greater or lesser density, establish new points of relation, and fall away from no-longer-viable affiliations. Insofar as the constellation of nodes and edges is graphed along n axes, words are afforded a virtual mobility. They shift horizontally and vertically across the screen's surface; they dilate or contract according to their position along the lines of depth and degree of proximity as defined by any of the other axes (e.g., frequency of appearance, relations to other keywords, etc.). Lines reposition accordingly. These metamorphoses transpire in response to multiple participants' interactions with the constellation appearing on-screen. Thus, Augusta App's keyword mapping of *Finding Augusta* exists semi-independently from the book itself. By establishing this relation to the book's description of computational processes that have become routine to us, Augusta App encourages participants to explore their operations and possibilities.

HABIT AND AUGUSTA APP

Augusta App is an experiment in thinking individuals and populations together. It offers participants new ways to reflect on,

and see more fully, what is entailed in their routine uses of mobile devices and the populations they connect. The application draws attention to the ways in which even the most minimally expressive but routine acts and gestures simultaneously proliferate streams of data. Carrying a mobile networked phone (in the "on" position) and pinching or swiping a screen are, for many, quotidian practices. They register details about one's whereabouts and habits of usage, not to mention recording data about the device itself. This proliferation of information ensures one's findability. Augusta App uses Scott Nixon's compilation film *The Augustas* and the Traveling Salesman Problem (TSP) complementarily to highlight the relation between individual engagements with technology—be it documenting on film various Augustas or posting mobile announcements about location—and more expansive efforts to keep track of movements (including flows of data) of populations. With its intention to incite participants to consider habit formation, and to constitute themselves as a community by means of that consideration, the application endeavors to emphasize both that shared habits enable governance (which turn people into a measurable population) and that such habits may change.

It is worth returning yet again to the example of Google, which has succeeded in demonstrating how this kind of logic works. A Google search delivers relevant returns only if a large enough population of users chooses links that "improve" the query results returned by Google's computation of relevance. The fact that we readily input keyword terms and click "Search" is indicative of our having become habituated to the Google way of thinking. Each time we search to "find what 'I' want," we are reinforcing behaviors already indicative of a population management problem. Search engines such as Google assume that patterns—of interest, desire, need, and so on—exist across a population. Moreover, they cultivate these habits. Returning sufficiently reasonable returns to

search queries, they guarantee their own capacity for continued service.

Like Google Search, Augusta App seeks to improve itself by engaging a population. Unlike Google Search, it also aims to invite experimental consideration and discussion of how such a population might become a community that can participate meaningfully in revising how they as a population are so managed. Without determining in advance what such participation will entail or produce, Augusta App is built on the insight that it will involve habit change. Of course, this change will only occur within the parameters provided by the application. That said, precisely because our technologies manage us through habit, we would not intervene in them decisively through argument or counterregulation alone. Potential intervention will require the cultivation of new habits. In the case of Augusta App, this may simply mean that participants "nod" in recognition when the app pings them. Or it may mean that they "game the system"—for example, by "noising up" or radicalizing "Augusta" or Augusta App. Either way, something will have shifted in the way participants think about Augusta.

Charles Sanders Peirce provides a way to theorize such shifts in thinking and doing (and vice versa). According to Peirce, habit is the commonsensical character of human behavior. Although it often connotes passivity, Peirce sees habit as neither fault nor weakness. Rather, habit materializes as a "readiness" to act. Such readiness is socially oriented and, therefore, abides a community of interpreters' shared normative principles, which at a very fundamental level regulate reason and belief and, therefore, action. As Karl-Otto Apel explains with respect to Peirce, the normative principles that shape habit are not simply "technical instructions"; rather, they establish the conditions whereby action is realized as "a social style of life."[34] Under certain conditions or circumstances a person "would do," "would act," or "would be" in a general manner

as made possible by the person's given sociohistorical context.[35]
This person would, for example, likely always have a mobile phone
on hand or near at hand; and it would be activated to receive in-
coming calls and texts. Moreover, the person might very well be
inclined to use her or his device to search the Internet.

In Peircean terms, habit functions at the level of the logical
"interpretant." It enacts a correspondence between an object and
its sign (e.g., mobile device → connection). Thus, habit is the very
condition of signification. In order for signs to mean something,
there must be shared, habitual interpretations of them. Peirce
equates cognition with semiosis, which he defines as a "species of
conduct."[36] The general manner by which people, that is, a com-
munity of interpreters or inquirers, arrive at meaning assumes, as
Apel specifies, the form of a "rule embedded in human behavior."[37]
Consider, for instance, that a great many contemporary users
rarely, if at all, remain technologically disconnected for extended
periods of time, because connectivity is an implicitly agreed-upon
way (or style) of life. We anticipate that others, like ourselves, are
"on" and online. We refer to Internet searches as "googling." We
agree to be reachable (e.g., textable) by phone, and for many of us,
this likewise means being linked in to social-networking platforms
such as Facebook and Twitter. Such thinking is a shared habit. And
shared habits are habit forming: others likewise will connect and
be "on"; they, too, will "google"; they will accept an invitation to be
Facebook "friended," announce that they are "following" someone
on Twitter, or otherwise "share" information about themselves and
their activities.[38]

Because habit, for Peirce, transpires according to general prin-
ciples that govern possible behavior, it proceeds according to the
conditional mode of the future tense: "the 'would-be' [of nascent
habitual behavior]."[39] That is, the process of habit is not "mechan-
ical."[40] While there may seem to be an automaticity or regimenta-

tion at work in habit, Peirce contends that what one fully believes (or does) today, one might, in fact, disbelieve (not do) tomorrow. For example, we may or may not log on to any one or more social-networking platforms. This is because habit is not attributable to any cause as such; it does not simply proceed according to some predetermined or preestablished course of action in response to a stimulus. Rather, habit works toward some idea of action based on some desired outcome as informed by one's inclination or predisposition. It proceeds according to actions that have "this or that *aim*."[41] But again, such actions are never definitively prescribed, even as repetition, or iteration, might seem to promise consistency of behavior and thereby render habit regular.

Habitual behavior, then, only ever functions to ensure variability.[42] Habits are relative and, therefore, subject to influences of context. Habit understood in this manner embraces change, although it does not guarantee it. Neither are the tendencies attributable to habit predetermined. So while repetition of a particular behavior might perpetuate already existing patterns of behavior, it might very well result in an alteration, or change, of habitual behavior. The effects of such change manifest as continued behavior of a different sort and, according to Peirce, last until such time as habit change occurs again. In other words, habit and habit change are inextricably linked. They are so in the moments when the individual, as cognitive being, is "just coming into life in the flow of time"—or, as I will discuss in the next chapter, Bergsonian duration.[43]

Importantly, Peirce emphasizes that an individual's "coming into life" in the time of thought always occurs in relation to a "circle of society."[44] This means that habit and habit change are necessarily historically specific and socioculturally oriented. As individuals, we do not think, act, or exist alone. Rather, we acquire ways of thinking (and doing) that are collectively shared and be-

long to social life, that make sense only in light of a general manner of thinking across a population. Habit change is the guarantee of generality at work across a population, that is, the guarantee of possibility that is ever a condition of the potential actualization of some other reality, some other habitual behavior, as made possible at the level of the social. As individuals, we might very well select an unlikely link in a list of more relevant ones. This choice might alter, for example, Google's PageRank scoring, thereby affecting to some small degree subsequent habits of thought for many others. Or we might switch our mobile phones to vibrate in order to compromise between a requirement of silence and a desire to be connected. These shifts occur within the limits of possible behavior. The limits of possible behavior as such are determined by what is sensible to a larger community.

Although Peirce attributes a sociality to habit and habit change, he does not provide an account of how sociality is actually situated in the world. In his abstraction, the concrete aspects of physical space, the technologies and technological infrastructure that define it, and the people who inhabit or pass through it go unspecified. If habit and habit change are social, as Peirce rightly contends, then they of necessity are practiced somewhere and according to the constraints of place and time—as our devices, in their time and date stamping and location metadata, make so very clear. We would be wise to consider how material context plays a role in how habits take shape. For example, we have learned to perform certain site-specific behaviors: we turn mobile phone ringers to "silent" or "vibrate" when we enter movie theaters; we excuse ourselves from the table at a restaurant in order to take an important call; and we put our computers to sleep (if we don't power them down) when visitors come for dinner.

At the same time, we should recall, as Michel Foucault has instructed, that the habits we acquire through training and practice

are situated;[45] they abide protocols defined by institutions that constitute society and are materialized as physical sites and structures. We learn to inhabit particular places in site-specific ways: classrooms, medical office waiting rooms, work spaces, queues in grocery stores, parking structures, and even one's own bedroom. Each of these sites presumes a manner of conduct, or etiquette, specific to it. Appropriate conduct when normalized operates most intensively as disguised habit. Frequently invisible, because naturalized into a way of living that spans a population, routine everyday practices make smooth the various operations and transactions that maintain society. Even so, they simultaneously function to locate individuals. In the context of mobile devices, the means whereby management is accomplished are more pervasive: we are always persons locatable—and measurable—in real time.[46] Those of us whose routines involve connectivity (e.g., text messaging, mobile image sharing, posting updates, e-mailing, and googling) are placed and, therefore, locatable by those routines. A mobile phone in or near at hand, activated and in the "on" position, signals one's location to cellular towers within range. GPS coordinates (e.g., mobile phone or navigational system) come within meters of one's geographical position. Even an IP address places one at a particular computer.

AUGUSTA MOBS

That habits, routines, and everyday patterns of existence are grounded in the physical and social world means that habit change has to work within and on social space (or, a la Foucault, the milieu). Among those who have worked on this problem, Lefebvre has perhaps most effectively thought about the relationship between spatial habits and spatial habit change.[47] In *The Urban Revolution*, Lefebvre explains that our everyday uses of space abstract it. It is parceled into units. It is bought, sold, and exchanged. As a consequence, we inhabit it according to a logic of surplus value. It

is relegated to the status of a commodity.[48] Instead of exploiting space in this manner, Lefebvre proposes that we begin to think of space as "a medium" (but not in the sense that Foucault uses the term).[49] The city serves as his example of such a space. He recognizes that the city is an urban center and, therefore, an entity that is administered, dominated, and permeated by networks. But he notes that it is also a site for movement, gathering, and assembly.[50] For him, the features that make a city recognizable as such are the very indication of the potential for assembling and in ways that boast revolutionary potential. Its grid of sidewalks, streets, and lights facilitate various routine traversals of space. But it also has the capacity to inspire unexpected happenings.[51]

Here, we might consider "flash mob" events that repurpose public—often commercial—spaces. Venues for flash mob happenings are typically corporately owned sites. Frequently, the gatherings are organized via e-mail or text message. A call for an impromptu gathering circulates electronically and, in response, people assemble at a designated site, such as a shopping mall. At a specified time those who have gathered perform something unexpected, such as a dance or pillow fight, before peacefully disbanding. The event lasts for fewer than ten minutes. Such events point out the normatively routine operations that underpin contemporary socioeconomic life by momentarily interrupting them. They demonstrate an organizational alternative to the necessary and ceaseless circulation of goods, money, and people. In the process, they make apparent the ways in which we have been habituated as workers and consumers of, among other goods and services, the very technologies that make flash mob practices possible.

Without necessarily intending to do so, flash mob practice implicitly comments on the rote character of consumption. But it is not political in the sense of hoping to redistribute power or somehow slow corporate or individual pursuits of wealth. As Bill Wasik, the person who initiated the first flash mob event, describes it, flash

mobs perform the act of coming together—especially in an era of social-networking platforms, such as Facebook and Twitter, where social interaction is frequently just virtual.[52] He comments that flash mobs demonstrate what social media technologies and social networks are capable of: they bring people together. Lurking in Wasik's claim is one common way of thinking about technologies—especially mobile technologies. This perspective offers us an optimistic or hopeful vision of community that allays fears about antisocial behavior or isolation. Wasik's picture of flash mob "togetherness" also wards off threats of political contest and potential social degeneration. Having identified pervasive consumerism as a problem, Wasik's proposition contains it by redirecting substantive critique. Things can continue as usual—and do once a group of flash mobbers exits the scene of shopping mall or department store.

A different "mob" mentality emphasizes a more agonistic, democratizing energy, inspiring rallies and protests. Howard Rheingold was an early champion of this model. In 2002, he intimated that mobile technologies are productive of spontaneous collectives, or "smart mobs."[53] Smart mobs, as described by Rheingold, demonstrate the potential (political) power of increased coordination and cooperation among people worldwide, especially youths. The Rheingoldian "mobile many," in swarming the public square, portends the overturn of the status quo—but without acknowledging how those "so-mobilized" are also trackable. In this way, Rheingold's model has something in common with Wasik's. Both neglect the poignant fact that digital, networked, mobile, and almost always "on" technologies place individuals on grid and always in relation to a larger population. Albeit in different ways, flash mobs and smart mobs vastly underestimate the significance of the fact that individuals who compose them are always already constituted as part of a population in the biopolitical sense.

Augusta App is a response to this assumption. It understands that

technologies like the Google Search habituate us to perpetuate the status quo. We inhabit everyday routines that extend to mobile networked devices and our uses of them. In the process, we often fail to see that the infrastructure that "allows" us to connect also requires us to connect in some ways rather than others. Even as we curse dropped calls and other inadequacies in our cellular service, we often forget that we are always "on" grid and trackable. At the same time, we take being locatable as a matter of course. We ourselves expect to be able to locate persons, places, and things with the touch of a button or a "pinch" or "swipe" of a screen. Thus, Augusta App recognizes Lefebvre's insight about the nature of consumer citizens (or what he terms "inhabitants"). But it deliberately avoids connecting to any particular project of political transformation. This is because it endeavors to offer participants a laboratory that might be useful for investigating the conditions of possibility for any habit change whatsoever in our current mediated environment.

To a remarkable degree our political culture continues to understand government in physical terms, as geographically situated and territorially bounded. It is often said that the United States is governed from Washington, D.C.[54] Likewise, we persist in thinking that our decision making and the responsiveness whereby we are governed are a matter of choice in the juridico-legal sense. These are both habits. Such habits encourage us to overlook the fact that governance is also a matter of administering populations by means of infrastructures that enable the continuous monitoring of mobilities—wherever they go—and of gathering and parsing various statistics. To imagine an outside to these conditions of being "on," connected, and on grid in the twenty-first century would be a mistake. If we wish to act and be regulated differently, that will require Peircean habit change, which transpires at the level of the organism as part of processes of cognition of those who inhabit a milieu. Augusta App aims to contribute to such change.

In Hand & On the Go

DESIGN, NEUROSCIENCE, AND

HABITS OF PERCEPTION HANDHELD

Texas

Eastman Kodak introduced the Cine-Kodak 16 mm movie camera in 1923, and the Cine-Kodak B two years later. Distinctive camera marks visible on the original filmstrip of *The Augustas* demonstrate that Scott Nixon shot the sequences of the Augusta Military Academy on a B model. Nixon also occasionally shot with the heavier, more professional Cine-Kodak Special.[1] However, he seems to have relied mostly on the K model, which was introduced in 1930.[2] The Cine-Kodak line of cameras targeted amateur filmmakers. Although all the cameras were designed to be portable, the B and K models were particularly suited to handheld use. Neither required a tripod. By design, these cameras encouraged filmmakers to take them everywhere, and someone like Scott Nixon could document Augustas with little more fuss and forethought than ensuring that the camera had been loaded with film.

This chapter takes up the design logics that encourage the portability of twenty-first-century handheld devices, specifically the mobile—or smart—phone. I am interested in how concerns regarding heft and "wieldiness," or physical manageability, that informed the design of amateur film cameras like the

Cine-Kodaks, inform a new set of questions about intuitive interfaces and about how to engage a very large populations of users as opposed to the more select category of amateur filmmakers. I interpret industrial design's pursuit of a "natural" look and feel as a managerial gesture, one that operates on individuals at the level of their nonconscious engagements with mobile devices. I find that the "nature" designers and engineers imagine collapses a plurality of individual hands into the abstract ideal of a universal "human hand," a category that cares very little for skills-based, talent-oriented, or economically informed distinctions that seem to typify early twentieth-century discourses promoting affordable ("professional"-like) technologies for "amateurs," that is, people who have disposable income and free time. For the purposes of this discussion, I focus on Apple's iPhone as a representative example of contemporary industrial design's commitments to evoking an "intuitive" feel and interface.

That millions of consumers carry mobile devices in hand points to the success of this approach and also implicates industrial design in a larger biopolitical project. Design systematizes individual expression as personalization and thereby guarantees our psychic attachments to, for example, brand, platform, and carrier. The process whereby consumers select devices suiting their style and configure them to personal specifications obfuscates design's accomplishment in setting the range of options that encourage such selections. We might more fully understand how populations come to embrace mobile devices and the managerial projects they entail if we think about our bodily attachments to them. In a very immediate and visceral way, the design of our handhelds pleases. For many hands, these devices do indeed feel like "natural" extensions of the body. To describe this relationship in ways that acknowledge design's ability to succeed so spectacularly and also the cultural and scientific work involved in producing a new second nature, I

turn to biophilosopher Henri Bergson, neurophysiologist Antonio Damasio, and semiotician Charles Sanders Peirce.

DESIGNING (FOR) THE HUMAN HAND

In the early twenty-first century, the iPhone epitomized the sophisticated, methodical, and successful effort to provide a tactile interface that feels "natural" and intuitive to all potential users. Manufactures such as Nokia, LG, and Samsung (which in August 2012 lost a legal battle to Apple, Inc., for patent infringement) also developed this approach, without, however, exemplifying it. In his MacWorld keynote address on 9 January 2007, Steve Jobs introduced the iPhone by asserting, "We've designed something wonderful for your hand. . . . It fits beautifully in the palm of your hand."[3] One might question to whom exactly this "we" refers. A good deal of practical labor goes unnoticed in the rhetorical sleight of hand whereby the CEO showman offers himself as a metonym for Apple. One might also question what is intended by the words "designed . . . for" and "your hand." Just whose hand is imagined by design processes? And to what end? In truth, Jobs's wonder implies an unacknowledged assumption that haunts the history of industrial design, namely, that the best interfaces will go unnoticed, that they will be intuitive and ultimately "invisible." In striving to fit devices into myriad individual hands without calling attention to them as computer interfaces, Apple's industrial design team follows an institutionalized practice of forgetting that "your hand" may be unlike any other. Insofar as industrial designers eagerly seek intuitive relationships between devices and hands, they simultaneously work to efface the particularities of the very hands that hold devices.

From the beginning, Apple embraced a design logic that communicates approachability and familiarity. As Paul Kunkel explains in *AppleDesign: The Work of the Apple Industrial Design Group*,

Steve Jobs as the company's cofounder (with Stephen Wozniak and Ron Wayne) demanded that Apple's products move away from the "cold and impersonal" corporate aesthetic typical of companies such as IBM.[4] Likewise, he disapproved of the wooden boxes other companies produced; to him they were "naive."[5] He contended that the personal computer ought "to look and feel like a real product—something that ordinary people could use without being confused or intimidated."[6] For Jobs, this meant that a PC—the Apple II (1977) in particular—should boast "a slick-looking plastic case with soft edges, muted colors and a lightly textured surface."[7] Such characteristics would "inspire" first-time buyers.[8] By 1991, Apple aspired to "cater to users' cognitive and cerebral demands . . . address users' subliminal needs and satisfy sensory demands for beauty, tactile quality and surprise."[9] Apple's design ethos can be summed up as one of "elegant simplicity": friendly, intuitive, and sophisticated without being complex.[10]

Apple offers a specific instance for considering the historical motivations—and corresponding omissions—driving industrial design practice. It should be more widely acknowledged that Apple's design philosophy develops that of the German company Braun in the 1950s and 60s. Posting to the popular technology and electronics blog *Gizmodo* in early 2008 in celebration of the iMac's tenth anniversary, editor Jesus Diaz identified a direct link between the design philosophies of Jonathan Ive, senior vice president of industrial design at Apple, and Dieter Rams, former head of design at Braun. Both men share a commitment to a sparse use of color; they have similar taste in materials; and they both emphasize that function ought to determine form. Diaz concluded that Rams is the "influence that permeates every single product at Apple." Moreover, Diaz specified at the time that Rams's ten principles of "good design" inform the "passion" for the kind of good design that Ive advocates when he appears in interviews and promotional videos.[11]

The design of Apple products is not about "styling" or "lifestyle" (in marketing terms) according to Ive; rather, it's about "human-iz[ing] technology" such that persons are inclined to engage.[12] On this view, a technology's physical attributes—its identity—ought to invite ready understanding and therefore use.

Other industrial designers have shared this pursuit of technology that seems human friendly because its simplicity and purity (Rams) breeds familiarity (Ive). A logic of "natural design" drives the field. According to the broadly influential appraisal of engineer Donald A. Norman, "good design" aims to communicate through "natural signals" that facilitate use.[13] Following this thread, Ellen Lupton, curator of contemporary design at the Cooper-Hewitt National Design Museum, and her sister Julia Reinhard Lupton assert that "a well-designed object diagrams its own operation,"[14] insofar as form makes readily legible how the object might be used. They point to the "twin ideas" of affordances and constraints to explain how such design operates. Affordances invite certain kinds of interactions, and constraints define which set of affordances is available. Their example is a ceramic coffee mug's handle, whose shape and placement make apparent its use: to lift and hang the mug. The kind of design Norman and the Luptons advocate, heeds, according to designer and design theorist Victor Papanek, a "basic, underlying organic principle" that allows an object to express directly how it should be used.[15]

In the case of mobile technologies, the kind of design Papanek advocates places hands. The goal is to make any hand whatsoever respond easily and effortlessly to the device.[16] For the iPhone, this principle informs not only how one holds or handles the phone as an object but also the way one interacts with its multitouch screen. It inspires the device's "natural user interface" (NUI) as well as its shape and size. The NUI allows—in fact, encourages—pinching, swiping, and tapping as gestures by which one controls or, as Lev

Manovich notes, "plays" the iPhone.[17] In identifying the interaction as playful, Manovich calls attention to the "rich sensorial and often seductive experiences," turning interaction into an event, something akin to theatrical performance.[18] This marks a shift from the principally utilitarian functionality attributable to jog knobs, buttons, and keys that defined earlier mobile devices. As such, the iPhone allows users first to imagine and then to expect a more tactile experience from our mobile technologies.[19] In the process, we grow more attached—quite literally—to them.

Contemporary mobile devices aspire to fit beautifully in hand, but what is meant by "the hand"? Whose hand? And under what circumstances or conditions? In the case of the iPhone and kindred devices, the concept of the human hand derives in no small part from ergonomic studies and associated biomechanics, which measure hands in order to produce a paradigm that generalizes particulars. Both ergonomics and biomechanics examine individual bodies in order to explain the workings of "the human body" as a mathematical ideal. For example, biomechanics' interprets the flexing of myriad individuals' fingers in terms of the logarithmic spiral also found in the accretive shell of the chambered nautilus.[20] Such interpretation accomplishes thinking about the body as unmarked and generic, abstracted into specific proportions on which calculations may operate. This kind of rationalist procedure produces a "nature" that need not correspond to any empirical instance while simultaneously describing all instances. It creates a norm in relation to which all particulars can be arrayed according to their degree of deviance.[21] For example, many handhelds, especially those predating the iPhone, emphasized one-handed operation. This tended to mean left-handed operation. Right-handedness was treated as the norm. Designers placed jog knobs and dials within easy reach of the left thumb to free the right hand for other tasks. The disciplines of ergonomics and bio-

mechanics validate such normative judgments and give industrial designers far more precise information about "the hand" than the notion of left-right dominance.

Take Apple's iPhone 5, for instance. Measuring 4.87 inches by 2.31 inches by 0.30 inches, with a weight of 3.95 ounces (i.e., just under a quarter of a pound), this most recent iteration of the iPhone line assumes a (young) adult hand, with digits slender and agile enough to interact with the "buttons" and "keys" that mobilize content on the multitouch screen (itself measuring 4.0 inches on the diagonal). Apple assumes this normal hand belongs to a consumer who can afford to purchase such a device and maintain a service contract that charges monthly fees.[22]

As research in fields such as work environment studies and industrial health make clear, design's approach to the hand is not uncommon. A representative instance suggests how hands are conceptualized beyond explicit interests of commercial retail. Writing in 1992, Bryan Buchholz and Thomas Armstrong asserted the need for a predictive model of the hand that would "deal with all the segments of the hand together" as a "kinematic-link system."[23] Whereas previous approaches had proved useful for comparing "normal hand function to abnormal [hand function]," what industry needed was a model that would enable designers to improve industrial tools that require power grasp tasks, such as those involving levers. Their objective was to manufacture hand tools that would "minimize muscular effort and maximize grip strength" to "increase efficiency [of production]"—and by implication, to reduce risk of injury and related fiscal repercussions. Their model intended to measure "the grip strength capabilities of the work population." To evaluate the "sensitivity" of their mathematical model, they tested six subjects: three men and three women. Each subject was directed to hold variously sized circular cylinders according to two different power grasps. In order have statistics for a represen-

tative population, "hands were chosen so that the range of hand length . . . was covered": "from first percentile female to ninety-fifth percentile male."[24] The degree of statistical generalization at work in this discussion of outcomes is notable. Even as the authors critique certain methods that fail to measure the "work population" effectively, they themselves reduce that population to a select and presumably characteristic set of attributes.

Built from samples and generalizations, design takes sides; it is never neutral. Its "nature" points to a long-standing multidisciplinary project of instituting universals. This is a biopolitical imperative. Always a process of inscribed socialization, design's work extends well beyond the point of inception, manufacture, and purchase, for it continues at the site of articulation between human and nonhuman entities. Science and technology studies (STS) and actor-network theory (ANT) have both encouraged us to keep in mind that practices such as design provide for new arrangements of people and things and, therefore, reproduce and rearticulate power relations. As sociologist of technology Madeleine Akrich explains, new technologies can "generate and 'naturalize' new forms and orders of causality and, indeed, new forms of knowledge about the world."[25] Likewise, technohumanist Anne Balsamo argues that design does not simply produce "novel devices and solutions"; it is also responsible for (re)producing "cultural understandings at every turn."[26] In other words, designers of (new) technologies participate in projects of social norming, ethical valuation, and distribution of power across populations of user consumers.

We might recall the familiar example of this process from actor-network theory: the hinged door.[27] Bruno Latour offers a descriptive account of how the hinged door, as a sociocultural object and construct, functions both to condition people in the ways of entering and exiting buildings and to designate a process of information management whereby what gets in and out is determined and regulated. Only in the event that the door itself

proves insufficient to train those who come and go is it necessary to provide a "delegated human character," a "doorman" or like figure, to perform the task. In the instance of that kind of delegation, the door-human ensemble establishes a set of social relations that differentiates between those who come and go and the one who tends the door. We enter and exit buildings routinely without particularly noticing the doors or even any one person who may work to ensure our passage. We notice when inconvenienced—when a door doesn't work, works poorly, has been unexpectedly locked or left untended. Only then might we begin to realize the hinged door's awesome agency, although more typically we might perceive not the door's regulatory power but its limitation of our own movement and will. Design often absents the agency of the objects it creates and thereby naturalizes power relations.

Jobs's pronouncement of a beautiful fit provides a case in point. As we have seen, the beauty of the fit presupposes "fitness," a conception of the healthy normal hand. Such norms both allow design to do its work and manage populations in a biopolitical sense, by defining some hands and user experiences as deviant outliers. At the same time, though, the biopolitical project that design facilitates is not a static process. Both Akrich and Balsamo indicate that new arrangements, new formulations, and new assemblages are possible, which produce revised or different modes of knowing and relating to the world and each other.[28] Governance always exists in tension with how people inhabit their environment, including their technologies. And so we can admit that, precisely because they work biopolitically, designers really do understand something about human bodies. Because design does not impose its model of the hand "from above" but rather develops it from experimental contact with particular hands, this holding a well-designed object, such as an iPhone, in one's hand, may have unpredictable consequences. Design has an account of this, too.

Writing in 1999, Paul Kunkel offers a compelling elaboration

of the quality Jobs designates a beautiful fit. In his discussion of the Sony Design Center, he explains that Sony designers strive to elicit "unconscious 'play,'" that is, a kind of contact wherein fingers continue to engage the surfaces and dials of a device well after a desired function has been performed.[29] The Sony Discman—predecessor to the iPod and iPhone, and descendant of the Sony Walkman—provides one pertinent example. According to Kunkel, the Discman invites a relationship of integration, which he explains is a hallmark of "today's sports and lifestyle designs,"[30] which foreground and facilitate mobility because of their being compact and lightweight, that is, portable. Unlike electronics of the 1980s, which "were conceived as high-tech prosthetic devices, artificial appendages that allowed the user to greet the world as a champion," "today's" devices are about instantiating "fusion." The distinction can be thought of in terms of the degree of interaction between body and device, as a movement from attachment to integration.

In this regard, Alexandra Schneider's assessment that iPhone's screen is "rather like a skin" has particular relevance.[31] By design, the iPhone's surface "requires" touch. As Schneider explains, the iPhone "registers my every touch in its specific degree, direction, and expressiveness."[32] This idea of human-device interaction as skin-on-skin contact discloses something profound about ourselves as well as our devices. Anatomically speaking, skin is the site of interface par excellence, as Ellen Lupton explains in *Skin: Surface, Substance, and Design*.[33] Not only is it precisely where the body comes into contact with the world and its objects, but it is also where the body, in its sloughing, becomes part of the materiality of the world; it encloses life and becomes dead matter. Similarly, our designed objects boast industrial skins that enclose a depth, density, and complexity of substance that equip them with "their own identity and behaviors." They achieve "a life of their own." The seeming autonomy of the device is a function of interaction.

It lives for me, thanks to the skin-like character of design materials that ensures responsive contact between hand and device. Finger, hand, and wrist muscles synergistically flex and extend, abduct and adduct, in response to this tactility. Hand and device "live" fluidly and in concert.

The experience of integration that the Sony Discman and its successors are designed to elicit is similar to what neurologist Frank R. Wilson has called a "becoming one."[34] Working with musicians, puppeteers, and machine operators, Wilson has had experience with attending to and assessing a variety of hand-device relations. He describes becoming one as an experience of bonding between a person (specifically, a person's hand) and a tool or device. This bonding produces a "mystical feel" that arises out of a "combination of a good mechanical marriage and something in the nervous system."[35] Wilson describes the mystical feel of becoming one as entailing a certain intimacy and communication, which resonates with what industrial designers and design engineers and theorists such as Norman recognize as the result of "good design." To this end, designers seek material combinations that bring textures, shapes, and heft to handheld devices to encourage continuous holding, and not simply portability as in the case of amateur film equipment. When successful, this effort results in a nonconscious bonding, a kind of relation that is not aware as such but neither is it repressed or unconscious. Insofar as our handheld devices are more often than not equipped with network capabilities and GPS, their being in hand means that we are on grid.

IN-RELATION

I call "in-relation" the kind of engagement between hand and device to which "good design" aspires. A responsive relationship, it is not invested in any objective or rational outcome, and it does

not aim for utilitarian functionality, even as it may sell phones. Like Elizabeth Grosz's "acquaintance," which she first elaborated in *Architecture from the Outside*, it refers to an intimate apprehension and interconnectivity among people and technologies.[36] In the case of smartphones, especially, it is easy to see commercial motives behind cultivation of the hand-device relationship. Profit models involve selling devices and encourage running up the meter on call time and data transfers. While it might be appealing to think of personal attachment to our devices as somehow counter to commercial imperatives because we regard them as in excess of them, in truth design efforts establish such attachment as a condition of possibility for continued capitalist relations. Nonetheless, the experience of acquaintance that Grosz describes speaks to something supplemental that accounts for the deeply personal attachments people exhibit toward their devices and that Jobs refers to as a beautiful fit.

In-relation transpires as an intuitive process in the temporal register of duration as posited by Henri Bergson.[37] Bergson explains perception as a cognitive process that unfolds across matter and memory. Current thinking in neurophysiology confirms and extends Bergson's insight and allows me to elaborate how bodies live this condition of in-relation to mobile devices.[38] Drawing on Antonio Damasio, specifically, I refocus the discussion of duration, that is, the temporality of movement and becoming of matter, in a hybrid formulation of philosophy and science, which refuses to privilege the metaphysical and its abstractions. To consider a concrete historical instance of being in-relation requires an analysis of particular conventions and habits of interaction. To enable that analysis, I extend the discussion of philosophy and science in the next section to include the semiotic of Charles Sanders Peirce. In the process, I offer an account of how we might better interpret the cultural artifacts—text messages, mobile imaging thumbnails,

mobile updates and posts, and so forth—that circulate as a consequence of our being in relation to mobile technologies that are always (presumably) connected.

Broadly, Bergson's philosophical perspective argues against a mechanistic view of existence. In *Creative Evolution*, he aligns such a view with a determinism that refuses the creative vitality of the living world to which we belong—a world that includes technologies of various sorts. For him, such a perspective assumes matter to be something inert, something to be divided and used for instrumental purposes. It negates our own relation to the material world; it causes us to abstract ourselves from the "inner becoming of things."[39] Instead, he explains that we need to return to a mode of sympathetic communication with that which surrounds us, such that we might reengage with the living principle and, thereby, experience its creative potential. By "living principle," Bergson is not suggesting any sort of transcendental, omnipotent, and omniscient force or entity; rather, he is referring to the continuous, dynamic, ephemeral generativity of all matter, all life.[40] Importantly, his is not a metaphysics that finds an ideal force outside of matter; rather, he understands force to coincide with matter.

Bergson offers a more particular conception of the body that is relevant for thinking of the body in relation. This appears early in his oeuvre. In *Matter and Memory*, he explicitly describes the body as an image among images; it is an image that affects and is affected by "the aggregate of images" that constitutes the material world.[41] Here "image" does not mean picture or representation but refers rather to the kind of interaction commonly understood as sensory perception, wherein no subject-object distinction pertains. An image stands in for matter, but in a manner that is neither "a representing it" nor "a being it." It is that which is "less" than a thing, in that its ontology is momentary and unstable, but "more" than a representation, in that it is not a readily legible and falsifiable

iconic or symbolic abstraction (although I will argue in a few pages that it functions as an index in the Peircean sense).[42] As a philosophical term, then, "image" acknowledges the impossibility of our ever really knowing an object as such, for in our relations with the material world, we only ever have access to our perceptions of that which we find there.[43]

Bergson understands perception to be a matter of images—or more specifically, a "system of images" that is "conditioned" according to the particularities of "a certain privileged image—my body."[44] Later we will see that this accords with Peirce's notion of thought as a sign. Consciousness is selective; it merely has access to "certain parts and certain aspects of those parts" as dictated by our needs and functions.[45] Here, we might think in terms that David Rodowick uses to describe Bergsonian perception: "*samplings* of a continuous flow" rather than a series of discrete snapshots.[46] Perception proceeds as filtering not abstracting (i.e., into representation). Moreover, it is not to be understood as something we do or execute (intentionally or not); there is no essential agency to be accorded to this "consciousness." Instead, perception emerges out of an already dynamic networking of images—images that exist without having to be perceived. A process of discernment, that is, of separating or distinguishing as Rodowick clarifies, perception is subtractive; it is "cut" or "isolated."

I want to reiterate the point that, while perception for Bergson is discerning (as Rodowick explains), it does not register as individual snapshots.[47] Bergson explicitly states that it would be misleading to imagine perception to be "a kind of photographic view of things."[48] Such an interpretation incorrectly presumes a "fixed point," separated off from the material world, from which a picture is taken by "that special apparatus which is called an organ of perception."[49] This is precisely the separation of (conscious) mind and (supposedly

inert) matter that he rejects. Bergson regards as specious the notion of an anchoring consciousness that separates the person (mind) from the world (matter). Instead, he asserts that our perceptions *"vary with"* the molecular movements of the brain, which themselves "remain inseparably bound up with the material world."[50] The body is a "center of action," that is, an ensemble of transmissions of movements in relation; perception is never an indication of a centered and stable subject.[51] The body-as-image responds within the aggregate of images in a way that is always virtual. Virtual, in this context, refers to a potentiality that does not have any preimagined or preordained determinants; nothing is a priori.

Contemporary neurophysiology confirms Bergson's early insight that perception is not attributable to an already formed, coherent, and self-aware subject. In fact, his conception of the body-as-image aptly forecasts Damasio's point that the proto-self happens multiply, "emerg[ing] dynamically and continuously out of multifarious interacting signals that span varied orders of the nervous system."[52] As Damasio explains, nonconscious processes that precede consciousness are central to "maintaining life" of an organism.[53] Damasio calls this fundamental level of living the proto-self. It is the site at which "seemingly intelligent and purposeful [but not yet conscious] behavior" emanates.[54] This "covert knowledge of life management," while elementary, is not at all "primitive."[55] Rather, the nonconscious proto-self is "a coherent collection of neural patterns [distributed across the brain and its structures] which map, moment by moment, the state of the physical structure of the organism in its many dimensions."[56] Bergson's body-as-image, which is a site of transmission, seems to accord readily with Damasio's proto-self as the "first-order representation of current body states" that provides "the roots for the self [but is not yet the self as self-aware]."[57] At this level, first-order neural patterns do not infer a consciousness attributable to a reflective self, for the person, as

biological organism, "has no powers of [conscious] perception and holds no knowledge."[58] It is merely a "reference point at each point in which it is."[59]

Damasio and Bergson alike conceptualize human beings as essentially unpredictable. For Damasio, the proto-self is not singular, static, or contained, neither is the body-as-image for Bergson. Any encounter with a stimulus (or Bergsonian "image") "provokes in the organism . . . a collection of motor adjustments required to continue gathering signals about the object as well as emotional responses to several aspects of the object."[60] The moment at which these neurobiological responses to stimuli resonate as something felt, there is a mapping (second-order neural patterns) of being in relation, which marks the "beginnings" of consciousness. The in-relation of body and device, when they join in the reciprocity of nonconscious play, happens here.

Here, at the "beginnings" of consciousness, the body is only potentially a human subject that might explain itself to itself. It is not yet autobiographical. Rather it is the site of what Damasio calls the "core self," a sense of self that transpires as an always perpetual present (minus any personal-historical context). As core consciousness that involves the formation of neural patterns, it is a simple biological phenomenon that gives rise, again and again, to an awareness of being. In the process, it instantiates a core self. A core self is a more elaborate sense of self, which is fundamental to extended consciousness. Extended consciousness orients the person with respect to a personal historical time, complete with memory images of a lived past and anticipated future. Extended consciousness provides the sense of self to which "my body" refers; it is the condition of possibility for the autobiographical self that has so preoccupied the Western intellectual tradition. While the autobiographical self of extended consciousness is bounded and continuous and experienced as a "unified whole," the core self is transient, a "primordial"

feeling[61] that emerges at "the very threshold that separates being from knowing."[62]

Core consciousness opens onto what Damasio describes as a nonverbal, or imaged, knowing. It is a knowing that cannot yet be spoken as "I," for it is without language, without reason, and is anterior to processes of inference and interpretation. When one encounters an object, whether actual (e.g., handheld device) or recalled (e.g., thoughts of some handheld device or other), the brain forms images, or mental patterns, of the object, and those images affect the state of the organism (i.e., the proto-self, where emotion transpires). At another level of brain structure, a nonverbal accounting of these events takes place. This "second-order neural mapping" effects a feeling or sense of knowing: it is "the sense of self . . . [that] informs the mind, nonverbally, of the very existence of the individual organism in which that mind is unfolding and of the fact that the organism is engaged in interacting with particular objects within itself or in its surroundings."[63] In this state, as media-culture theorist Brian Massumi explains, one experiences "a thinking-feeling" of what happens in the time of its happening.[64] It is the moment of integration (a la Kunkel) and the experience of Jobs's "beautiful fit" as produced through the "natural" that "good design" espouses. Bergson and Damasio provide a means of explaining how industrial design works on "nature" without it itself becoming "nature." All told, industrial design, in the context of biophilosophy, and neurophysiology, helps to explain how design works on "nature" without turning design into nature.

In this regard, reading Damasio and Bergson together allows us to move beyond the normative strictures of industrial design to conceptualize the kind of vitality I attribute to the condition of in-relation. Active and always unfolding, in-relation assumes the rhythm and time of a present that is always becoming, never still. In Bergsonian terms this is the condition of "duration," which Dama-

sio explains as a "resonant loop," wherein body states (as mediations of the body's direct contact with its surroundings) and brain mapping "become virtually fused."[65] It is lived as a subtle flow, rather than discrete instances of knowing attributable to an already constituted subjective perspective.[66] This aspect of core consciousness, which is the becoming of "my present," is a gentle and persistent awareness of being, not a concerted and definitive self-awareness: an experience of awareness of a here and now, which is only ever here and now. At each moment, my body-as-image and in-relation meets with contingency at the point where the past bleeds into the future in the moment of my present.[67] At moments, I experience "my present" poignantly, as it happens to me and through me, as a site of mediation—between some now and some number of thens and in the context of what might be. Involuntary, this becoming is experienced materially, temporally, that is, vitally, as "shock" (Walter Benjamin)[68] or déjà vu, or a flooding of recognition (a la Proust's madeleines)—or the delightful, perhaps even comforting, feel of a well-designed device in hand.

Damasio and Bergson describe "nature" differently than does industrial design. In tandem, they help us understand our relations with our mobile devices as potentially open and variable—even if in the process they explain how such a process can be normalizing. Consequently, we become equipped to locate a complex transaction between hand and device that explains why industrial design works the way it does, and in terms that industrial design itself cannot supply. It is in this discursive space that I locate the potential that in-relation might ultimately afford: a potential for habit change.

THUMBNAILS, TWEETS, AND TEXTS

Although the iPhone doesn't fit every hand beautifully, the promise of a beautiful fit is crucial to the normative functioning of indus-

trial design, which has sustained interaction between hand and device as a primary goal. Kodak likely shared this objective, but its four-pound Kodak Cine K home movie camera cannot have satisfied it to the same degree as do early twentieth-century devices.[69] Through its difference as a kind of mobile media practice, Nixon's home movie calls attention to particularities of our present that result from more beautiful fits between hand and device. Handheld, "on," and connected mobile technologies are productive of cultural practices that evidence new ways of being in the world. Handheld devices encourage new habits of "sharing." Unheard of until the last decade of the twentieth century, for example, texting and related forms of mobile updating had become ubiquitous in much of the world by the end of the first decade of the twenty-first century. Moreover, as cultural anthropologist Mizuko Ito explained early on regarding camera phone culture, a camera phone in hand encourages "persistent alertness," or more precisely a "new kind of personal awareness."[70] A wide variety of people demonstrate a tendency to image anything whatsoever more immediately and less deliberately than was likely the norm for most of the twentieth century.[71]

Neurophysiology thickens our understanding of the heightened attentiveness that Ito describes. Device in hand, a person encounters her surroundings. Then something beyond the device in hand, what Damasio would call a "causative object," strikes a perceptual chord.[72] At such moments, the object out there, just beyond the handheld screen, is "*set out* from less-fortunate objects"; it is "selected as a particular *occasion*."[73] It is attended to. This more focused attention engenders a more poignantly felt awareness, a deeper sense of knowing. And in addition to "greater alertness, sharper focus, [and] higher quality image processing," Damasio explains that this state of increased knowing awareness "forms the basis for simple nonverbal inferences which strengthen the process of core consciousness."[74] These nonverbal

inferences, the result of "the close linkage between the regulation of life and the processing of images," initiate a sense of personal perspective, which is the condition of possibility for ownership, whereby one claims one's perceptual images as one's own in the process of, for example, mobile imaging.[75] In being able to "own" one's images, one arrives at a sense of action and, subsequently, a sense of agency.

It is precisely in this moment of an intensified sense of knowing and a newly instantiated sense of personal perspective and agency that the impulse to text, image, or post an update emerges.[76] Such an impulse transpires in a moment just prior to the utterance of an autobiographical self, when the organism as such predominates. Because of its feel, a mobile device in hand encourages such responsiveness, perhaps more than it does any intentional, studious approach to communication. Hands and eyes operate in tandem: the brain engages in analogous processes simultaneously, treating the sensitive portions of both the fingers and the retina in comparable fashion.[77] Surfacing above the continuous neurobiological processing of images, mobile imaging (and related behaviors) can be understood as a response enacted in a here and now by a transient core self whose body is almost always "on the go."[78] While it is certainly possible to use these devices with deliberate forethought or simply as smaller versions of Nixon's camera, by design, they encourage a new kind of engagement. It happens on the edge of things—on the edge of consciousness and amidst the many edges that structure our physical world.

To the degree that texts, mobile updates, and images are responses of core consciousness rather than or in addition to being autobiographical gestures, we might interpret the sundry artifacts so produced as material traces of a way of being in relation with the world around us. In their various streamings, such artifacts provide evidence of a particular encounter as made possible by a reciprocal

relation between hand and device—even as they might simultaneously register us with respect to some population or other. As such, they "point to" the having-been of a particular moment and manner of perception, which may have been distracted, or "multitasked," even when it seems to be autobiographical.[79] Dispersed across multiple planes of interest, this kind of attention frequently fails to define or frame the kind of subject recorded by such practices as photography, home movies, scrapbooking, or journaling. As an example, we might think of the appearance of spontaneity characteristic of a series of mobile imaging thumbnails. Such sets often suggest haphazardness through canted framing and blurry focus. Similarly, the "selfie" is a practice of self-portraiture that frequently includes in frame the arm of the one who is self-imaging. In contrast, the images typically found in family photo albums, tourist scrapbooks, and home movies bespeak more deliberate selections, of what to frame, how to frame it, and of which images to retain over time.[80]

"Cut off" from the moment of perception out of which they originate,[81] thumbnail images, text messages, mobile updates, and so forth, tend to present, or gesture toward, a self in the process of becoming autobiographical—but a self that does not yet speak an explicitly autobiographical "I."[82] Remnants of neurophysiological processes in their happening, these artifacts are indexes. That is, they are actually signs of what it means to be a living organism. They offer proof of life anterior to self-consciousness. Consequently, they present us with a semiotic problem of the kind described by Charles Sanders Peirce.

According to Peirce, life is a matter of sign relations.[83] Because "we are in thought" and not the other way around (i.e., thought is not in any one of us), existence is always an interpretive process. He goes on to emphasize that thinking happens as a process of relation: "At no one instant in my state of mind is there cognition

or representation, but in the relation of my states of mind at different instants there is."[84] For him, meaning arises as a consequence of how "this thought may be connected with in representation by subsequent thoughts; so that the meaning of a thought is altogether virtual."[85] Peirce's "virtual" has a lot in common with Bergson's, insofar as there is no prescriptive or predetermined outcome of thought and its meaning. At each moment, thought transpires as an event experienced as "mere feeling"; it has no meaning in and of itself. "Only the material quality of a representation [a mental sign]," thought is not yet representation.[86]

At the same time, there is no feeling that a person experiences that "is not also a representation, a predicate of something determined logically by the feelings [cognitions] which precede it."[87] In this way, every feeling (e.g., sensation, emotion, and passion) is an act of thinking (cognition). "Intellectual value" only surfaces in relation to how any one thought "may be connected with in representation by subsequent thoughts,"[88] which is what makes them representable, for example, by language, picture, or gesture. In the moment of texting, imaging, or posting an update from a handheld device, we do not simply produce signs, that is, representations. We, first and foremost, materialize our feeling, our thinking, thereby actualizing ourselves as signs. This is not dissimilar to Bergson's my-body as an image among images or Damasio's proto-self whose first-order neural patterns open onto core consciousness.

This comparison across the fields of neuroscience, philosophy, and semiotics acquires greater resonance given the trope Peirce uses to characterize the nature of thought. He explains that each thought-sign translates or interprets a previous one, such that thought "runs in a continuous stream through our lives."[89] The continuous stream that is immediate consciousness undergoes continuous mediation as one thought-sign affects, shapes, and informs

another. Inexplicable at the level of autobiographical being, this ongoing process is the "real effective force behind consciousness."[90] Constitutive of "the continuity of it [consciousness],"[91] it is temporal in the manner of Bergsonian duration and Damasio's perpetual present of core consciousness. Moreover, Peirce describes, again in terms reminiscent of Bergson and Damasio, how "the striking in of a new experience is never an instantaneous affair, but is an *event* occupying time, and coming to pass by a continuous process."[92] Like the unfolding or ripening that Bergson attributes to perception and the "something felt" that Damasio associates with the beginnings of consciousness, Peirce's description of cognition emphasizes the durational quality of thought.[93]

Ultimately, Peirce posits that cognition is a ceaseless process of interpretation. Each thought is "always interpreted by a subsequent thought," which likewise "suggests something to the thought which follows it."[94] Text messaging, mobile imaging, and mobile updates are kinds of interpretative action. In registering acts or events of core consciousness, they are signs of a physiological process. And what remains of these acts or events—the texts, the images, and the updates—gives digital signature, or autograph, to a having-been present of cognition—at a particular time, in a particular place. From a Peircean standpoint, then, such artifacts are functionally prospective and retrospective, requiring both future interpretation and recognition of a combination of already existing interpretive possibilities (as a consequence of past interpretations). We do not live outside of this process of semiosis.

What's more, we do not live semiosis in isolation. As mentioned in chapter 1, and as I will elaborate in chapter 3, a sign is a "medium of communication." This means that semiosis is social; it transpires in relation to a larger interpretive community. Cultural concepts conveyed by neologisms such as "googling," "pinching," and "friending" demonstrate the social character of semiotic behavior.

In the era of social networking, such concepts circulate horizontally by means of interactions among individuals who are in the habit of practicing Facebooking, tweeting,[95] texting, and MMS-ing, among a variety of social-networking engagements, as a way of life. Cultural concepts evolve as and through the practices and language that characterize particular styles, or habits, of living and communicating.[96] We tend to carry our mobile technologies in hand (or at least on our persons or within close reach), and we use acronyms and abbreviations to expedite our text-oriented exchanges; these practices bind us together in an interpretative community that extends beyond the particular individuals involved in semiotic transactions. In Peircean terms, cultural concepts demonstrate "a wonderfully perfect kind of sign-functioning,"[97] which involves a community of minds being "at one" with each other because they are in relation to each other. This condition is constitutive of a sort of collective mind, one that delimits population.[98]

Latourian interpretation encourages a recognition that the collective mind evolves over time as part of technological assemblages. Thinking that knows, for example, how to approach hinged doors differently than sliding sensored ones exhibits such transformation. In the same way, the mobile device, as a convergence of telephone, computer, Internet, camera, and audio player, among other devices, is necessarily a product of a shift or change in some previous routine or habit of thinking. Change is sure to occur again. To figure this out, we need to understand the device as human-machine assemblage, in the way Latour and other actor-network theorists see it. Being in relation with a mobile device opens onto semiotic habits that are not readily explained in terms of "what I choose to do with my phone." Rather, the terms we ought to be using are "what my phone and I do together."

Industrial design interprets the human-device relationship otherwise. While it eagerly measures and normalizes bodies, it ulti-

mately conceives the devices it develops as useful and aesthetically pleasing for potential consumer users. It abstracts the body from the individual in order to work on the device as if it were an autonomous thing. Moreover, it does not particularly concern itself with how this design approach regulates individuals by establishing norms—encouraging some activities while discouraging others, defining some bodies as aberrant, and so on. Less concerned with subjects—and subjectivity—than, for example, retailers, content providers, and analysts, industrial design continuously registers and evaluates multiply proliferating statistics to optimize size, shape, and heft for the target market.

In constellation, Peirce, Bergson, and Damasio provide an alternative means of considering subjectivity as it is in relation to a mobile, networked device. They invite us to understand that each of us is the consequence of ongoing impulses, synapses, thumbnail images, tweets, and other forms of sign production. Insofar as handheld technologies such as iPhones proliferate various data, they offer a concrete point of departure for understanding persons as ongoing articulations of signals, that is, pulsings, of "core consciousness." Text messages, mobile imaging thumbnails, and other mobile updates register us as locatable and readily subject to various techniques of assessment. These practices also stream an autography—what I will refer to in the next chapter as expressivity—that, precisely because it is semiotic habit, also involves habit change. Read together, Peirce, Bergson, Damasio, and Latour underscore that change will be a largely nonconscious process that occurs in relation to our technological devices.

CHAPTER THREE

"Location, Location, Location"

PLACING PERSONS, ACCESSING

INFORMATION, AND EXPRESSING SELF

West Virginia

Contemporary image-sharing practices that make use of keyword tags provide an excellent opportunity to observe the interaction of conscious choices, nonconscious habits, and technological mediations that make persons, places, and things findable. Scott Nixon's *The Augustas* reel allows us to contextualize these current trends in social networking within a longer history of technology-enabled practices of self-recording. The social-networking platforms and tools I consider in this chapter are those suggested by the moment of writing. A decade ago, one would have written about Myspace rather than Facebook, Twitter, Instagram, YouTube, and Vimeo. This field of practice is rapidly evolving. Nonetheless, it remains possible to discern some common problems contemporary practices share with celluloid home movies and with the forms of "sharing" likely to follow them.

Central among these problems is the issue of image-label relationships: the very labels that enable finding and locating may very well frustrate findability—and, by extension, accessibility. Charles Sanders Peirce's triadic theory of the sign, which distinguishes between icon, index, and symbol, provides a vocabulary with which to understand this issue. Recall that for Peirce an icon

is representational; it signifies by means of likeness or verisimilitude. In contrast, a symbol conforms to rules and conventions that establish the conditions that make signification possible: there is no "natural" or intuitive relation between, for example, a word and its referent. As for an index, it manifests meaning materially, either as a physical trace (a fingerprint or photograph) or a real-time indication of some event (the wind's direction). Moreover, any kind of sign requires another sign—a thought-sign—to interpret it. To become meaningful, icons, symbols, and indices must interpret each other. Peirce's semiotic emphasizes that symbolic labels have no inherent capacity to fix, that is, stabilize or secure, the iconic and indexical unruliness of the photographic documentary image. Only through habitual usage does the fact that an image bears a place name suffice to map it. If findability is a central technique of governance, then we can expect its operations to be both habit dependent and open to habit change.

FINDABILITY

In the last chapter, I concluded by positing that the streams of data we disseminate by means of our mobile devices constitute an autography—not an autobiography. We who have been brought up in liberal nation-states might readily transpose the former (autography) into the latter (autobiography). Furthermore, we might characterize such autobiographical practice as belonging to the province of self-expression, which we assume to be personal and essential. We typically understand ourselves as individuals who may decide or not to document where we have been and what we have done. We tend to understand such practice as boasting a style or voice particular to us. For this reason, it makes sense to interpret a collection of home movies as expressive of a particular individual, for example, a man named Scott Nixon. We

rely on an assumption that we express ourselves as self-aware individuals through the artifacts we produce, be they images we collect or narratives we craft. We rarely, if at all, consider that documenting ourselves and our movements helps others to regulate us and the populations to which we belong. Michel Foucault taught us to question and historicize this common sense when he identified a tradition of disciplinary practice that requires "speaking the self."[1] Always-in-hand mobile devices extend and alter that tradition. Not only is self-expression not outside techniques of governance, but also it is not entirely, or even primarily, a function of individual will. After all, as I showed in the previous chapter, much of what we document of ourselves transpires at the nonconscious level of the proto-self (Damasio), at the level of impulse.

Nevertheless, we tend to think of ourselves as self-conscious, autobiographically inclined individuals. Thus, even at this late date, it can still seem news that information technologies facilitate the management of persons within and across populations. In March of 2011, the *New York Times* reported of the ordinary cell phone, "It's Tracking Your Every Move and You May Not Even Know It."[2] Although cell phone companies rarely divulge how much information they collect, they are clearly in the business of tracking their customers' whereabouts by means of their devices. This requires a sophisticated and highly integrated infrastructure—and likely recourse to some heuristic oriented or related to the Traveling Salesman Problem. To route calls efficiently, cell phone companies must be able to locate any active phone at any moment. For billing purposes, they register and record where incoming calls originate and their duration, numbers of text messages, and the volume of data traffic for phones equipped to process it. Any time a cell phone is in the "on" position it signals information, which cell phone companies record. This record provides a resource for law enforcement agencies and marketing firms alike.

Instructively, the *Times* article points to AT&T's partnership with Sense Networks, a company whose website's home page proclaims, "Indexing the real world using location data for predictive analysis."[3] The company has developed a "state-of-the-art method" for parsing large quantities of data to provide "remarkable real-time insight into aggregate human activity trends." That is, it identifies patterns of usage and movement within populations. The method registers behavioral data, movement trails, and traffic density in order to find points of similarity and relation.[4] One of the outcomes of AT&T's work with Sense Networks is CitySense, a consumer application for mobile phones that offers recommendations regarding local social activity in real time. It does so by "passively 'sens[ing]'" the overall activity level of a given city. Given a person's habits of movement, the application identifies hot spot locations that may interest this person based on pattern matching with "like" activity of numerous other persons in the vicinity. Importantly, the application does not "care" about content; it only "cares" about patterns. In other words, CitySense is not interested in what kinds of places a person likes or what that person does while there; it simply registers where the person goes and how frequently. It calculates the individual's "presence" or frequency of presence at particular sites and makes recommendations by computing those sites that might be similar based on the habits of presence of numerous others.

That CitySense, along with other smartphone applications, is interested in "where-ness" should not be a surprise. After all, we have been documenting our whereabouts for quite some time. Maps of all sorts, to be sure, but also family albums, tourist photographs, nineteenth-century cartes de visite, and of course such films as Nixon's *The Augustas* attest to this inclination: it matters that one has been "there," that one has been present at a particular place. Location and place matter. It's important that we've been someplace or that we will be somewhere; this means something. And appli-

cations like CitySense make this apparent, even as they confront us with another reality: our desires to place ourselves (i.e., speak or document where we have been—when and how) implicate us in a broader biopolitical project. In this case, the ability to make patterns predictable would seem to have many uses. Among these are, not surprisingly, emergency response protocols and staffing: in vicinities where a greater number of vehicular events occur, there might be a greater proportion of emergency response personnel on shift. We might think this is to our advantage. In the meantime, our intentional or unintentional investments in autographical practice coincide with and, indeed, facilitate governance.

What the CitySense example reveals is a pervasive concern for findability, where "findability" designates a complementary relation between "locatability" (i.e., identification of place) and "navigability" (i.e., mobility).[5] Importantly, findability is not simply about specifying a stable and stationary position or location. Rather, as Peter Morville explains, findability names the capacity to access and recombine data about location such that shifting patterns of movement can be identified and even anticipated. It refers to an ability to manage shifting relations among multiple entities, be these persons, things, or ideas, within a particular context or milieu. In the case of mobile devices, user practices enhance findability. These devices encourage self-documentation in the form impromptu personal updates via SMS and MMS and social-networking platforms in addition to the automatic recording of time and location data of which the user may not be conscious.[6] Time- and location-stamped copies or voice messages, images, links, texts, documents, and e-mails also accumulate in ways that are not visible to most users, producing an ever-accreting record of the shifting relations among digital objects as they traverse a range of storage media (hard drive, flash drive, cloud, and mobile phone) and various (digital) networks. Persons located and tracked by

means of such traces cannot be said either to control their findability or to represent it.

Peirce's semiotic establishes that the expressivity attributable to self-recording—whether conscious or not—is ultimately a question of social habit. While we might map tendencies and patterns, these are not expressive of an autobiographical self in the way that Cartesian subjectivity purports. One may not be explicitly cognizant of the fact that one's mobile device is connected, nor might one be aware that one's captioning or labeling an image or archiving text messages and mobile updates categorically already bear automatically encoded metadata (e.g., date and time stamps, and location coordinates). The latter case, whereby one labels, tags, or comments after the fact, provides an example of the secondary gestures that allow us to consider the relationship among keyword labels, findability, and where-ness as these inform how we interpret habits of self-expression and expressivity.

CALCULABILITY AND THE PROJECT OF WHERE-NESS

Social-networking and related Internet-oriented practices involve people producing and sharing untold quantities of words, sounds, and images depicting themselves and their surroundings. By means of texting and "updating"; by e-mailing, blogging, and image sharing; by posting comments or reviews to websites; and by "clickstreaming" and "pinging," people proliferate data trails that disperse details about personal interests, views, and habits—and, in all instances, reveal data about time and place. The emergence of the term "life caching" captures the all-encompassing nature of this kind of project of self-record.[7] A term that appeared in a 2004 trendwatching.com article, "life caching," derived from "geo-caching," specifies a then emergent trend made possible by an

"onslaught of new technologies and tools, from blogging software to memory sticks to high definition camera phones and other 'life capturing and storing devices.'"[8] Populations began caching "every second of [their] existence." Presumably, those investing in the project of "collecting, storing and displaying one's *entire life*" understood data accumulation, in and of itself, as a defining principle and desirable outcome.[9]

The same year witnessed Microsoft's SenseCam (2004). A personal black box of sorts, SenseCam offers an extreme instance of life caching. Unlike typical imaging devices, this badge-sized camera is worn about the neck. It automatically records up to two thousand images per twelve-hour period, capturing frames when it detects movement and changes in light conditions and temperature. When first prototyped, it was anticipated that future SenseCam models would capture "heart rate or other physiological data." At the time, Microsoft researchers explained the benefits of SenseCam: it would aid memory (for example, by offering reminders regarding misplaced personal items), record details regarding accidents (enabling emergency technicians to attend to injuries more effectively), and even "lead to greater understanding of ones self [*sic*] and one's motivations."[10] More recently, the device, now available commercially as the Vicon Revue, has been promoted as a memory aid for persons suffering from Alzheimer's and other memory-sapping diseases.

The Vicon Revue highlights the extent to which we expect to cache iconic traces—images—of our lives. But as many of us know, if we don't append our photos with dates, names of those in frame, and place names, we will likely struggle later to recognize where we were and whom we were with. In part, the GPS stamp is a solution to this problem. Of course, facial-recognition software provides a technique for remembering those who appear frequently in images: snap an image of someone, and the software "recognizes" that per-

son and generates a label that names her or him—to which is appended geolocation data. But I suggest that Scott Nixon serves as an early specialist in such matters of labeling. What he recognizes, as his film *The Augustas* demonstrates, is the significance of the label as such and its relation to that which it names. Implicitly, this concern suggests a need for timeliness, to which the automatic encoding of metadata to mobile images provides a twenty-first-century response.

As described in the introduction, Nixon's sixteen-minute home movie documents no fewer than thirty-six various Augustas from across the continental United States from the 1930s through the 1950s. (We assume that much of this travel was business related, and we know Nixon sold insurance.) A drama of image-place label relationships propels the film. Shots of diverse places are repeatedly labeled with some variation of "Augusta" ("South Augusta," "Augusta Street," etc.).[11] Certainly the tendency to mark shots by identifying location suggests a desire to catalog for purposes of subsequent recognition and memory, as any tourist's photo album might do. And yet, Nixon's insistent appreciation of and commitment to signs as visual objects exceeds the merely functional requirement of recall. In this regard, the work performed by and through the Nixon Augustas opens onto several currently fundamental concerns regarding the relationship between the photographic image and information retrieval, concerns informing the creation of the metadata through which the content of computerized image files becomes searchable.[12]

On one hand, Nixon's film underscores a still prevalent expectation that there exists a connection between an image and a label that places it. At the same time, it reveals that identifying a place as "Augusta" does not suffice to find it. Because there are multiple Augustas, any one place might very well serve as referent for the signifier "Augusta." In Nixon's analog film reel, the organization of

images by means of keyword or "tag" looks like an anomalous, or at least distinctive, device.[13] This device becomes a defining characteristic of digital, mobile imaging streams. We assume that keyword tags label and thereby place into various categories of likeness a wide array of digital content. Suggestive of a proto-database aesthetic in which information is malleable, navigable, and accessible, Nixon's compilation of Augustas forecasts—and yet is substantially different from—the now prevalent logic propelling the proliferating streams of digital thumbnails that accumulate and circulate according to the distributed and collaborative pulsings of social networking.

Whereas Nixon's reel of Augustas frequently shows a sign in frame that explicitly names an instance of Augusta, mobile imaging thumbnails (as accessible via publicly designated social-networking services) very rarely depict actual signage appellating place. In fact, the image itself may bear little, if any, apparent association with anything remotely recognizable as Augusta. For example, one might search a social-networking site for images associated with "Augusta" (not case sensitive). Such a search might very well return, as did a 2009 Facebook search, an image of paint-splattered galoshes, a street corner in Brazil, or a couple posed in an ardent embrace.[14] It is likely that in any particular case, nothing recognizable as "Augusta" will appear anywhere in the mise-en-scène. The label may "only" be a title or tag. Clicking on the keyword in a link-enabled list or "tag cloud" might very well deliver one to another iteration or catalog of augustas.

At the level of iconic representation, then, any thumbnail image posted to a social-networking site may seem excessive of the keyword that functions to identify or "name" it. However, the tag serves to taxonomize the single thumbnail within a larger—cross-platform—network of statistically related thumbnails. The tag "augusta" affiliates thumbnails as a group but does not necessar-

ily group places, persons, or things with that name. As metadata, the keyword tag makes it very easy to find "augusta" in all its multiplicitous and continuously proliferating manifestations. At the same time, it rapidly becomes impossible to understand "augusta" as a unique location. This kind of symbolic textual metadata presents an indicative paradox: "found" is nowhere, that is, no place, in particular.

Beyond what tagging patterns might reveal, mobile imaging devices, such as camera phones, encode location information, including GPS coordinates and GSM cell information from network towers—which refer then to, for instance, city and country names.[15] This information is not simply an extension of keyword tagging. GPS coordinates, and so forth, do in advance the detective work that the imaginary filing cabinet of Nixon's film would do to tell us where and when Nixon was. But even as location coordinates and date and time stamps might succeed in determining where-ness (and a when), there's still the contingency of relations between what an image shows and the where and when of photo's having been taken. As media art and photography theorist Daniel Palmer intimates, the representational, or iconic, register of the image—despite the promise of indexicality—is almost beside the point.[16] This is because information trumps representation: a picture appended with metadata becomes less about what it represents than the information it carries.

This both is and is not the case with Nixon's *The Augustas*. His inclusion of the place sign in the image suggests the possibility of recombination in relation to an infinite field of information, a potentially unquantifiable number of Augustas populating a catalog. Once the name "Augusta" becomes a catalog index term, it offers itself for endless new combinations. Nonetheless, the catalog term in *The Augustas* is nearly always part of the iconography of the film and thereby acquires an indexical

status of a second sort: although the name "Augusta" may not distinguish it, the road sign bearing that name still specifies that light bounced off a particular sign in a specific place visited at a particular moment. Each such Augusta indexes the fact that someone, presumably Scott Nixon, with camera in hand, visited the site and was present at the time of filming. Insofar as the resultant image provides a record of his location, it also can be said to "track" him in something like the way our mobile imaging devices now do using numerical symbols, such as GPS coordinates and date and time stamps. But Nixon did not carry a mobile device programmed to register—indexically and subsequently symbolically—location data. Were one disposed to confirm his being at a particular Augusta as documented by his labeled film frames, one would have to match the visual evidence provided by the film with a corroborating picture or view.

As a record of Nixon's having been in one Augusta or another, *The Augustas* reveals the workings of the panoptic principle, which has inspired administrative uses of photography from its beginnings. In his widely cited article "The Body and the Archive," Allan Sekula examines the "instrumental potential" of the photograph's iconicity.[17] Citing Foucault's turn to Jeremy Bentham's Panopticon for illustrating the functioning of disciplinary society, Sekula explains that explorations of the instrumental potential of photography coincided with the "birth of the prison."[18] In its policing capacity, the photograph isolates, individuates, and makes visible the criminal body. For example, facial features, and their measure,[19] were used representationally both to demonstrate criminal types and to identify individual criminals. To this end he notes the influence of Francis Galton and Alphonse Bertillon, whose separate endeavors expose "a crisis in faith in optical empiricism." Ultimately, the veritable failure of photographic portrayal, due to its "messy contingency," and the sheer number of photographs

amassed necessitated a "bureaucratic-clerical-statistical system of 'intelligence'": the filing cabinet.[20] To "index" a particular criminal by means of iconic likeness proved insufficient to the task of policing. Symbolic information (e.g., known names, height and weight, distinguishing features, and last known whereabouts) was needed to organize the files. At work here are Peirce's three semiotic registers—icon, index, and symbol—just as in the case of Nixon's Augustas.

The Augustas and its cousins populating various social-networking sites reproduce the form and logic of this police function even when they are not used by the police.[21] Retrospectively, Nixon's movements may be found out and made accountable—as Augusta App demonstrates. To do so effectively, however, requires a better filing (or processing) system than Nixon's own film provides, one capable of cross-referencing the trips to Augustas Nixon jumbles together with sources that aim to tell them apart by comparing them with other evidence. Once the filing cabinet becomes a database, the instrumental functions latent in *The Augustas* are vastly expanded. On social-networking sites any image might explicitly be tagged "augusta." Just as likely, however, it might bear an inference of location by means of tagging patterns, in which an algorithm determines the degree to which it is related to a keyword such as "augusta" and, by extension, a place (or person or thing) so called.[22]

Although they continue a nineteenth-century interest in using images to identify and locate individuals, the metrics produced via mobile technologies notably emphasize site specificity. Technological development increasingly emphasizes biological metadata gathering, as the SenseCam/Vicon Revue illustrate, rather than physiognomic measurements of the head, face, or body in their photographic representation. These processes function less to fix the identity of any individual than to track and anticipate move-

ments within the context of a milieu, as indicated by changes in lighting or other environmental factors. A fingerprint or DNA test will establish identity, but contemporary biometric initiatives aim to do that swiftly enough to reveal patterns—series, repetitions, combinations, chunkings, juxtapositions across tags, geocoordinates, and time stamps. Metadata encoded to thumbnail images register persons and render them accountable in a specifically time-based way and in a manner not unrelated to the emerging technique of thermal scanning at airports. We, therefore, become legible not as more or less deviant types—or even as individually named persons—but as patterns of mobility and choice, as well as degrees of health as measured by body temperature.

Nixon's film and images appearing on social-networking sites such as Facebook or Instagram prompt us to distinguish two processes that enable governance: (1) identifying and norming by means of visibility and (2) locating and predicting by means of tracking. If, for example, Nixon's images "track," it is not because of their iconic properties (which may make visible evidence of some location) but because of their indexical ones—that the photographic image in each instance materializes Nixon's presence as a chemically preserved trace. Analogously, GPS coordinates constitute an index-symbolic relation that locates, because the numbers point back to a phone having been in a particular place and time and because we believe that electromagnetic waves striking a receiver can indelibly "stamp" a location into a file. While many commentators concerned with the policing functions of mobile devices have sought to extend Foucault's panopticism to explain it, the formulation "visibility is a trap" can obscure a much more complex semiotic process involving relations among various types of signs.[23] Neglecting this semiotic process can occlude the fact that biopolitical governance functions in ways that have very little to do with self-discipline as encouraged by explicitly panoptic techniques

because they act on groups that engage shared habits of practice. In the next chapter, I explore in more detail the fact that populations can be made accountable without necessarily being made visible.

In the province of social networking, our movements and transactions can be monitored and stored on multiple levels simultaneously, and in near, if not real, time—not only by abstract authorities but also by ourselves. Insofar as metadata provide quantifiable measures, such as date, time, and location coordinates, they make persons findable. As Geert Lovink explains with regard to blogging (an early mode of social networking often designated Web 1.0), "Today's 'recordability' of situations is such that we are no longer upset that computers 'read' all our moves and expressions (sound, image, and text) and 'write' them into strings of zeros and ones."[24] For decades now, we have been transposing ourselves into metrical code through our transactions with computers. Mostly without noticing it, we ceaselessly constitute ourselves as "calculable," in Nikolas Rose's sense of that term. Metrical transcoding of the person along with the person's every move facilitates the "government of subjectivity" via the "management of individual difference."[25] Insofar as our mobile devices boast a variety of analytical features and services, as Kate Crawford notes, we have opportunities for "self-analysis and self-management" according to various "personal, social and biophysical environments."[26] The more we allow our devices to source, that is, register or record details about, our behaviors, the more "richly detailed" will be the accounts of our day-to-day habits and how such habits evolve.[27]

At the same time, "calculability" of the person is the condition of possibility for the calculability of the social sphere. In their trackability, "patterns of use" always ensure that persons are findable within a population as well as across a territory.[28] This is how credit card companies detect instances of unusual spending and how CitySense knows to suggest where one should go next.

Those who are findable in this sense are not necessarily visible to those doing the finding, nor do they necessarily see themselves as potentially "found out" according to the logic of surveillance. But because the streams of information they disseminate are signs, they acquire meaning, that is, legibility, through interpretation in the Peircean sense. Findability is an interpretive process that renders persons manageable.

LOCATING AND TRACKING EXPRESSIVITY: THE CASE OF AUGUSTA

I have distinguished between expression understood as a creative act of, for example, deliberate self-narrative and expressivity understood as all individuals' spontaneous, habitual relationship to their surroundings made possible by a condition of in-relation to their mobile imaging device. This difference becomes significant in the context of biopolitical governance. To see how, we can begin by recalling the history of autobiographical practice as elaborated by Michel Foucault. Foucault proposes that modern governmentality makes one's "analytical exploration" of oneself a central technique. He theorizes the relation that developed between "care of the self" and confession, when, at the beginning of the Christian era, "know yourself" became a matter of confessing oneself completely to a spiritual guide.[29] This transition initiated what Foucault calls "the hermeneutics of the self," in which the subject began to engage in deciphering hidden subjective data and thereby became committed to uncovering or "excavating" some truth located deep in the unconscious or soul. Ultimately a project of self-renunciation, confession is the "formidable injunction to tell what one is and what one does, what one recollects and what one has forgotten, what one is thinking and what one thinks he is not thinking."[30] According to Foucault, "We have since become a singularly confessing society . . .

one confesses one's crimes, one's sins, one's thoughts and desires, one's illnesses and troubles; one goes about telling, with the greatest precision, whatever is most difficult to tell."[31] Such a project was essential to creating the self-regulating individuals envisioned by liberal democracies and their distinctive penal, educational, and medical institutions. Once this disciplinary practice moves from the confessional to one's pocket, it readily becomes an un-self-conscious habit that serves a wide array of administrative goals.

Imagine a person who regularly posts to social-networking services images in which the color red figures prominently. Such an example allows us to contrast Foucault's understanding of the ever-confessing abstract subjective "I" in encounter with Peirce's notion of identity. According to Peirce, identity "consists in the consistency of what [man] does and thinks [as organism]."[32] Consistency is physiological because it is of the organism. But also, it is "the intellectual character of a thing . . . its [way] of expressing something."[33] In the act of expressing something, person-organisms, insofar as they think, express themselves; the consistency in doing so amounts to identity. Not only is this approach completely counter to the Cartesian separation of mind and body, but it also differs from "confessional" understandings of self-discipline. We need not impute a self-conscious decision to emphasize "red" in order to understand that quality of our hypothetical subject's images as, simultaneously, a form self-expression and the result of social training. This is because "my language is the sum total of myself; for the man is thought . . . [and] the organism is only an instrument of thought."[34] "Every thought is a sign."[35] When we think, there is present to consciousness something that serves as a sign: feeling, image, or conception—or inclination. Because signs may be icons, indexes, and symbols, we can amend Peirce's point that "life is a train of thought."[36] The corollary might be articulated in this way: life is a stream of thumbnails (but also

mobile updates or otherwise "shared" communiqués, etc.). If "the word or sign which man uses is the man himself," then similarly the imaging that "man" practices is likewise "the man himself."[37]

For Peirce, attention "is the power by which thought at one time is connected with and made to relate to thought at another time."[38] It is aroused "when the same phenomenon presents itself repeatedly on different occasions."[39] It affects the nervous system such that we come to perform a certain act "upon every occurrence of the general event" to which the particular is related as an instance thereof.[40] For example, this has the character of that; therefore, I attend in a manner consistent with all preceding experiences pertaining to that, and moreover, I will likely behave similarly in future instances wherein the character of that presents itself. Imaging, texting, and so forth, are such behaviors: in the moment of red—be it flower, car, shoestring, signage, or discarded boxing material—I attend, I image (or I might text). The example clarifies that attention is a function of habit. As Peirce posits, habit forms by means of "multiple reiterated behaviour of the same kind, under similar combinations of percepts [perception] and fancies [imagination]."[41] He goes on to explain that repetition inclines a person to "behave in a similar way under similar circumstances in the future." What Peirce posits, ultimately, is that habit operates according to the future conditional and, therefore, guarantees a certain predictability of recurrence.

Any consistency in sharing, that is, any patterns observable in the streams of thumbnails, texts, or mobile updates a person produces, is an expressing of the person as such. Here, we might consider rate and frequency of imaging, typical times and locations for imaging, kinds of objects and people imaged, quantity of images for any one (kind of) object or person, typical quality of imaging (amount of blurring, suggestive of movement of different sorts), and so on. Self-expression is legible in these patterns

once they are made visible by clever software as series, repetitions, combinations, chunkings, and juxtapositions across streams of mobile imaging thumbnails.[42] Consider, again, the color red—as it so pervades my own imaging practice. Viewing habits cultivated by institutions such as museums as supported by the discipline of art history might encourage us to focus on red objects in a series of images, to consider the quality of the overall composition, and to speculate about the aesthetic skill and intentions of the person who composed them. The recurrence of red in a person's streamings of images, however, allows us to ask an entirely different sort of question—one more oriented to spontaneous response than artistic skill. One might well wonder how red, in its varying shapes and hues, catalyzes affect in the person who images, in what ways and at what moments it inspires—or incites—imaging. If a person chooses to reflect on a particular framing of red in an image and whether or not it is pleasing to others, the person may remain in ignorance of a "deeper" response to red as revealed in her or his image streams.[43] Attention to patterns in imaging practice—how many times, at what time, and by what manner red appears—allows for recognizing modes of expression constitutive of, for lack of a better word, identity and how said identity is articulated across various platforms.

Expressivity is twofold in this context because, in the moment of imaging (or texting, etc.), one is also activating computational processes. On one hand, expressivity refers to autobiographical practice (broadly construed); on the other, algorithmic operations as coded by computer scientists.[44] To distinguish between these is to acknowledge what Espen J. Aarseth terms a "functional difference" between the discrete—and intentionally organized—narratives of self one might consciously articulate in prose, speech, or internal dialog and the data one proliferates daily—at the level of impulse, which provides an ongoing accounting of one's whereabouts and

doings, be these purchases, tweets, or GPS coordinates.[45] And almost always, the data one proliferates is parsed algorithmically.

Thinking in terms of "expressivity" allows us to consider conventional assumptions we may have about the role of narrative in practices of (self-)expression. Narrative is retrospective: at a distance from, though not necessarily objective about, events being recounted. And it assumes an integral relation between sequence and consequence. In recounting some incident from one's experience, one explains, describes, and contextualizes a series of (micro-)events into a whole and, significantly, from a place or moment beyond the experience itself. The formal habits or conventions of such autobiographical practice promise, even if they do not deliver, coherence and semantic clarity, neither of which characterizes the kind of documentation of self one generates through typical practices of mobile imaging (or texting, or otherwise posting updates from a mobile device, for that matter)—which frequently occur at the level of spontaneity and impulse, or proto-self, as I suggest in the preceding chapter.

This is not to say that social media abolish the narrative conventions of autobiography. Certainly, any number of narrative accounts might be attributed to a particular string of images after the fact. Nonetheless, the shear volume of images posted to various social-networking sites exceeds the conditions of possibility for narrative as typically imagined—or better yet, desired. Narrative coherence is significantly troubled by social networking's encouragement to link across various threads of interest, engagement, and interaction. If narrative residue surfaces in streams of thumbnails, it is, in part, because of people's disciplined relation to imaging. We have been habituated to make our pictures illustrate, for example, a vacation trip, to accompany the story we might tell about it. Nixon's *The Augustas* demonstrates a basic point amplified and augmented by a particular platform's (e.g.,

Flickr circa 2009) articulating streams of augustas; images may also render an expressivity that has little to do with the syntax of a journey. After all, one who may be drawn to imaging red is not necessarily "confessing" a love of red; the person is not necessarily engaged in a critical self-disciplining work. But this person's "sharing" of self via images of red she or he posts might very well participate in a regulatory process. In which case, sharing differs from confessing even as it bears a functional similarity.

More relevant than whether or not narrative serves to explain any series of images is the fact that images are distributed across the broader social-networking community. While any participant might provide her or his images with a personal inflection by means of habits in imaging and tagging, this expressive particularity is parsed in relation to a variety of external inputs and influences, including other platform-specific members and subscribers, visiting commenters, software companies and their employees, and so on. Importantly, then, expressivity, and the aesthetics thereof, only emerges as such within a semiotically dense, highly organized social situation. What constitutes the expressive as such is not necessarily a matter of an individual's concerted (self-)expression as might be the case, for example, with diaristic practice. Instead, what constitutes the expressive is a historically contingent socio-cultural construct involving many contributors and technologies.

To illustrate we might consider the difference between Nixon's home movie and a tag cloud. As a system for visualizing tag usage according to frequency, tag clouds are "folksonomy" pools—loosely controlled vocabulary clusters that are participant generated, not institutionally (in explicit sense) produced and overseen. Tag clouds alphabetically order all of the keyword tags in use by any one or more participants. They appear in strings of text that wrap around at the end of lines within a delineated field. Boldness of color or font scale indicates each tag's frequency within a given

pool, which may include data added by one participant or billions. Not only do tag clouds track tag usage, but also they serve a navigational purpose. One can browse a cache of assets, such as a series of related thumbnail images, simply by clicking on a desired tag.

However, navigation proves curious at times, since the semantic relationship between two assets (e.g., images) is frequently based upon a statistical relationship identified algorithmically in tagging patterns. An image might acquire tags through a process other than personal choice and designation when an algorithm determines the set of instructions (or "recipe") for defining a series of operations that associate variously labeled images. As information architect Gene Smith explains, two seemingly unrelated—and, in fact, non-identically tagged—assets might be statistically related as a consequence of other tags the assets have in common.[46] For example, any two thumbnail images posted to a particular social-networking site may not be tagged identically with the keyword "augusta," yet the two images might very well share a relationship based upon other tags identified as related—because such relation is inferred by an algorithm parsing usage patterns of a population of users. Inversely, two images tagged "augusta" may never inhabit the same screen space because their statistical relationship ensures their separation. This occurs because algorithms function to "look at" tagging patterns.[47] They are not interested in semantic relationships. They interpret words not as symbols but rather as degrees of relationship with other terms. No individual act of tagging can effectively equal a feat of categorization for the community of users, since an algorithm oversees that process.[48]

In contrast, the organization of Augustas in *The Augustas* seems easily attributable to an idiosyncratic individual. Nixon edited shots together in a single string of celluloid to be threaded through a projector and screened at a later time. Technological affordances determine linear organization and

temporal duration of the work.[49] Despite its requisite sequentiality, however, there is a haphazard or random character to the order of Augustas; neither chronology nor geography explains their organization. Nonetheless, this seeming randomness is bracketed by the film's opening and concluding sequences, which suggest a narrative thread that is never quite accessible to the audience. The imperative that "gentlemen will please refrain from smoking, spitting, or using profane language during the performance" begins the film, and a title shot that reads ". . . and so our trip ends" concludes it.[50]

If the cinematic sequence defines Nixon's film, the logic of the template or the stream governs how images appear on social-networking sites. Frequently, images posted to such sites are relatively confined to the schematic view of columns (and perhaps rows) upon a screen in reverse chronological order according to date and time of posting by a particular "member" of the community. Rather than the intentional editing together of shots, such sites register updates in the time of their posting. An actual database introduces properly algorithmic associations and a "database rhythm," altering the relations between the enframed image and its sequencing, thereby opening onto a new expressive dimension through the surplus value of more or less elegant code. So while there may be a linearity of sorts—perhaps line or grid formation—to images proliferating on social-networking sites, they have a seriality that Nixon's *The Augustas* does not. Really a matter of chunking (e.g., of similarly tagged assets), counterpoint (e.g., of variously posted content), and chronology of posting, this seriality can be understood in terms of rhythm and pacing according to more than the spatially oriented terms of an image's form, content, and placement. While the naturalized visual structuration of the content management system might focus an eye on and suggest the prominence of a linear logic as established by columns and rows, which is suggestive of unidirectionality belonging to left-to-right,

top-to-bottom scansion, the expressive tempo of imaging and posting, and subsequent tagging, is what matters. The pauses and repetitions, and the nuances of a steady or staccato pulsing of imaging or its more sporadic occurrences, are what count—because these are always potentially indexes of the proto-self (Damasio). It's not the image that matters so much, as I suggest above, but the act of imaging—which occurs in the moment of the Peircean "interpretant," or at the time of the proto-self.

In chapter 2, I describe the neurophysiological phenomenon of attention as it transpires in relation to a mobile device being in hand. This attention in relation can now be considered more fully in its expressive dimension. In the example of image postings appearing on various social-networking sites, constituted with the aid of a database and software, a device in hand materializes intensities of various kinds, including degrees of attachment, interest, fancy, surprise, distaste, and so forth. To approach the thumbnail image as an image only, that is, as a two-dimensional representation cut off from the rich metadata it accumulates and entails, would be to reduce the complexity of the articulated engagement of a person with a device and the person's milieu. Rather than emphasize the image as a discrete visual artifact, social-networking platforms emphasize the tendencies, or habits, in imaging both for a person and across a larger community or population of users. Traditionally and according to a still current educational practice, one would look for the "art" of a photograph in how the image is framed and composed, what it depicts, and whether it suitably heeds or defies conventions of representation. I am suggesting a reorientation of concerns about expressivity away from the artifact and its subsequent interpretation toward the practice of expression organized through the mediation of mobile devices.

Rhythm and pace communicate something about a particular experience or a tendency in the way of experiencing with a mobile

imaging device in hand. In other words, the patterns so material-ized might be understood as a semantics or grammar of experienc-ing: an expression of semiosis. Certainly, images as discrete objects within a string or collection provide content to be parsed and rendered legible, but I propose that it is more relevant to think in terms of a dynamics of inflection as modulated through the imme-diacy or force of stimulation. This is to suggest that the expressive character of a discrete thumbnail image is actually a matter of how attraction is cognitively constellated in relation to a stimulus or stimuli (at the level of the proto-self). In this instance, imaging is cognition, or semiosis; it is interpretation, to which the keyword tag appends a second(-order) interpretation.

Foucault's genealogy of confession falls short of providing a suitable account for the kind of practice this is, principally because of its emphasis on the self. Likewise, his later turn to *teknē* and *askēsis* suggests—and only in the abstract terms of philosophy—a sense of what habit might be.[51] Peirce, on the other hand, offers an account that is grounded. That the streaming of thumbnails and related artifacts is governed by an imperative to accumulate and disperse in streams (as determined by the content management system) indicates that autobiographical impulse supplants auto-biographical intent as the motivating force propelling the act of self-documentation. As intensities—that is, ebbings and flows of attraction and peaks and valleys of interest—become the mode of expression driving self-record, the conventions of narrative and the "distanced" contemplation of the canvas hold less sway. What's more, a potentially ceaseless accounting of oneself results in a pro-liferation of self-record that exceeds the graphy underpinning more traditional autobiographical practice that tends to be devoted to establishing relations among distinct episodes in a personal story framing a life via prose.

In offering evidence of a proto-tagging sensibility in formation,

The Augustas is unwittingly prescient about what expressivity entails in the context of mobile technologies. At the same time, it reveals that the signs that mark our sites always already signal that the terrain upon which we tread is virtually ever shifting. Extending beyond Nixon's film through the present, the "case" of Augusta provides a frame through which to reconsider how persons get mapped, how social relations get instituted, and how populations are thereby managed. These pictures of Augusta teach us that findability always has an expressive as well as an instrumental capacity and that the former may destabilize the latter—without ever really dismantling it. For a long time now, we have desired to place ourselves and our peers on the map. Such feats of self-placement make calculable persons of us all. We need a language to describe the expressive dimension of such quotidian feats, one that does not engage the confessional, evaluative apparatus of art criticism. After all, the issue is not really "aesthetics" in general but an expressive register that is neither always intentional nor necessarily confessional. Nor is expressivity necessarily attributable to any individual person, who might be declared self-aware and purposeful. This is because expressivity transpires at the level of the organism, at the level of attention as triggered by impulse, or cognition—at the level of habit formation—and, therefore, at the level of population.[52]

Secured Mobilities

HOW TO THINK ABOUT POPULATIONS

Louisiana

Governmentality and self-expression are not opposed but reciprocally confirming. As I have suggested, this relation looks different when we think of mobility, location, findability, and metadata, rather than the Panopticon's architecture of surveillance, confession, and self-discipline. This chapter develops this account of governmentality by setting it within the larger historical context of liberalism and neoliberalism. In contrast to the model developed in the preceding chapters, these political discourses posit the individual as an autonomous economic and political agent. In so doing, they nonetheless confirm the effectiveness of biopower. This is the lesson of Michel Foucault's theorization of security, which posits that good governance involves the ongoing management of the circulations of various "bodies," be these goods, persons, currency, or information. The management of circulating bodies does not require them to be visible, but it does require them to be findable.

This insight reorients consideration of contemporary media culture. In 2006, Wendy Chun called attention to the control-freedom paradox.[1] In her discussion of the Internet and fiber optics, she identified a tendency for people to assume that freedom

amounts to invulnerability and that invulnerability eludes impli-
cation in processes of control. In a complementary way, I contend
that we should be concerned less with privacy than with location,
less with democracy than with mobility, less with the smartness
of networked collectives than with their mappable interconnec-
tions. It is also useful to consider the problem of administration in
mobile media culture as having a longer history, one that reaches
back past the personal computer, the movie screen, and the Panop-
ticon to Roman camps and roadways. If *The Augustas* reminds us
that camera-carrying mobile insurance agents precede the mobile
phone, Augustan Rome teaches us that governance has long con-
cerned itself with managing circulations of all sorts. Indeed, from
one point of view, governance itself is a matter of infrastructures
and techniques for keeping track of but also facilitating
mobilities.

"1984 WON'T BE LIKE '1984'"

Read against the grain, Apple's legendary "1984" commercial sup-
ports the point that governance requires mobilities even as it aims
to regulate—and, in fact, place—them.[2] Introducing the Macin-
tosh personal computer, the advertisement perpetuates the liberal
fantasy of individual persons as political and economic agents of
change by depicting media as a means of disciplining the masses
while addressing consumers as members of a population. Invoking
Orwell's "Big Brother" trope as well as Fritz Lang's dystopian view
of an industrial future in *Metropolis* (1927), it begins by associating
control of information with habitual obedience. The commercial
opens with an extreme long shot that discloses a vast gray industrial
interior comprising an uncountable number of floors. A lumi-
nescent tube stretches diagonally across the image. The camera
draws closer to this tube, and we hear a low rumble punctuated

by a recurring chime over what sounds like a PA system. The tube is transparent; through its curved surface we observe hundreds of human bodies marching centipede-like offscreen. An authoritative masculine voice intones, "Today, we celebrate . . ."[3] A low-angle shot reveals uniformly dressed bodies trudging through the tube single file as the voice continues: ". . . the first glorious anniversary of the information glorification directives." The rhythm of marching of feet against grated metal flooring reverberates throughout the tubular corridor, which is lined with CRT screens that emit an unpleasant aqua-tinted glow.

A rapidly edited sequence follows revealing a blonde woman in red running shorts charging down a corridor with a hammer in hand, heavily armed troops in pursuit of her, and a line of gray-attired individuals marching toward, and then seated rank and file, in an auditorium. The intercutting of these shots provides a narratively elliptical counterpoint to the authoritarian voice-over, emphasizing words like "ideology" and "unification of thoughts." We see that voice has a source in a bespectacled talking head, whose visage appears Big Brother–like on a massive screen. The size of the screen commands the attention of the stultified masses. In contrast, the woman gives the impression of being an Olympian; her motion and attire mark her difference.[4] The commercial concludes with the shattering of the screen, the blonde athlete having hurled her hammer into it. In the wake of this destruction, a refined masculine voice announces, "On January 24th, Apple Computer will introduce Macintosh." This new voice continues, "And you'll see why 1984 won't be like '1984.'" The image dissolves into a black title screen featuring Apple's iconic rainbow-striped apple logo.

The Macintosh itself is withheld from view. Instead, the commercial solicits identification with the colorful deviant who resists mass discipline. True, the camera's viewpoint sometimes places us among the seated bodies staring in blank submission at the screen.

In this way, it may encourage savvy viewers to equate that position-ing with the screen encounter they are simultaneously experienc-ing. That irony qualifies without obviating the principle fantasy on offer: rejection of uniformity and passivity in favor of the willful attitude of the woman in red running shorts—"think different."[5] The commercial hails those seated in front of television screens to want to see why "1984 won't be like '1984'" and to embark on an investigation of "Macintosh" that Apple hoped would result in purchases of the device its design team described as a "personal communications appliance."[6] By means of this mass-produced product one might claim iconoclastic self-expression.[7]

Post-1984, millions have invested in "personal communications appliances" made by Apple and its competitors. If this activity succeeds in thwarting the dystopian future envisioned in the advertisement, that is because the advertisement con-jured as Apple's foil an image of control that was already obsolete. Lang's late Weimar idea of machinelike social control and Orwell's depression-era vision of information control are hyper-obsessed with the masses versus individuals. But liberalism really works by placing individuals within populations. If they move toward Macintosh, consumers may adopt the athlete's ethos, but they hardly embody her defiance. Consumerism accommodates and encourages differences. In this context, individual choice does not rebel against mass marketing but embraces it. Similarly, that we have imagined ourselves as having individual opinions that count in the context of the whole is evidence of a mode of governance that does not oppose individuality and regulation. Those who mo-bilize politically by means of their mobile devices may challenge particular regimes, while simultaneously reinforcing mechanisms of governance that work by making individuals findable and calculable.

Seeing is much less important than locating for contemporary governance. Among recent media theorists, Richard Grusin is rare in pointing this out.[8] In *Premediation: Affect and Mediality after 9/11*, he explains that connectivity (i.e., of our various devices) supplants surveillance as previously understood. Not only does connectivity provide the capacity to connect the dots, as Grusin suggests, but it also makes increasingly evident a fundamental and pervasive desire for and expectation of locatability. Habits of connecting and sharing, which emerge out of technological connectivity, coincide with an increased attention to and awareness of location. We are and apparently want to be "locatable" at all times. That our various devices default to GPS connectivity and the applications that populate our devices invariably "would like to use your current location" underscores this now principle concern, as does the fact that mobile phone users voluntarily announce "where-ness," for example, when answering calls and texting friends. The emphasis on findability makes apparent the importance that mobility has for contemporary individuals and those who would manage populations of them. That nearly all of us are almost always locatable explicitly recognizes the increasing tendency for persons and things to be always on the go.

Unlike the trope of surveillance, "tracking" designates an ongoing triangulation of bodies, information, and security endemic to societies whose members are compelled to proliferate information via mobile technologies. In this context, the term foregrounds the fact that risk management relies on ceaselessly trailing movements and tracing shifts. "To trail" and "to trace" refer to the continuous registering as data of proliferating (micro-)events that are not necessarily seen ocularly. "Keeping track" indexes, as opposed to im-

ages or symbolizes, various mobilities' proliferating circulations. The processing of such indices always potentially transpires in real time.[9] While we might say that technology "sees" where an asset is, when we do so we apply a visual metaphor to an essentially avisual process that registers that asset's location via electromagnetic waves, independently of sight as such. Contemporary vernacular misleads us when it uses "being seen" to refer to the availability of one's data traces as opposed to, for example, the iconographic capture of one's body. Tropes such as "sniffing," "phishing," and "mining" better capture what it means to manage data. It is well worth asking whether metaphors of visibility are appropriate to describe how power operates by the first decades of the twenty-first century. If persons are not literally "watched" or "seen," then we need to reconceptualize governance and the specificities of its techniques.

In truth, governance has for a long time depended on such avisual mechanisms. It is necessary to point this out thanks to Foucault's success in popularizing Bentham's Panopticon as a metaphor for power—not to mention his related observation regarding the French infinitive *voir* (to see) and its etymological centrality to both *savoir* (to know) and *pouvoir* (to be able, i.e., power). It can be easy to forget that Foucault developed the panoptic principle in relation not only to Bentham's prison but also to a discussion of public opinion, which he identifies as an important political force dating to the French Revolution and Jean-Jacques Rousseau's ideal of a "transparent society" that is "visible and legible in all its parts."[10] In calling attention to the fact that liberal society idealizes a form of visibility, Foucault challenges the habit of understanding opinion formation as a process that occurs primarily through reading and writing. He also calls attention to the habit of using visual metaphors to describe avisual processes. Here, the idiomatic expression "I see what you're saying" is a case in point. Liberal-

ism's account of self-governance heavily emphasizes the efficacy of speaking one's mind and also imagines citizens capable of being able to see—know, or be informed about—the "whole of society" in order to govern themselves within it. Foucault notices this discourse of visibility within what is more typically thought of as a verbal process of public opinion formation, whether it transpires in the coffeehouse, town hall forum, or public square. Announcing one's opinion in such venues functions as a form of visibility. One might say that opinion is "cellular." Individual views either gain or lose distinction in relation to "public opinion." From the verbal interaction of variously interested individuals, a collective will is imagined to take shape and become a ruling force, but like the norms of good conduct governing Jeremy Bentham's prisoners, "public opinion" is a regulative abstraction produced and maintained within state institutions.

The development of "public opinion" after Rousseau supports this point.[11] Management of opinion has become a major undertaking of government and private enterprise. When surveys and polls quantify and objectify public opinion by means of statistical samples, as they learned to do with increasing precision in the twentieth century, individuals' views are represented numerically without being seen or heard at all.[12] Opinion management employs all types of signs. It works, however, not by making individuals feel that they are under observation but by making them feel that their opinions have been heard or taken into account. This is why Foucault is right to describe Bentham as a "complement to Rousseau": panopticism and public opinion are halves of a whole.[13] The Panopticon isn't the "true" power behind liberal self-governance, merely part of the machinery of it.

Foucault's work acknowledges the insufficiency of visual metaphors in his turn, in the late 1970s, to problems of "circulations" and "multiplicities." Whereas his *Discipline and Punish* inspired

numerous critics to think about modern culture as "surveillant," the lectures on governmentality characterize a reconfiguration of power in which discipline, liberty, and security function as complementary logics that replace sovereignty.[14] Foucault develops an account of security as an exercise in risk management that sources and assesses information regarding the routines, patterns, and sequences of transaction and engagement among persons and products. Although security does not begin to replace sovereignty in Europe until sometime in the eighteenth century, the physiocrats of the seventeenth century nonetheless have important antecedents in ancient Roman administration.

Starting in the eighteenth century, Foucault sees the emergence of an order that conceives movement—of persons, goods, contagions, and so forth—as inevitable. Security "allow[s] circulations to take place."[15] The shift to securitization is a response to the effective impossibility of exercising sovereign control over a multiplicity of concurrent movements, or what I refer to as mobilities. Those responsible for governing mobilities understand that movements that might appear totally unrelated to one another might nonetheless have a common effect on the welfare of the realm. In eighteenth-century Europe, this involved the emergence of a notion of "mutual commerce" (i.e., across Western Europe) and the inception of a globalized, or open, market (insofar as the world becomes a market for and in relation to Europe).[16] This kind of thinking has since become so familiar that even the dullest conspiracy thriller can conjure catastrophic outcomes out of seemingly unrelated electronic transfers of funds, mobile phone conversations, and long shots of numbers of commuters. For a long time now, it has not been feasible to control such movements by means of prohibition, restriction, or sustained confinement. Thus, Foucault explains, security hinges on knowing where things are and ensuring that they "are always in movement, constantly

moving around, continually going from one point to another."[17] It proceeds according to risk management.

Governance qua security reconceptualized "the town," itself informed by the spatial arrangement of the Roman camp, as a "space of circulation."[18] Like a heart, eighteenth-century planners began to explain, the town's infrastructure regulates hygiene, prosperity in trade, and public safety. By paying attention to how goods, people, water, germs, and the like, moved in and out of towns and through them, planners and administrators found a means to address overcrowding, make room for new economic and administrative functions, deal with relationships out of town, and allow for growth. Organizers of circulations learned to distinguish between "good" and "bad" arrangements in order to maximize the former while diminishing the effects of the latter. Crucially, they developed a capacity to think in terms of and thereby manage an "indefinite series of mobile elements."[19] This requires a flexible framework that evolves and adapts according to "what might happen."[20] Such a framework does not rely on what is plainly visible or readily ascertainable. And while it measures and quantifies, it does not do so to fix, that is, to still and isolate, but to forecast future trends.

Growth of population and increased commerce between town and surroundings required opening up enclosures and managing flows of people, goods, and money, but also—and more abstractly—knowledge and power. The town became something other than a concretely bounded site defined by, for example, a gate barred and locked nightly. Foucault begins to use the term "milieu" to characterize the new permeability attributed to the town. It suggests greater plasticity and adaptability. Comprising both natural and artificial givens, the milieu is "that in which circulation is carried out."[21] More like a web of circumstances than a site-specific environment or a demarcated territory or property, a milieu com-

prises natural and built physical sites as well as persons, commodities, vehicles, germs, and information—all in motion: multiple and simultaneous mobilities.

Perforated by constant comings and goings, the border's import could scarcely be grasped according to the previous logic of containment and permission. A more permeable set of boundaries posed "new and specific economic and political" challenges and made apparent that a system of rigid constraints would not provide a viable means of effecting control. Administrators needed a new repertoire of techniques. In order to manage the various circulations constitutive of that milieu, techniques of security try to "grasp" these mobilities "at the level of their nature," that is, "at the level of their effective reality."[22] Here, "reality" refers to the locus where "things are taking place, whether or not they are desirable."[23] Implementing and subsequently sustaining effective governance requires government to "respond" to the fluctuations, accumulations, dispersals, reallocations, and various other mobilities experienced by and in the milieu—whether these be vehicular or biological, naturally occurring or manufactured.[24]

Governance according to the logic of security strives to take advantage of the various phenomena that function within and support the milieu. It seeks to make compliance as easy as possible, to work prophylactically, and to apply corrective measures only when necessary. There is no "exercise of a will over others in the most homogeneous, continuous, and exhaustive way possible."[25] Neither is there "exhaustive surveillance of individuals."[26] Rather, there is the pervasive and ceaseless management of the states and conditions—that is, the reality—of what comprises the "milieu." Or, as Foucault clarifies, security assesses degrees of risk. It seeks to address a threat's ill but not necessarily abnormal effects.

It may be tempting to oppose security to discipline, which Foucault opposes to sovereignty in *Discipline and Punish*. Like the

sovereign's power, discipline acts on individuals and territories, whereas security administers mobilities and as such is interested neither in self-regulation nor in the prohibition and containment of movement. But this is misleading. Concerned with populations, security tracks multiple and distributed movements. In this sense, it does not rely on the self-discipline of individuals, nor does it seek docility. But the logic of security is not wholly distinct from that of discipline. Like discipline, security deals with norms and seeks to make conduct manageable by making it knowable and predictable. Whereas discipline thinks the norm to be an "optimal model" according to which the abnormal or deviant gets defined, security multiplies distributions of normality across a population (e.g., according to age, neighborhood, and occupation).[27] It works with normative ranges defining conditions in need of more or less managerial intervention. This means that security always involves a great deal of data processing: sourcing and assessing information regarding various routines, patterns, and sequences of transaction and engagement. The census, polling (as occurs in politics as well as consumer reviews and other surveys), Internet browsing histories, log-in registers for networked servers, and phone and credit card usage summaries are all examples of the ways in which security samples data about and thereby monitors—that is, tracks—the population.

CAESAR AUGUSTUS, ROMAN INFRASTRUCTURE, AND THINGS IN MOTION: A HISTORY LESSON

In the introductory pages of *Security, Territory, Population*, Foucault mentions the Roman camp as a precursor to the early modern town. The "famous form of the Roman camp," he notes, reemerged as an organizational strategy in Protestant countries in the late sixteenth and early seventeenth centuries,

when it provided a model for regulating circulations by means of organizing space.[28] This prototype invites a more complex analysis of the problem of circulation than Foucault finds himself able to develop. Specifically, it challenges us to see the relationship between administration and infrastructure networks as more resilient and extensive than might appear in accounts of modernity that emphasize the eighteenth and nineteenth centuries.

Visual renderings of the Roman camp are abundant online and in print, and they typically represent the camp as a square or rectangular perimeter within which all structures (also square or rectangular) are arranged in grid-like fashion. Adhering to a logic of subdivision, the Roman camp presents a semirigid outline. Ever-smaller quadrants of varying dimensions fill the fixed boundaries, although they do not necessarily abide a prerequisite of symmetry. Diagrams of the Roman camp make readily apparent the modular architecture that inspires Foucault's comparison between the camp and the town. They also reveal a protodisciplinary configuration: an abstract and measured space well suited for legibility and ease of navigation according to charted pathways such that it would be easy to recognize something or someone as out of place. It is, as Foucault states, an instance of "structuring a space" according to gridded but flexible containment.[29] Foucault emphasizes the completely artificial, that is, (re)constructed, character of space, which he contends does not apply to a notion of territory. Whereas a territory is a bounded area of land at the center of which is the seat of power, the town is structured so as to organize the people who inhabit it. Thus they might be governed without being dominated. Significantly, he notes, the move to structure the space of the town along the lines of the Roman camp recognizes the problem of circulation: increase in trade introduces more circulation and a "greater need for streets and the possibility of cutting across them."[30] As a model, it acknowledges the need to provide

"a hierarchical and functional distribution of elements,"[31] which is both measured and measurable even if it is not fixed or stationary. In other words, it is a configuration that anticipates movements of various sorts the better to direct them.

Accounts of the Roman camp based on archeological evidence provide an even better perspective on how this spatial arrangement regulates movement. As discussed in Lawrence Keppie's The *Making of the Roman Army: From Republic to Empire*, the histories of Polybius (ca. 160 BC) describe a temporary and portable but "regularly laid-out" military camp.[32] It was itself mobile at the same time as it patterned movements within its boundaries. Used initially during the Roman Republic (ca. 508–27 BC), such camps were town-like before Foucault's towns were camp-like. They had a main street (for the movement of animals, persons, and vehicles) and an open market (for the circulation of goods and currency). Keppie indicates a strong likelihood that "military engineers adopted the layout from contemporary town-planners,"[33] a fact that suggests an interesting instance of complementarity between military strategy and social order. This point finds confirmation in the fact that a consistent and "precise plan" defined camp installation hierarchically, making transparent each man's station.[34] The tent belonging to the commanding magistrate "occupied a central position."[35] On either side of this tent stood the tent of the junior magistrate (the one responsible for handling financial affairs) and the forum (i.e., market). Tents "housing" the legions were erected in front of this configuration. Keppie goes on to explain that camp design underwent refinement during the years of empire (27 BC–AD 14), becoming more stationary under Gaius Octavius—who assumed the name Gaius Julius Caesar Octavianus (Octavian) upon the death of Julius Caesar and who later came to be known as Caesar Augustus—for whom the month of August is named. In the later years of empire, the more stationary summer and winter camps developed

into forts and fortresses. Some camps eventually evolved into still extant towns.[36]

Under Augustus, the Roman Empire's social order developed along with its spatial organization. In *The Urban Image of Augustan Rome*, Diane Favro describes Augustus as committed to the "care of the city," beginning with Rome's urban infrastructure. Augustan Rome developed waterworks, transportation systems, public works, and what we would now call emergency response systems (e.g., brigades of men charged with fighting fires and keeping order at night).[37] This mode of urban management inspired a new ratio-aesthetics that demonstrated an increasing concern for pragmatism, functionality, and order in the shaping of the cityscape. Engineering, management skills, and aesthetics received equal emphasis under Augustan rule. The aim was to construct roads, aqueducts, and sewers to form "pragmatic networks of a large metropolis."[38] This urban infrastructural development existed in tandem with a "clear articulation of landmarks, notes, paths, districts, and edges"[39] to effect a new sociospatial legibility that privileged vertical lines and repetition.[40] The tight visual configuration of public building projects of the time adhered to principles of functionality. Significantly, Augustus favored "multipurpose building forms" that were "adaptable for the changing needs of the Imperial bureaucracy."[41] This, then, was a pioneering instance of a flexible networked infrastructure of the sort that we now take for granted as desirable.

The rise of "what would become a permanent municipal bureaucracy" dates to 17 BC.[42] Augustus instituted various curatorial boards, which were organized hierarchically. Tasked with clearly defined responsibilities, these boards were provided with state funding and permanent, trained staff. According to Favro, "Curators [heads of board] held their posts for long periods, allowing them to develop expertise in their areas of responsibility, document their activities, and develop pride in their achievements."[43] More-

over, the bureaucratic structure according to which administration evolved under Augustus meant that "the compilation of comprehensive records for urban maintenance also stimulated pride in the office, not just the individual."[44] Warehouses were constructed (for holding goods before distribution), and a census was conducted, the result of which was the reapportionment of Rome into fourteen regions (instead of its previous configuration as the "seven hills"). Ultimately, Favro explains, "the XIV Regions represented a comprehensive system," and Rome acquired "the appearance of a well-ordered society with everyone having a place and a responsibility" such that Augustus "stabilized his broad power base."[45] Power, here, is an imperial power belonging to a sovereign Augustus; we have not yet arrived at the invisible hand of the market or "public opinion," for example, as a regnant force. Still, the techniques for administering by managing flows look uncannily similar to those that would later be imagined by the French town planners Foucault talks about.

The process of rationalization that began to define Rome's legal and administrative framework finds a corollary in the Roman intellectual endeavor of the time, as the contributors to the explicitly Foucauldian *Ordering Knowledge in the Roman Empire* explain. In their introduction, editors Jason Konig and Tim Whitmarsh assert, "The fact of empire crucially changed the way in which knowledge was used, abused, presented, and represented."[46] In particular, they note the "move towards specialised knowledge."[47] They describe intellectual work of the Roman Empire as predominately functional (as opposed to aesthetic) in nature. Underpinning Konig's and Whitmarsh's argument, and central to the other essays comprising the collection, is Foucault's notion of archive. They remind us that Foucault conceives the archive as a "habit of thought, an intellectual genre, an inter-related set of culturally operative, but also embattled, propositions as to the necessary

properties and social role of language."[48] Furthermore, they explain that "archival thinking" is propelled by a "desire to itemise and order knowledge."[49] Here, the example of Roman texts of miscellany (textual compilations of diverse objects of knowledge) proves instructive. The editors describe such texts as being not simply random collections or enumerations of discrete and seemingly unconnected phenomena. Rather, such compilations serve as "map[s] of society"—and thus, are "archive[s] in action," wherein one can observe the hierarchies, equivalences, regularities, and equivocations structuring the world as a locus for the production of knowledge.[50] Their principle example is Roman doxography, which gathers and records philosophical opinions of various sorts.[51]

This period of empire also gave rise to two transformative technologies related to the encyclopedia: the codex (i.e., bound book) and the table of contents. The former particularly interests Konig and Whitmarsh. Proceeding according to what the editors anachronistically (albeit suggestively) call "hypertextuality," the codex afforded new practices of "cross-referencing and non-linear reading," because it could index contents by page number.[52] What these developments suggest, the editors argue, is that in the Roman Empire, "'knowledge' is to be conceived of as an aggregate of discrete particles that are to be subjected to a process of analytical ordering."[53] Already in the first centuries of the Roman Empire under Augustus, knowledge was becoming a function of ongoing processes of sorting, sampling, and classification. Because it was a function of a process, it could not be regarded as particularly stable or permanent.

Not surprisingly, intellectual endeavor in ancient Rome (pre- and early empire) was initially the domain of the elite—or more specifically, individual families of wealth and, therefore, political influence. However, with the civil war, Augustus revised who commanded and mobilized knowledge. No longer matter-of-factly the

province of elite families, knowledge came under the jurisdiction, that is, "care," of designated experts—a historical move toward a bureaucratic logic that complemented the development of urban infrastructure. As Konig and Whitmarsh explain, "Political authority was based on delegation of knowledge rather than possession of it."[54] Power, as defined by the sovereign ruler who delegated intellectual responsibilities, managed knowledge production: the organization of empire mapped onto the ordering and orders of knowledge. Authorship no longer entailed the expectation of inspiration but rather could be thought of as a self-conscious utility (e.g., the Stoic practice of the regular nightly accounting of one's actions). An author edits and organizes "pre-existing units of knowledge";[55] arrangement becomes an "intellectual project in its own right";[56] and commentary, translations, "epitomisation," and summary all become considered viable modalities for arranging and rearranging knowledge. The emergence of various but interrelated approaches to organizing an "empire" of knowledge coincided with the development of a network infrastructure necessary for imperial rule. Ordering knowledge and ordering empire were mutually reinforcing activities dedicated to accumulation and expansion, respectively.[57]

I want to underscore the analogies among Augustan Rome's military camps, adaptable architectures, and reference-based knowledge production, for they indicate a commitment to maintaining and ensuring fluidly functioning mechanisms of social existence, including the movements of bodies, goods, and ideas. This is why the Roman camp provides Foucault with such a good model for the early modern security state. If, in turn, we understand the early modern security state as conditioned by the kind of Roman camp that Keppie helps us to envision, we can understand eighteenth-century Enlightenment and panopticism, not as markers of fundamental historical shift, but instead

as genealogical forebears within a long-developing governmental logic that, since Augustan Rome, has recognized the importance of flexible, adaptive, and mobile techniques of management.

To a degree we have yet fully to appreciate, contemporary digital networks inherit this legacy. The "mobile many," recalling Howard Rheingold, are administrative entities in ways that could not have been imagined in Augustan Rome. Yet the mechanisms by means of which such entities are managed form a complete infrastructure—cities, maps, techniques for organizing knowledge, and so forth—that has been developing for millennia. That we carry mobile devices in hand intensifies the effects of governance. We inhabit the logistics of tracking and the avisual logic of findability (which coordinates investments in locatability and navigability). Always on the move and always connected, we are simultaneously bodies in motion and sites of relay—that is, points of mobility and conduits through which pass various mobilities. Monitoring registers, or tracks, these mobilities and, as such, facilitates findability. And nearly always, its operations go undetected, its effects imperceptible—diaphanous, weightless. It spreads by means of the very mobilities it monitors and, in the process, acquires the quality of automaticity that epitomizes normality. And we adapt: mobile and findable, connected and on grid, we interact with a panoply of secured mobilities that accelerate, make more efficient, but also texture, our modes of living.

2002: "SMART MOBS"

In 1984, Apple envisioned consumer choice as rebellion by pitting the colorful individual against the monochromatic mass. In the process, it pointed to an aporia in liberalism's own logic. To be self-governing, as consumers or voters, individuals required a milieu regulated in a manner that secured and encouraged such prac-

tice. Thanks to lessons learned from administrative efforts stretching back at least as far as Augustan Rome, Apple's defiant athlete encouraged millions of television viewers not to smash the screens at which they were staring but to desire another, better, screen. Although obviously different in its aims and methods, Howard Rheingold's widely read and cited 2002 *Smart Mobs* presents a similar contrast between utopian and dystopian futures and points to the same fundamental aporia that results whenever individual expression and "public opinion" float free from self-discipline and population management.[58] As stated in chapter 1, Rheingold predicted that mobile technologies would facilitate coordination and cooperation among people worldwide. He based his claim on his observation that in Japan and Finland young people were beginning to "[walk] around with an always-on connection to the Internet."[59] He also foresaw that an increase in cooperation would be shadowed by threats against personal liberties, especially privacy. Thus he represented, in 2002, a moment of impending change defined by a sustained tension between doom and optimism. Nonetheless, despite often prescient assessments of a technological future in which monitoring would be omnipresent, it is clear that Rheingold's "smart mobs"—who would accomplish the "next social revolution"—expresses a romantic hope that youthful citizen-individuals will join altruistically in collective action to create a "a higher level of democracy."[60] This claim belies how biopolitical governance operates in and through individual practices and across populations.

Parsing Rheingold's phrase "smart mobs" allows us to understand how the mobile many collaborate in their own management regardless of whether they are overthrowing states or arranging dates. The term "mob" in isolation still bears the negative connotations of an uncontainable "rabble," and some commentators found it unclear what exactly Rheingold meant by qualifying it

with the addition of the technology-oriented adjective "smart" (as in "smartphone"). Referring to the networked activities of large and often geographically dispersed groups of people, "smart" cannot denote individual intellect or cognitive potential. Rather, as the *New York Times* reported in December 2002, the "smart" in "smart mob" designates "the intelligent 'emergent behavior' of hive-style animals."[61] That groups of people are described as exhibiting hive-like behavior as a consequence of their engagements with mobile technologies (in particular, mobile phones) is interesting to consider for numerous reasons. Most significantly, such intelligence would seem to be incompatible with a democratic social contract of rational, self-interested individuals conceived according to the Rousseauian or Lockeian ideal for national communities. Of course, it is not unusual to explain sociocultural phenomena metaphorically; human temperament, motivation, and the like, are frequently explained in terms of animal and insect traits. But to the extent that emergent behavior is behavior that just emerges, that is, without intention, the analogy hints at a mode of agency that might be at odds with democracy as we have learned to think and practice it. This distinction has been lost in most discussions. The "smart mob" has generally been framed as exemplary of democratic activity in the early twenty-first century: individual citizens taking action—indeed, willfully deciding to take action—collectively, by means of their mobile devices.

Rheingold's claim for this new "mob" smartness and the success of his formulation make more sense in light of a more complete history of the word "mobs." Etymologically, "mob" is a derivation of "mobile," which itself is a truncated form of "mobile vulgus," and functions as the root of "mobility"—a noun that historically signified in contrast to "nobility." The term thus bears the traces of a contest over political power, and over not only who should have it but also how it should be conceived. The *Oxford English Dictio-*

nary (online) identifies a shift in the meaning of "mob" around the middle of the eighteenth century.[62] What in the late seventeenth century meant "a disorderly or riotous crowd, a rabble" came to signify "a large crowd or group of people; esp. a group of people sharing distinctive characteristics or a common identity or occupation." These two definitions are quite distinct. Whereas the first figures the crowd according to its lack of containment, that is, its unruliness and amorphousness, the second succeeds in finding order in the crowd by means of qualifying it as "a group of [readily classifiable] people," who might, for example, motivate historical change. The first definition emphasizes the otherness of the crowd; the second finds commonalities across a range of differences. We shift from a model of exclusion to one that seeks to account for discontinuities within a delimited field of possibilities. This semantic shift points to a fundamental revision in the logic according to which bodies are managed. Whereas once the goal was to exclude an unsavory mass, the new logic seeks to apprehend what unites the different constituents of the crowd, to understand them as numbers of individuals who might come to be associated in some other manner. This latter mode of thinking about groups of people as a problem to be studied assumed prominence in the late nineteenth and early twentieth centuries. We might think, here, of Gustave Le Bon's "agglomeration of men," Arthur Schopenhauer's "porcupines," and Siegfried Kracauer's "mass ornament," wherein the transition from mob as unformed mass to population as social problem becomes definitive.[63]

A comparable change in thinking of people, Foucault tells us, occurred in Europe as administrators of various sorts learned to treat mobile populations as both demographic units and citizen-individuals entitled to liberties under the law.[64] The resulting system of governance, according to Foucault, is "frugal."[65] Its techniques proceed according to a logic of "least state," that is, *lais-*

sez-nous faire. Law and freedom become complementary.[66] Foucault identifies these mutually constitutive principles as underpinning modern liberal governance, at the root of which is only an interest in interests.[67] Interest, here, is not the material interest of sovereignty, which invests in things in themselves (e.g., land) for itself. Rather, what constitutes interest for modern liberal governance is more abstract (and less stable or certain) insofar as it deals in processes, actions, resources, and so forth. This new governmental reason is interested in the collective body of individuals. It cares less about obedience than about the health and productivity of a growing, mobile population. The revolutionary "mob" and the population laissez-faire governance would manage are one in the same.

In contrast to a logic that opposes individual liberty and sovereign control, the biopolitical project of risk management is ensured, in part, by the perpetuation of once revolutionary ideals that established an equivalence between the ability to express personal opinion and freedom of choice. Biopower has long counted on the public to mistake an investment in social legibility for political agency. That there is a continuity of administrative endeavor does not mean that nothing has changed. In fact, our present might very well be as different from early modern France as early modern France was from imperial Rome. Nonetheless, it is crucial to acknowledge that those of us who recognize ourselves as concerned, engaged, and informed "private" citizens are, at the same time, behaving in a highly disciplinary fashion.

Effective political action can and does occur by means of mobile devices, as Rheingold rightly points out in his now canonical example of the 2001 ousting of Philippine president Joseph Estrada. More recently, mobile devices abetted the Arab Spring, wherein a wave of civilian uprisings erupted across the Arab world, successfully forcing rulers from power.[68] If we imagine, however, that the "mobile many" texted their way to political intervention through

feats of individual will and deliberation—as neoliberal rhetoric tends to do—we will mistake the reality of contemporary rule. That the Rheingoldian interpretation overlooks the management of the "mob" becomes clear once we shift our attention from the problem of what the mobile many are texting to the problem of their devices being "on" and connected.

The responses of repressive governments to the Arab Spring's social-networking practices prove interesting to consider. Beyond the use of police and military force to suppress demonstrations on site, the Mubarak regime in Egypt, for example, shut down the Internet and blocked cellular service. However, as Thomas Sander, executive director of Harvard's Saguaro Seminar, explains in a January 2011 blogpost titled "Twitter, Facebook and YouTube's Role in Arab Spring (Middle East) Uprisings," such an "unsubtle crackdown" had adverse effects.[69] Not only did it serve to radicalize many rural Egyptians who might not otherwise have been mobilized, but also it imposed great economic costs. The denial of access to social media may, then, have been more helpful to the revolution than was usage of it. Learning from this experience, governments seem to appreciate that media can be more usefully controlled if they are not shut down. In the case of "second-generation revolutions," Sanders continues, "the state is becoming more sophisticated." Instead of full-frontal assaults on Internet and cellular access, and instead of targeting "ring leaders," states are spreading misinformation and slowing the speed of network access. In other words, management of populations—even those engaged in protest—involves managing signals, circulating signs, and the interpretation thereof.

Despite its replication of liberalism's blind spot, Rheingold's forecast nonetheless seems prescient. It would be difficult to dispute that people have become increasingly motivated to abide by the rules of online cooperation, coordination, and sharing that belong to what Henry Jenkins, in 1992, called "participatory

culture."[70] Examples abound, such as text messaging, mobile imaging, and posting announcements via mobile device, which have become staple means of engagement for citizen journalists and flash mobs. Such practices do not deny the fact of national or territorial boundaries. Yet, it is the case that geography and terrestrial distance matter less because networked devices are ready at hand: a variety of content is always facilely and multiply distributable across numbers of users regardless of where in the world they connect. Moreover, that persons worldwide post frequent status updates to their communities of "friends" and "followers" underscores an important shift in how we think about borders and how they demarcate "here" from "there." It seems like frequent updates can be shared (Ito) from anywhere on location in real time. We are connected and on grid: this condition is integral to the smartness that Rheingold attributes to the mobile many.

To conclude I want to recall Clive Thompson's 2002 suggestion that we consider the novelty of hive smarts. Offering an image of social group formation that is "controlled by no single person, yet which moves as if it has a mind of its own," the hive metaphor connotes an automatism absent self-awareness and willfulness.[71] The related metaphors of swarming and pack behavior function similarly. There is certainly an optimism to the images such metaphors conjure: notions of efficiency, natural design and order, resilience, generativity, and so forth. At the same time, these metaphors imply that those persons constitutive of the group qua "smart mob" are not free-thinking individuals in the Cartesian or Enlightenment sense so much as organisms or biological entities akin to bees or ants.[72] Human behavior is obviously more complex—not least because we study ourselves relentlessly. Nonetheless, the "hive mind" metaphor helps us recognize ourselves as creatures of habit—wherein habit is necessarily social—and thought.

In the mobile present, our habits make us findable and manageable as populations. Avisual in nature and intensive but lightweight in its techniques, this management regime is not easily overthrown. It does not look like a Big Brother one may smash, or a despot one may depose. Malleability is its virtue and also its vulnerability. To these ends, I propose we begin think toward habit change.

Conclusion

AN "AESTHETICS OF EXISTENCE,"
OR HABIT-ING DIFFERENTLY

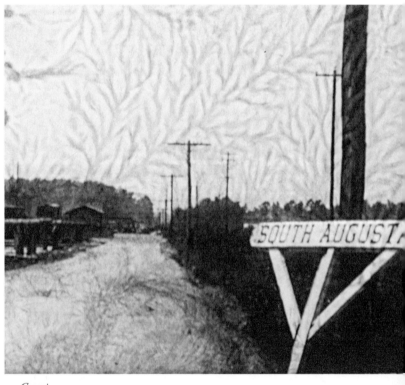

Georgia

In the previous chapters of this book, I describe how various mobilities come to comprise what Michel Foucault calls the milieu. I show how industrial design, in its crafting of mobile handheld devices, creates and normalizes a type of relation between hands and technologies that encourages a spontaneous rather than a deliberate or reflective relation to imaging, texting, and sharing content of all sorts (chapter 2). I explain that semiotically the content rendered by these devices, precisely because it sets in play a full range of interpretive relations, offers itself to the kinds of recombination and leaving of individual traces we associate with self-expression, while encouraging expressions of a nonconfessional sort (chapter 3). And I argue that such practices or habits of expressivity, insofar as they have become routine, extend techniques of tracking more clearly and powerfully than they do techniques of surveillance (chapter 4). This book's digital supplement Augusta App (chapter 1) provides readers with a laboratory whereby they might engage explicitly the kinds of practices I have discussed and thereby test the limits of my argument.

In the pages remaining, I would like to add one final dimension to the project of habit change that I have been advocating through-

out. Foucault's conception of a "politics of ourselves" resonates with the project of habit change and suggestions that it must have an aesthetic dimension. Foucault describes an "aesthetics of existence" as a means by which the disciplinary subject, an individual subject to normalizing self-regulation, might be instantiated as an ethical subject, someone whose practices of living demonstrate an awareness of self that simultaneously facilitates an attunement to the community of which she or he is a part. This idea of aesthetics, then, cannot be understood as a quality distinguishing a specialized art practice but rather refers to a manner of conducting daily life. To be relevant to twenty-first-century life, this project needs to acknowledge the ubiquity of mobile devices, pervasive connectivity, and constant locatability.[1] An "aesthetics of existence" invites us to reimagine the routine practices that, for example, litter social-networking feeds with self-divulging updates. As I have explained, we should understand these reports as involved in efforts to manage us as populations as well as entailing expressive aspects beyond those intended because they involve habits of which we are nonconscious. Physiological and semiological, habit change manifests as "a sort of intellectual sympathy,"[2] or a kind of "mediated immediacy,"[3] wherein intellection produces a quality of feeling that speaks both to Bergsonian becoming (what he also calls "intuition"[4]) and Antonio Damasio's "feeling of knowing [that belongs to core consciousness]." Likewise, it is consonant with Foucault's "aesthetics of existence" and suggests a reframing of the problem of "art" in relation to mobile media.

In a 1983 interview entitled "On the Genealogy of Ethics: An Overview of Work in Progress," Foucault asks, "Couldn't everyone's life become a work of art?"[5] The question may seem unexpected, given its seeming divergence from his previous scholarship on institutions, power, and architectures of truth.[6] But it signals an increasing interest in ethos, or prac-

tice of living, which, as Foucault interprets the term, always pursues a particular kind of knowledge: *tekhnē*, or art, not in the sense of "high art" but in the sense of practical arts, or practice.[7] Ethical living was the subject of a two-part lecture series three years earlier in which Foucault considered a "politics of ourselves," wherein a person's style of living cultivates a creative relation not only to self but also to a population.[8] As Foucault envisions it, a politics of ourselves seeks to stimulate within a community of persons a sensitivity to shared habits as opposed to the shared deliberations emphasized by the liberal democratic notion of citizen-individuals. He imagines a "very strong structure of existence, without any relation with the juridical per se, with an authoritarian system, with a disciplinary system."[9] Ultimately, he suggests how such habits morph in relation to a likewise ever-evolving milieu and according to the development of communal life as a future-oriented project rather than as a Benthamite calculation.

Habit change serves as an alternative to (neo)liberalism's framing of change as a problem of individual and collective choice or will. Instead of conceiving decision making according to that familiar juridico-legal model, it finds responsiveness at the level of the organism as part of processes of cognition that involves our nonconscious proto-selves. While responsiveness is always informed by processes of normation entailed by communal sign usage and a long history of biopolitical regulation, it is socially "binding." Our ways of knowing, which materialize our ways of being, are shared collectively through semiosis.

Foucault's practice of artful living and Charles Sanders Peirce's intellectual sympathy are among a variety of theoretical calls for enacting a more ethical existence. Others would certainly include Gilles Deleuze's "pure immanence," Félix Guattari's "three ecologies," and Jacques Derrida's "hospitality"—all of which reject an end-directed political metanarrative in favor of ethical practice un-

derstood as an open-ended orientation toward others with whom one has social relation.[10] In this vein, contemporary theorists such as Brian Massumi, Elizabeth Grosz, and Mark B. N. Hansen have proposed models that privilege aesthetic experiences as means to live ethically. Massumi's recent writing about "crafted facts of experience" considers how aesthetic events might themselves "speculate on life" in order to "resonate elsewhere, to unpredictable affect and effect [in the persons who experience them]."[11] Grosz's "plane of composition" as the "field" of artistic production continues politics "by other means" such that new futures might be inhabited.[12] Similarly, Hansen's consideration of a haptic aesthetics that disorients one's relation to space asks us to call into question our tendency to abide visual spatial regimes.[13] Aesthetic practice is not, however, the only route to this destination, as Karen Barad demonstrates in turning to the quantum mechanics of Neils Bohr to conceptualize "agential realism" as an ongoing performative "intra-action" among material bodies, which are not discrete entities but phenomena in relation.[14]

Despite their differences, these lines of thought converge in insisting that change worth pursuing will require not new "ideals" but new types of lived relations with a changing milieu. Among those ethicists who draw directly on Foucault to imagine a "more attuned" (Grosz) practice of living, Roberto Esposito has advocated a biopolitics that affirms life. His "affirmative biopolitics" proposes that biopolitical "immunitas," which operates according to a logic of social hygiene and prophylaxis, can be turned into its inverse, "communitas," or collective life.[15] Esposito's model rightly affirms that advocacy of life in our present cannot reject but must seek to modify the regulatory process through which our institutions care for populations. It is a matter not of rejecting normalizing habit but of modifying it. To identify moments that exemplify this kind of change, however, ethicists working in this vein typically turn to di-

sasters or other punctual events rather than less momentous every-day happenings. For instance, John Protevi cites the delayed rescue efforts of post–Hurricane Katrina in 2005 and the 1999 massacre at Columbine High School in elaborating "political affect." Encour-aging us to recognize that we "make our worlds in making sense of situations,"[16] he stresses that "affective cognition," insofar as it shapes how we engage the world, is crucial to imagining how we constitute a body politic. Moreover, it provides a means for thinking toward empathic solidarity.[17] I am in favor of empathic solidarity, but Protevi's emphasis on traumatic events points to a limitation of his theorization of it. Specifically, the emphasis on big institutions and national narratives of crisis neglects the everyday transactions that, Foucault and Peirce agree, must be at the center of any project to inspire more ethical ways of living.

In her discussion of various "tactical media" projects, Rita Raley provides a way to imagine more concrete and specifically mobile conditions for intervention in the status quo. Orchestrated to effect a "shared sensibility," the tactical media projects that she investigates engage in and promote cultural critique by means of a micropolitics that mobilize "the network" to raise awareness.[18] Ev-eryday governance becomes the object of the disruption, interven-tion, and education. Working in and against dominant semiotic re-gimes defining the global present, the media artists and collectives she discusses strive to trouble or disrupt routine processes of global capitalism, border control, and political campaigns. They aim to make visible, intervene in, and educate by co-optation of the very systems they challenge.

To pick one example, Rafael Lozano-Hemmer's *Amodal Suspen-sion* (2003) sought to render palpable what we routinely consider to be transparent: the traffic of information.[19] By offering to a globally dispersed but networked public an experience of the materiality, or in Lozano-Hemmer's words, "density,"

of their communications, the installation drew attention to the pervasive means by which populations are tracked in real time via interpersonal communications. Between 1 November 2003 and 24 November 2003, text messages encoded as flashes of light pulsed through the night skies over the Yamaguchi Center for Arts and Media (YCAM) in Japan. Each sent message hung "suspended" above the center as it "bounced" from one search light to another in the form of a patterned light sequence. No message ceased its circulation until it was "caught" by its designated recipient.[20] Ultimately, the installation provided a striking example of how the "mobile many" (Rheingold) might visually redefine a public landscape.

John Craig Freeman and Mark Skwarek's *Border Memorial: Frontera de los Muertos* (2012) offers another example, one that pursues a more overtly political intervention. An augmented reality (AR) application for mobile smartphones, it uses geocoordinates to locate and give representation to the thousands of migrant workers who have died along the U.S.-Mexico border in attempting to find work. Since the application is on-site and "live" in southern Arizona, individuals with the application downloaded and launched can raise their mobile devices to face the desert landscape. One is able to "visualize the scope of the loss of life" in real time through the camera view as one scans the desert.[21] At each location where a death has been documented, a three-dimensional skeleton effigy appears on-screen as an overlay. In October 2010, the Museum of Modern Art (in New York City) hosted a version of *Border Memorial*, whose skeleton effigies appear in a virtual desert setting overlaying a real-time image of the museum's courtyard. By bringing to visibility the lives that have fallen for the sake of "securing our borders," *Border Memorial* contests U.S. policies that continue to overlook the human costs involved in contemporary labor and security arrangements.[22]

Amodal Suspension, *Border Memorial*, and the many other works that Raley discusses in *Tactical Media* might readily be designated

discrete artworks, even as they leverage a politics that would transgress a more conventionally accepted notion of artwork. This may be a limitation. The "artwork," and perhaps especially the status of a political artwork, delimits in advance a social, conceptual, and often physical space. While they might pursue other pedigrees, new forms of media "artwork" nevertheless bear a filiation to fine art—painting, sculpture, digital art, and performance art—and the histories of disciplined appreciation and engagement they entail.[23] Often, artworks happen or are situated in museums or other sites specifically dedicated to the practice of engaging them. Such aesthetic objects often bear a burden of instantiating separatism and enabling elitism, or at least they invoke a kind of privilege: those who are "in the know"—whether by "right," upbringing, or study. Habits of engaging artworks may very well interfere with the project of living one's life as a work of art, even as they might suggest what it might mean to do so.

Augusta App does not aspire to be identified as artwork. Nor does it avow a specific politics. Not installation art, activist inter-vention, or locative artwork, it is more aptly described as an experiment, that is, a laboratory for exploring a potentially viable approach to an aesthetic existence that is not principally an effort at art as such. As I explain in chapter 1, Augusta App attempts to cast the question of technologies in terms that suggest their role in larger biopolitical techniques of governance that benefit from routine behaviors. In the process, it hopes to elicit awareness of our inclination to announce location and thereby render ourselves findable. Through such awareness we might begin to see Augusta everywhere we look. Not only would this change what Augusta means, but also it might very well signal a shift in our manner of inhabiting our mobile present and contending with, even as we perpetuate, innumerable streams of data. It would constitute a habit-ing differently and demonstrate both that this is possible and a means by which it occurs.

"Augusta" Revisited

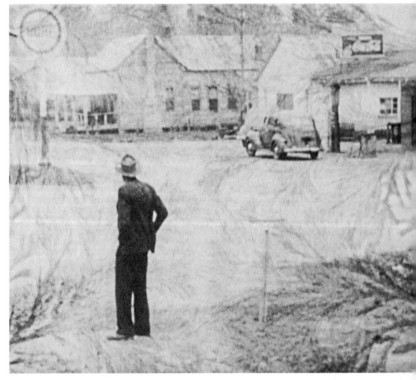

Mississippi

If in reaching a conclusion, one imagines having arrived at an end, "Augusta" demonstrates otherwise. In July 2012, the University of South Carolina's Moving Image Research Collections found a second Scott Nixon "Augusta" reel. While in keeping with the first, this second reel is less finished—most certainly a rough cut. As with the first reel, title cards name locations as Augusta, but in very few instances do images of the places so named appear in subsequent sequences. There are five shots in which a typed (nonadhesive paper) label overlays and names a photographed place. These include one that names a place other than Augusta: "Old Homes" in Washington, Georgia. In addition, two Augustas appear on-screen that do not figure in the first reel. In this second reel, we are presented with an Augusta in Wisconsin, which features Lake Eau Claire, its fountain, and its waterfowl. We also see an aeronautical facility whose signage reads, "Augusta Aviation," at which Nixon (presumably) and his camera land. Sixty-three shots, including the leader sequences that begin and conclude the reel, comprise the film.

The Augustas and its confrere share themes and a method of presentation. They collaborate to render visible mobilities of all sorts. The two reels feature technologies of and infrastructure for facili-

tating transportation: cars, trains, river boats, pedestrians, a plane, roadways and highways, intersections, train stations, hotels, and gas stations. They picture communications systems: post offices and telephone lines. They frame platforms for the transmission and dissemination of information: train schedules, maps, road signs, broadcast antennae, churches, schools, and academies. They evidence the workings of commerce: billboard advertisements, industrial facilities, department stores, mercantiles, and groceries. And they show natural landscapes reorganized into natural resources for the maintenance of a midcentury American milieu: farmlands, water towers, wind mills, silos, manicured flora with their eye-catching "wildlife," rivers, and a fountain. In the process, both reels offer an opportunity for us to reflect on the fact that the viability of our present depends upon the existence and maintenance of this astonishing array of mobilities.

At the same time, both reels comment on our efforts to manage such mobilities. Labels, photographs, diagrams, charts, schedules, maps, ledgers, and the like stabilize and distill into legible units our interactions with and understandings of the mobilities that constitute our world. The two reels draw attention to various practices that accomplish this feat. They make explicit our often unremarked and unnoticed habits of naming and, subsequently, finding. We document, we keep track, we take account, and we follow. We record, we list, we enumerate, we quantify, and we calculate. And we do all of these activities routinely because it makes sense for us—whether or not we understand why. We endeavor to establish nodes of connection and contexts for making meaning and count on this to become a habitual, nonconscious activity. This is what Nixon's Augustas and the sundry Augustas that have been accruing since the launch of Augusta App illustrate. Even as we may not fully grasp the underlying processes that make connection and meaning possible, Augusta points to the fact that some logic—be

it a principle of editing or a computational heuristic—organizes, makes accessible, and renders legible things of all sorts.

From Augusta to Augusta—that is, from *The Augustas* to Nixon's second reel of Augustas to Augusta App—we find that "where-ness," while trackable, is also a state of mind; that while a name or label may refer to a place, it does not ensure locatability; and that our investments in technologies of mapping and navigation underscore the fact of our being always on the move. Moreover, we come to realize the possibility for new habits, new routes, new combinations, and new ways to be in relation. That said, in the spirit of traveling salesman Scott Nixon and his *The Augustas* I conclude:

" . . . AND SO OUR TOUR ENDS."

NOTES

KEYWORD

1. John R. Searle offers a classic formulation of this problem in "Proper Names." Proper names are descriptive pointers, or "pegs on which to hang descriptions" (172), they do not constitute the identities of the objects to which they refer. John R. Searle, "Proper Names," *Mind* 67, no. 266 (1958): 166–73.

2. Piero G. Delprete, "Revision and Typification of Brazilian Augusta (Rubiacae, Rondeletieae), with Ecological Observations on the Riverine Vegetation of the Cerrado and Atlantic Forests," *Brittonia* 49, no. 4 (1997): 487.

3. Ibid., 488.

4. Ibid., 487.

5. Augusta, Georgia, from whence Scott Nixon hailed, likewise acquired its appellation in honor of a royal personage: Princess Augusta of Saxe-Gotha, Princess of Wales. Augusta, Georgia, was established and named in 1735 by James Oglethorpe, who had tasked Noble Jones with establishing a settlement at the head of a navigable part of the Savannah River.

INTRODUCTION

1. Initially, we understood Scott Nixon to be a traveling insurance salesman. But on a visit to Augusta, Georgia, in May 2013, Cobbs Nixon, Nixon's son,

corrected us: Scott Nixon was an independent insurance agent. He presented us with examples of stationary, cards, blotters, and other materials, all bearing the imprint "Scott Nixon—Independent Insurance Agent." Cobbs Nixon explained that his father did travel extensively for work (e.g., conventions, professional meetings, etc.). And he made it a point to travel through Augustas when he was on the road—always with one or more cameras in tow. Then Cobbs Nixon declared that if his father "sold anything, it was Augusta!" Extremely proud of his hometown, Nixon promoted it wherever he went.

2. Shooting on 16 mm and Super 8, Nixon amassed thousands of feet (approximately 26,400 feet of 16 mm and 10,000 feet of Super 8) of film documenting five decades of travel across the United States. Originally donated to the Augusta Museum and the Augusta chapter of the National Railway Historical Society (both of which are in the state of Georgia in the United States), these home movies were gifted to the University of South Carolina (USC East) in 2000 and currently reside in the Moving Image Research Collections there.

I thank Greg Wilsbacher, curator for the Fox Movietone News Collection at the Moving Image Research Collections (MIRC), who took the time (academic year 2007–2008) to show me Nixon's *The Augustas* one frame at a time via magnifying loupe. My continued thanks to Moving Image Research Collections, whose initial interim director, Mark Garrett Cooper, and current interim director, Heather Heckman, have supported my ongoing use of the film. I also thank Dan Streible (Orphans Film Symposium/NYU, 2010), Andrew Lampert (Orphans Redux/Anthology Film Archive, NY, 2011), UCLA Film and Television Archives (Celebrating Orphan Films, 2011), and Joan Hawkins (University of Indiana and IU Cinema/Bloomington, 2011) for ensuring *The Augustas'* sustained visibility. Finally, I thank Dan Streible and Simon Tarr (UVA) who advocated for *The Augustas* to be included in the U.S. National Film Registry (2012). *The Augustas* was named to the National Film Registry by the Librarian of Congress on 18 December 2012.

3. The problem did not acquire its official name until 1949—the year of the Pulitzer Prize–winning and Tony Award–winning play *Death of a Salesman* (Arthur Miller)—when it became a listed RAND Corporation prizewinning challenge. However, William J. Cook indicates that Harvard mathematician Hassler Whitney posed the basic problem in 1934. According to Cook, in a seminar talk delivered at Princeton, Whitney referred to the "48-states problem." In papers predating this public pronouncement, he had apparently described the basic principle in geographical terms: nodes (i.e., points) became countries, the

path connecting them was "travel," and a complete circuit through a designated series of sites was a "trip." Of course, as Cook notes, this kind of problem has confronted people for centuries. And mathematical antecedents were introduced in both the eighteenth and nineteenth centuries—most notably Eulerian paths or cycles (Swiss mathematician Leonhard Euler) and Hamiltonian circuits (Irish mathematician Sir William Rowan Hamilton). Likewise, later mathematicians, for example, Karl Menger of Vienna who worked on what he called the "messenger problem," had begun pursuing TSP-related problems in other parts of the world. The TSP still stands among the "impossible" problems in computational mathematics. See William J. Cook, *In Pursuit of the Traveling Salesman: Mathematics at the Limits of Computation* (Princeton, NJ: Princeton University Press, 2012).

4. According to the *OED* online, the phrase "travelling salesman" first appeared in 1885 in an article in the *South Florida Sentinel. Oxford English Dictionary*, s.vv. "travelling salesman," accessed 4 June 2013, http://www.oed.com.

5. Cook, *In Pursuit of the Traveling Salesman*, 19.

6. According to Cook, this was not uncommon. And salesmen frequently consulted travelers' guidebooks, while the itineraries devised in the central office might take advantage of optimization strategies such as pushpins, string, and a wall map.

7. Cook, *In Pursuit of the Traveling Salesman*, 21.

8. The TSP recently figured centrally in an "intellectual thriller" of the same name: *Travelling Salesman* (Timothy Lanzone, 2012). The basic story line posits that four mathematicians together arrive at a solution for the "impossible" problem and are approached by the U.S. Department of Defense. In a series of intertitles punctuating the trailer to the feature, we learn what possibilities might be unlocked were the TSP solved: TIME—SIMPLIFIED; POWER—SIMPLIFIED; CONTROL—SIMPLIFIED; TECHNOLOGY—POLITICS—MONEY—SIMPLIFIED; ENERGY—SCIENCE—DATA; DEATH—DESTRUCTION—ANNIHILATION—EVERYTHING—SIMPLIFIED. See the trailer at http://www.travellingsalesmanmovie.com.

9. My thanks to Duncan Buell, professor of computer science and engineering, whose (CSCE 146) course in spring 2011 introduced me to the Traveling Salesman Problem and whose continued conversations about computational mathematics and programming have been essential to this project. See Duncan Buell, *Algorithms and Data Structures Using Java* (Boston: Jones and Bartlett, 2013).

10. I will explain this with the concrete example of Nixon's Augustas in chapter 1.

11. John Urry, *Sociology beyond Societies: Mobilities of the 21st Century* (London: Routledge, 2000).

12. Michel Foucault, *Security, Territory, Population: Lectures at the Collège de France, 1977–1978*, trans. Graham Burchell (2004; New York: Palgrave MacMillan, 2007).

13. Mimi Sheller, "Mobility," *Sociopedia.isa* (2011), http://www.sagepub.net.

14. Ibid., 4.

15. Ibid.

16. Tim Cresswell, *On the Move: Mobility in the Modern Western World* (New York: Routledge, 2006), 16.

17. Sheller, "Mobility," 3.

18. Cresswell cites Schivelbusch's observations regarding the train's impact on notions of time and place. For one, the development of train travel altered people's experience of time and place. At the same time, they came to understand themselves as passengers. Cresswell, *On the Move*, 5–6.

19. Eric Gordon and Adriana de Souza e Silva, *Net Locality: Why Location Matters in a Networked World* (Chichester, UK: Wiley-Blackwell, 2011), 2.

20. Paul Dourish and Genevieve Bell, *Divining a Digital Future: Mess and Mythology in Ubiquitous Computing* (Cambridge, MA: MIT Press, 2011), 120.

21. Jason Farman, *Mobile Interface Theory: Embodied Space and Locative Media* (New York: Routledge, 2012), 3.

22. While Goggin addresses cultural impacts broadly speaking, Koskinen focuses more specifically on a Finnish context. See Gerard Goggin, *Cell Phone Culture: Mobile Technology in Everyday Life* (London: Routledge, 2006); Gerard Goggin, *Global Mobile Media* (Abingdon, UK: Routledge, 2011); and Ilpo Kalevi Koskinen, *Mobile Multimedia in Action* (New Brunswick, NJ: Transaction Publishers, 2007).

23. Mizuko Ito, Daisuke Okabe, and Misa Matsuda, eds., *Personal, Portable, Pedestrian: Mobile Phones in Japanese Life* (Cambridge, MA: MIT Press, 2005).

24. For example, coeditors Adriana de Souza e Silva and Daniel M. Sutko compiled a series of essays that consider how location-based, hybrid reality applications (re)shape public space and the city. Adriana de Souza e Silva and Daniel M. Sutko, eds., *Digital Cityscapes: Merging Digital and Urban Playspaces*, Digital Formations (New York: Peter Lang, 2009). As of spring 2013, two such collections have directly taken up the iPhone as an object of study. See Larissa Hjorth, Jean Burgess, and Ingrid Richardson, *Studying Mobile Media: Cultural Technologies, Mobile Communication, and the iPhone*, Routledge Research in

Cultural and Media Studies (New York: Routledge, 2012); and Pelle Snickars and Patrick Vonderau, eds., *Moving Data: The iPhone and the Future of Media* (New York: Columbia University Press, 2012).

25. Farman, *Mobile Interface Theory*.

26. "Dispositif" literally means "apparatus" or "device." Foucault emphasized that apparatuses and devices are not simply technologies (in a mechanical sense); rather, they are arrangements—or systems of relation—that afford and constrain ways of thinking, speaking, and behaving. In other words, not only is the mobile microscreen a technological device, but also it participates in shaping how we establish codes of conduct and relation and, therefore, make meaning in the world. For a detailed discussion of "dispositif," see Frank Kessler, "Notes on *Dispositif*" (unpublished paper, May 2006), http://www.hum.uu.nl /medewerkers/f.e.kessler/Dispositif%20Notes11-2007.pdf.

27. Nanna Verhoeff, *Mobile Screens: The Visual Regime of Navigation*, Mediamatters (Amsterdam: Amsterdam University Press, 2012).

28. Ibid., 137–38.

29. Wendy Chun, *Control and Freedom: Power and Paranoia in the Age of Fiber Optics* (Cambridge, MA: MIT Press, 2006); Alexander R. Galloway, *Protocol: How Control Exists after Decentralization*, Leonardo Book Series (Cambridge, MA: MIT Press, 2004); Alexander R. Galloway and Eugene Thacker, *The Exploit: A Theory of Networks*, Electronic Mediations 21 (Minneapolis: University of Minnesota Press, 2007); Richard A. Grusin, *Premediation: Affect and Mediality after 9/11* (Basingstoke, UK: Palgrave Macmillan, 2010); Lisa Parks, *Cultures in Orbit: Satellites and the Televisual*, Console-Ing Passions (Durham, NC: Duke University Press, 2005); Lisa Parks, "Zeroing In: Overhead Imagery, Infrastructure Ruins, and Datalands in Afghanistan and Iraq," in *Communication Matters: Materialist Approaches to Media, Mobility and Networks*, ed. Jeremy Packer and Stephen B. Crofts Wiley, 78–92, Shaping Inquiry in Culture, Communication and Media Studies (London: Routledge, 2012); Eugene Thacker, *Biomedia*, Electronic Mediations (Minneapolis: University of Minnesota Press, 2004); and Eugene Thacker, "Nomos, Nosos and Bios," *Culture Machine* 7 (2005), http://www.culturemachine.net.

30. Thacker, "Nomos, Nosos and Bios."

31. In addition to Mimi Sheller and John Urry (already mentioned), see Monika Büscher, John Urry, and Katian Witchger, *Mobile Methods* (Abingdon, UK: Routledge, 2011); Anthony Elliott and John Urry, *Mobile Lives* (London: Routledge, 2010); John Urry, *Mobilities* (Cambridge, UK: Polity, 2007); Mark

Simpson, *Trafficking Subjects: The Politics of Mobility in Nineteenth-Century America* (Minneapolis: University of Minneapolis Press, 2005); Caren Kaplan, "Transporting the Subject: Technologies of Mobility and Location in the Era of Globalization," *PMLA* 117, no. 1 (2002): 32–42; and Cresswell, *On the Move.*

32. Antonio R. Damasio, *Self Comes to Mind: Constructing the Conscious Brain* (New York: Pantheon, 2010), 269.

33. Ibid., 270.

34. Ibid., 275.

35. Ibid., 272.

36. Ibid., 270.

37. Ibid., 274.

38. Ibid.

39. Ibid., 270.

40. Ibid., 275.

41. Ibid., 281.

42. Rita Raley, *Tactical Media*, Electronic Mediations (Minneapolis: University of Minnesota Press, 2009), 6.

43. Ibid., 7.

CHAPTER ONE. MAKING TRACKS

At the time of writing, the discussion of Augusta App that I offer in this chapter is predominately conceptual. While my design team and I are in frequent conversation about the kinds of functionality these additional features introduce, and what they think they can deliver, Augusta App as a discrete downloadable app is likely to differ from my/our original conceptions.

I thank my design team who developed Augusta App: Dr. Duncan Buell, professor of computer science and engineering; designer and media artist Simon Tarr, associate professor of media arts; and Jeremy Greenberger, computer science honors college student. More recently, Cecil Decker, media artist, has joined the team.

This project received funding from a University of South Carolina Provost's Humanities Grant (2012).

1. Denso Wave, "QR Code.Com," accessed 30 March 2013, http://www.qrcode.com.

2. Fundamental to Augusta App as a theoretical experiment is the fact that

both LSI and SVD can be modeled according to the heuristic of the Traveling Salesman Problem (TSP). This association will become clearer in subsequent sections of this chapter.

3. A 1.0 version of Augusta App was available for download from the App Store prior to the book's release in print. The 1.0 version of the application featured the Augusta Map functionality only, which tracks participants in relation to computationally determined TSP tours of Scott Nixon's *The Augustas*. The description that follows in the body of the text details the 2.0 version of the app, which is activated once a reader has scanned the QR code at the head of this chapter and subsequently, downloaded the app, registered, and signed on to be locatable.

4. Registering involves providing a username, inputting a password (and confirming it), supplying a zip code, and indicating one's preferred mode of transportation and favorite mapping technology or platform. The latter three prompts point to Nixon's penchant for documenting places bearing the name of his hometown (or place of origin), transportation networks, and maps.

5. Turning the device's tracking function off limits that participant's access to ever-accruing Augusta-related data.

6. Of course, in the case of Augusta App, the population is a select population—a self-selected population—and participants may or may not opt in.

7. The design choice for this interface is informed by my first encounter with independent insurance agent Scott Nixon's compilation film *The Augustas*, which I experienced frame by frame, using a magnifying loupe on a light table at what is now called the Moving Image Research Collections (MIRC) at the University of South Carolina (USC East). (The Newsfilm Library became the Moving Image Research Collections in 2009.)

8. Augusta Feed allows participants to contribute assets. One can upload images, tag objects with labels and descriptors, and add links to Augusta-related news, as well as establish Augusta-oriented feeds, and so forth.

9. Augusta App 1.0 allows participants to click on Augustas and access one or more image related to that Augusta; it does not "push" these images to their devices. Also, the images that populate this version are images taken through a magnifying loupe, as I first encountered Nixon's film. As such, not all of Nixon's Augustas are represented. Attribution for the images belongs to Greg Wilsbacher, curator of the Fox Movietone News Collection at USC's Moving Image Research Collections.

10. The cache of keywords that classifies Augusta is dynamically shifting. While it initially processes the text of the book proper, active participants

who contribute to the Augusta Feed will provide additional content that will be used by the classification algorithms to describe Augusta. The classification process is one of collocation, whereby like and seemingly unlike words are deemed proximate—or "close enough"—to be ranked similarly. In this particular instance, participants' interaction with any or several keywords computationally reconfigures how these words are statistically associated to— that is, "similar" or proximate to—each other. At this level of interactivity, data intentionally contributed by individual participants as well as GPS coordinates automatically harvested from their devices will have become increasingly integral to the computational processes that constitute the application as such. Their engagement with Augusta's different features implicates them in a larger—and more global—network of data regarding variously identified and proliferating instances of Augusta.

11. Those who download version 1.0 will have already had an effect on the application's database of content. Their various movements from place to place will register, even if only slightly, a change in how "Augusta" is interpreted by the algorithm.

12. Here, I am careful not to assume that any person who has this book in hand has opted to join the Augusta community and is participating in the experiment.

13. "Digital supplement" is a generic term for what might be called an "evocative knowledge object." As Anne Balsamo describes, such objects are objects "to think with" (197); they are "speculative probes" (19). They intend to evoke knowledge by means of physical interaction. In the process, they interrogate conventional thinking and invite more nuanced and critical understanding of sociocultural practices. More recently, my colleague and collaborator, Duncan Buell, and I have begun to refer to such "objects" as "critical interactives." Informed by Mary Flanagan's scholarship on "critical play" and Ian Bogost's work on "procedural rhetoric," we strive to develop applications that engage participants in ludic interaction with socially and politically sensitive subject matter. Like Balsamo, we endeavor to design and build technological interfaces to impart knowledge, build awareness, provoke thought, and raise questions. In a distantly related way, Nanna Verhoeff takes up mobile devices (e.g., Nintendo DS, smartphones, and iPads) as objects for theoretical inquiry. She uses the term "theoretical consoles." See Anne Balsamo, *Designing Culture: The Technological Imagination at Work* (Durham, NC: Duke University Press, 2011); Mary Flanagan, *Critical Play: Radical Game Design* (Cambridge, MA: MIT Press, 2009); Ian Bogost, *Persuasive Games: The Expressive Power of Videogames*

(Cambridge, MA: MIT Press, 2007); Duncan A. Buell and Heidi Rae Cooley, "Critical Interactives: Improving Public Understanding of Institutional Policy," *Bulletin of Science, Technology, and Society* 32, no. 6 (December 2012): 489–96; Verhoeff, *Mobile Screens.*

14. Manuel Lima, *Visual Complexity: Mapping Patterns of Information* (New York: Princeton Architectural Press, 2011).

15. Here, I am citing Ian Bogost who defines "procedural rhetoric" as "a technique for making arguments with computational systems and for unpacking computational arguments others have created" (*Persuasive Games*, 3). It establishes conditions of possibility for interacting with a system. In the case of Augusta App, the logic of biopolitical governance informs the process whereby reader participants might recognize how they are routinely—and frequently unwittingly—located, tracked, and made legible.

16. Astrid Mager, "Algorithmic Ideology," *Information, Communication, and Society* 15, no. 5 (2012): 772.

17. Ibid., 775.

18. Christian Fuchs, "A Contribution to the Critique of the Political Economy of Google," *Fast Capitalism* 8 (2011), http://www.fastcapitalism.com.

19. Ibid.

20. Mager, "Algorithmic Ideology," 779.

21. Using Nixon's initial filmic itinerary, Augusta App proceeds to map the various possible tours that a participant attempting to visit (only once) each Augusta that Nixon filmed might pursue. Nixon's film presents us with twenty-three discrete cities called Augusta, beginning with the city in Georgia. This means there are $(23 - 1)!/2$ distinct tours of the twenty-three cities. Beginning with Augusta, Georgia, we have twenty-two choices of our next city in the tour, then twenty-one choices of the city beyond that, and so forth. Each choice is independent, so there are "twenty-two factorial" or $22 \times 21 \times 20 \times \ldots \times 3 \times 2 \times 1$ possible tours from Augusta, Georgia, traversing the other twenty-two Augustas, and returning to Augusta, Georgia. If we consider a tour in "the forward direction" (GA, KS, NJ . . . LA, MT, GA in Nixon's actual tour) to be indistinguishable from a tour in "the backward direction" (GA, MT, LA . . . NJ, KS, GA), then the number of possible tours is divided by two. Ultimately, we find that $22!/2$ equals 562,000,363,888,803,840,000 possible tours that Nixon's film offers.

22. Cook, *In Pursuit of the Traveling Salesman.*

23. In contrast, we might recall the preconstituted categories such as those at

work in the Dewey Decimal Classification (DDC) system, wherein taxonomy precedes sorting. The system organizes knowledge into ten predetermined classes: generalities, philosophy and psychology, religion, social sciences, language, natural sciences and mathematics, technology (applied sciences), the arts, literature and rhetoric, and geography and history. All possible texts must fit into one of the specified ten categories. Moreover, DDC organizes top down, assigning each document or book a "unique reference in an immutable hierarchical structure" (Lima, *Visual Complexity*, 62). Other approaches, like those based on faceted classification methods, such as Library of Congress MARC records, begin with a preexisting tree arrangement that establishes fixed positions according to clearly defined properties (i.e., search fields) of texts. Here, we might think of the conventions of bibliographic citation: author, title, year, and so forth. Such a system, while streamlining the general navigation of a particular set of materials, is not well suited to real-time retrieval of information from ever-proliferating streams of data. See Lima, *Visual Complexity*, 61–64.

24. Casey Boyle provides an account of "versioning" in a dissertation about composition in the age of wikis, and so on. Casey Boyle, "Abundant Rhetoric: Memory, Media, and the Multiplicity of Composition" (PhD diss., University of South Carolina, 2011).

25. The TSP can lead to improved heuristics for solutions involving information retrieval and data mining. These two problem domains differ in that information retrieval searches collections of data for information according to a specified need, whereas data mining seeks out new patterns in data sets for the purposes of discovering new connections.

26. Michael J. A. Berry and Gordon Linoff, *Data Mining Techniques: For Marketing, Sales, and Customer Relationship Management*, 3rd ed. (Indianapolis: Wiley, 2011); Michael J. Berry, *Science and Technology in the USSR*, Longman Guide to World Science and Technology (Burnt Mill, UK: Longman, 1988).

27. Of course, "mathematically sound" does not necessarily mean "better." It merely promises a more efficient—in time (for the user) and money (for any number of parties, including the search engine, e.g., Google)—return of search results. What might get sacrificed is specificity of proper nouns (e.g., names of persons or places). But also, an algorithm is hard pressed to recognize that "Heidi Rae Cooley, 1970–" and "Heidi R. Cooley, 1970–" and "Heidi Cooley, 1970–" name the same person. And for repositories that specialize in visual materials, such as the Moving Image Research Collections at University South Carolina where the Nixon collection resides, an algorithm will not find much without the labor of the human indexers who supply machine-interpretable index terms.

28. Angular measures of distance are distinct from Euclidean measures. Any Euclidean measure of distance will represent proximity between two points (e.g., cities) as a matter of the line length adjoining the two points as drawn on a two-dimensional map. (Here, we might invoke the idiom ". . . as the crow flies.") A vector-space model, on the other hand, measures the distance between two points according to the number of degrees of the angle that forms as the two points' individual vectors depart from (x_i, y_l). See Cook, *In Pursuit of the Traveling Salesman*, 56.

29. In the case of Google, though, the determination of relevant returns for a query involves an intricate ranking process. As Amy N. Langville and C. D. Meyer explain in *Google's PageRank and Beyond: The Science of Search Engine Rankings*, any one web page's relevance is determined by combining two scores: a content score, which matches data to a template of what ought to be important, and a popularity score, which depends on the data itself. Content scores are derived from the content index, which houses textual information (e.g., keywords, title, and anchor text) for each web page. This information is stored "in a compressed form using an inverted file structure." A kind of "quick lookup table," the inverted file structure registers each term along with a list of numbers. An initial number refers to that particular term's document identifiers (web page locations), while a series of additional numbers represent an n-dimensional vector that indicates, for example, whether or not the term appears in the title, whether or not it is included in the description metatag, and the number of times it appears in a page (see locations 36, 628, 645, and 717). These numbers are computed to determine a page's content score. Amy N. Langville and C. D. Meyer, *Google's Pagerank and Beyond: The Science of Search Engine Rankings* (Princeton, NJ: Princeton University Press, 2006), Kindle edition.

30. Here, Google is metonymic for a kind of process attributable to search engine culture or "search engine society." What I want to underscore is that user habits change according to the user's understanding of what Google is actually doing. As one learns how Google works, one's use of Google changes. See Alexander M. Campbell Halavais, *Search Engine Society*, Digital Media and Society Series (Cambridge, UK: Polity, 2009).

31. Langville and Meyer, *Google's Pagerank and Beyond*, location 697.

32. Langville and Meyer, *Google's Pagerank and Beyond*, location 709. Unlike the content score whose point of departure at the time of query is the user's search terms, the popularity score is query independent. It provides a "global measure" of a page's popularity with respect to the Google search engine's index of pages (location 741). Calculated by means of the PageRank link analysis

model developed in 1998 by Sergey Brin and Larry Page, the popularity score "harnesses the information in the immense graph created by the Web's hyperlink structure" (location 766). It delivers a ranking for each page based on the number of pages linked to it. As Langville and Meyer explain, these links are analogous to recommendations or endorsements. Each link pointing to a page is weighted according to the status of the linking page. Status is determined by considering the link against the total number of other links made by that page. Thus, a page that links indiscriminately to a variety of other pages earns a lesser status than a page that links to pages in a more selective fashion. As users surf from page to page by means of "outlinks," the Google code tracking their searches computes the duration of their stay—and tracks the number of their returns. Likewise, it tracks when users opt to input a URL and "teleport" (locations 1064 and 1048, respectively) directly to a new page, and it registers when a user enters a dangling node—that is, nodes without links, such as pdfs, image files, data tables, and so forth (location 1053). Google's PageRank vector assesses, in combination, hyperlinking (by means of outlinks), teleportation, and the inconveniences of dangling nodes. According to Langville and Meyer, the PageRank vector delivers consistently reliable measures of web page status across the Google search engine index. Note: Google updates its PageRank vector approximately once a month, whereas content scores are updated more frequently.

33. To identify keywords in the first place, Augusta Ledger employs an LSI technique—singular value decomposition (SVD)—that defines and enables "finding" in our present. It identifies the quantitatively most significant words in the text by first eliminating those words the algorithm is programmed to deem irrelevant. Words that might fall into this category would likely include articles and pronouns, as well as words that make very few appearances in the text. Additionally, as Langville and Meyer explain, LSI "can access the hidden semantic structure in a document collection" because LSI-based algorithms, such as SVD, parse a text for synonymity (i.e., similarity of words) and proximity (i.e., number of pages separating instances of keywords). For example, whereas a query for "car" might return "automobile" (Langville and Meyer's example), one searching for "Hardy Phlox" might very well return "Augusta."

34. Karl-Otto Apel, *Charles S. Peirce: From Pragmatism to Pragmaticism*, trans. John Michale Krois (New York: Humanity Books, 1995), 91.

35. Charles S. Peirce, *Collected Papers of Charles Sanders Peirce*, ed. Charles Hartshorne and Paul Weiss, vol. 5 (Cambridge, MA: Harvard University Press, 1934), 31, 319 (5.467, 5.482).

36. Ibid., 280 (5.419).

37. Apel, *Charles S. Peirce*, 89.

38. The term "autocatalytic" comes to mind here. The term refers to chemical reactions that, once started with an outside stimulus, generate internally that which keeps them going. In software and things like social networking, once you get enough market share, you don't have to continue the expansion because the user base will do that expansion for you. Everyone else has to join in order to be part of the club. Cf. "going viral" or "generating the buzz." I thank Duncan Buell for this connection.

39. Peirce, *Collected Papers*, 331 (5.481).

40. Ibid., 86 (5.136).

41. Ibid. (emphasis in original).

42. Ibid., 327 (5.477).

43. Ibid., 281 (5.421).

44. Ibid.

45. By his 1980s lectures at the Collège de France, Foucault speaks of the places of governance in terms of "milieu." A milieu is a "medium" of action and circulation that inspires management. Measures defining probabilities, acceptabilities, and optimal outcomes regarding a milieu call for continuous and complex mechanisms of tracking and assessment. Those who populate a given milieu become one with this process: in the aggregate, individual habits become (normal) tendencies particular to a population.

46. This is because the TSP-oriented processes that route our calls, map our trips, and deliver search results work in spatial terms. Whether our routine uses of technology have to do with geographical relationships or semantic proximity, the algorithms that process their outputs conceive their data sets in terms of spatial patterns. Those patterns measure habits that might themselves be spatial, for example, involving people's movements.

47. Henri Lefebvre, *The Urban Revolution*, trans. Robert Bononno (Minneapolis: University of Minnesota Press, 2003); Guy Debord, *Society of the Spectacle* (Detroit: Black & Red, 1970); Michel de Certeau, *The Practice of Everyday Life* (Berkeley: University of California Press, 1984); E. A. Grosz, *Chaos, Territory, Art: Deleuze and the Framing of the Earth*, Wellek Library Lectures in Critical Theory (New York: Columbia University Press, 2008); Gilles Deleuze and Anne Boyman, *Pure Immanence: Essays on a Life* (New York: Zone Books, 2001); Félix Guattari, *The Three Ecologies* (London: Athlone, 2000); Howard Rheingold, *Smart Mobs: The Next Social Revolution* (Cambridge, MA: Perseus, 2002); Brian Massumi, *Semblance and Event: Activist Philosophy and the Occurrent Arts*, Technologies of Lived Abstraction (Cambridge, MA: MIT Press,

2011); and John Protevi, *Political Affect: Connecting the Social and the Somatic*, Posthumanities (Minneapolis: University of Minnesota Press, 2009).

48. Lefebvre, *Urban Revolution*.

49. Ibid., 73.

50. Ibid., 18, 115.

51. We might recall the uses to which the Situationists (with whom Lefebvre had some affiliation) put urban space. Drawing on Dada and surrealism, as Mary Flanagan explains in *Critical Play*, the Situationists pursued "a radical redefinition of everyday experience" (195). They staged "situations" and conducted *dérives*. Such happenings reinterpreted public space. More specifically, they sought to intervene in routine traversals of the city. They were political statements about the banalities—that is, entrenched routines—of everyday experience.

52. Bill Wasik, "What Is Big Think?" Big Think, 2 July 2009, http://bigthink .com.

53. Here, we might recall the ways in which the media, in the initial months of 2011, represented the series of uprisings in the Middle East, beginning in Egypt, called the Arab Spring.

54. Governments have traditionally been situated in space, because the governed have been situated in space. What is new, and what governments are struggling with, is trying to govern things in the virtual domain of cyberspace, a site that doesn't match up to physical space. Here, we might recall Wikileaks, or we might think of the policy changes going on with respect to cyberwar and cyberterrorism. We know, for example, that if we target the Iranian nuclear program, we are in fact targeting Iran, but terrorist organizations conducting cyberattacks from multiple locations look more like Wikileaks storing data at multiple locations with anonymizing protocols. As a consequence, it's more difficult to determine a strategy of response to a cyberattack that avoids collateral damage to "noncombatants." Moreover, there's the question of jurisdiction, which in the United States is still being worked out. Take pornography, which can be dealt with by "local community standards," but also it becomes conceivable that porn delivered from Seattle to Miami might be prosecuted in Memphis. I thank Mark Garrett Cooper for these insights.

CHAPTER TWO. IN HAND AND ON THE GO

1. "Kodak," Collecting Movie Cameras, accessed 14 March 2013, http:// www.movie-camera.it/kodake.html.

2. I thank Greg Wilsbacher, the Fox Movietone News Collection curator at the University of South Carolina's Moving Image Research Collections, for his analysis of the Nixon Augustas reel.

3. While the keynote address is no longer available for viewing at Apple.com, a fairly complete transcript is available for review at Engadget. See Ryan Block, "Live from Macworld 2007: Steve Jobs Keynote," Engadget, 9 January 2007, http://www.engadget.com.

4. Paul Kunkel, *AppleDesign: The Work of the Apple Industrial Design Group* (New York: Graphis, 1997), 13.

5. Ibid.

6. Ibid.

7. Ibid.

8. Ibid.

9. Ibid., 231 (my emphasis). In this chapter, I will argue for a cognitive-perceptual understanding of our relations with handheld devices such as iPhone. Lev Manovich, on the other hand, distinguishes between the cognitive and the senses. See Lev Manovich, "The Back of Our Devices Looks Better Than the Front of Anyone Else's: On Apple and Interface Design," in Snickars and Vonderau, *Moving Data*, 281.

10. Kunkel, *AppleDesign*, 22.

11. Diaz lists Rams's ten principles of good design: Good design is innovative. Good design makes a product useful. Good design is aesthetic. Good design helps us to understand a product. Good design is unobtrusive. Good design is honest. Good design is durable. Good design is consequent to the last detail. Good design is concerned with the environment. And good design is as little design as possible. See Jesus Diaz, "1960s Braun Products Hold the Secrets to Apple's Future," *Gizmodo: The Gadget Blog*, 14 January 14, http://gizmodo.com.

12. Kunkel, *AppleDesign*, 280.

13. Donald A. Norman, *The Design of Everyday Things*, (New York: Doubleday, 1990), 4.

14. Ellen Lupton and Julia Lupton, *Design Your Life: The Pleasures and Perils of Everyday Things* (New York: St. Martin's Griffin, 2009), 73.

15. Victor J. Papanek, *Design for the Real World: Human Ecology and Social Change* (New York: Bantam, 1973), 210.

16. Norman, *Design of Everyday Things*.

17. Manovich, "Back of Our Devices," 280.

18. Ibid., 283.

19. Nanna Verhoeff distinguishes between tactility and the haptic quality of touch screen interfaces. In *Mobile Screens*, she explains that touch screen technologies invite "one to touch in order to see" (84), which transforms tactile practice into a haptic experience. This shift becomes important for her notion of "performative cartography" that typifies, for her, navigational interfaces of mobile, networked devices.

20. Fadi J. Bejjani and Johan M. F. Landsmeer, "Biomechanics of the Hand," in *Basic Biomechanics of the Musculoskeletal System*, ed. Margareta Nordin and Victor H. Frankel, 275–303, 2nd ed. (Philadelphia: Lea and Febiger, 1989), 275.

21. Papanek, *Design for the Real World*, 26.

22. Also worth noting is the obvious fact that the multitouch screen privileges sightedness. Of course, Apple's Siri software, first integrated in the iPhone 4S (2011), addresses this situation to some extent. An application that functions by means of voice commands, Siri enables an iPhone user to access and search content, manage appointments, check the weather, and send and listen to text messages, among other tasks. Even so, that the screen predominates underscores that the iPhone device (and iPad, the third generation of which will likewise feature Siri) is principally a vision-oriented machine.

23. B. Buchholz and T. J. Armstrong, "A Kinematic Model of the Human Hand to Evaluate Its Prehensile Capabilities," *Journal of Biomechanics* 25, no. 2 (1992): 149.

24. Ibid., 155.

25. Madeleine Akrich, "The De-Scription of Technical Objects," in *Shaping Technology/Building Society: Studies in Sociotechnical Change*, ed. Wiebe E. Bijker and John Law, 205–24 (Cambridge, MA: MIT Press, 1992), 207.

26. Anne Balsamo, *Designing Culture*. Balsamo explicitly addresses the iPhone in an essay published in Snickars and Vonderau, *Moving Data*, 251–64.

27. See Bruno Latour, "Where Are the Missing Masses? The Sociology of a Few Mundane Artifacts," in Bijker and Law, *Shaping Technology/Building Society*, 225–58.

28. This, too, is implied in Latour's account of the hinged door: hinges were an innovation at some historical moment. That we have sensor-driven sliding doors demonstrates one of the ways the hinged door has evolved.

29. Paul Kunkel, *Digital Dreams: The Work of the Sony Design Center* (New York: Universe Publishing, 1999), 79. This is not so different from Manovich's claim.

30. Ibid., 149.

31. Alexandra Schneider, "The iPhone as an Object of Knowledge," in Snickars and Vonderau, *Moving Data*, 54.

32. Ibid.

33. Ellen Lupton and Jennifer Tobias, *Skin: Surface, Substance, and Design* (New York: Princeton Architectural Press, 2002), 55.

34. Frank R. Wilson, *The Hand: How Its Use Shapes the Brain, Language, and Human Culture* (New York: Vintage, 1998), 63.

35. Ibid.

36. Elizabeth Grosz, "The Thing," in *Architecture from the Outside: Essays on Virtual and Real Space*, 167–83 (Cambridge, MA: MIT Press, 2001). The essay appears in revised form in E. A. Grosz, *Time Travels: Feminism, Nature, Power*, Next Wave: New Directions in Women's Studies (Durham, NC: Duke University Press, 2005).

37. Grosz also cites Bergson in her parsing of acquaintance. But in foregrounding intuition-intellect, she does not quite capture the biological (i.e., cognitive) underpinnings that prove most prescient in his theorization of duration and most useful for a consideration of myriad forms for hand-device relations new technologies inspire. Karen Barad's notion of "agential realism" also speaks to the experience of in relation. See Karen Michelle Barad, *Meeting the Universe Halfway: Quantum Physics and the Entanglement of Matter and Meaning* (Durham, NC: Duke University Press, 2007).

38. Several commentators have mentioned Bergson's consistent reference to the clinical studies of Charcot and Freud, among others, an observation that places him uncannily in line with current neurophysiological accounts of perception and consciousness. See, for example, Marie Cariou, "Bergson: Keyboards of Forgetting," trans. Melissa McMahon, in *The New Bergson*, ed. John Mullarkey, 99–117 (Manchester, UK: Manchester University Press, 1999); Susan Guerlac, *Thinking in Time: An Introduction to Henri Bergson* (Ithaca, NY: Cornell University Press, 2006); and F. C. T. Moore, *Bergson: Thinking Backwards* (Cambridge: Cambridge University Press, 1996).

39. Henri Bergson, *Creative Evolution* (Mineola, NY: Dover, 1998), 306.

40. For Bergson, philosophy has the capacity to account for the relation between mind and matter as well as the ways by which we (our intellect) have evolved distinctly from other species, and philosophy provides an opportunity for inhabiting, indeed mobilizing, this creative potential.

41. Henri Bergson, *Matter and Memory* (New York: Zone Books, 1988), 22.

42. Ibid., 9.

43. It is important to recall here that Bergson is writing in the wake of persuasive critiques of both idealist and realist positions. He explains that idealism (for which an image is representation) and realism (for which an image is a thing) both assume that "to perceive means above all to know," for him an incorrect assumption (Ibid., 29). But in endeavoring to chart a different path, he necessarily resorts to an ambiguous definition of image, one that attempts to dislodge the assumed a priori separation between matter's existence and its appearance that underpins Western thought. In arguing that interiority and exteriority (of thought with respect to the universe, i.e., matter) are "only relations among images"—that is, insofar as "we can only grasp things in the form of images"—Bergson thinks about the problem or question of being, universe (i.e., matter, including our sundry technologies), and thought in terms that assert the coexistence of two systems of thought: science and metaphysics. Ibid., 25, 26.

44. Ibid., 25 (emphasis in original).

45. Ibid., 38.

46. David Norman Rodowick, *Gilles Deleuze's Time Machine*, Post-Contemporary Interventions (Durham, NC: Duke University Press, 1997), 35 (my emphasis).

47. Of course, readers may recall Bergson's turn to the cinematograph in *Creative Evolution*, wherein he alludes to the string of discrete photographic images that acquires movement at the level of the apparatus. He does so in order to exemplify, not perception (i.e., cognition that takes place at the level of the organism), but ratio-scientific thought. Even as he explicitly includes perception in his short list of processes attributable to "the apparatus of knowledge," effectively collapsing the distinction between knowledge and perception, we would be wise to return to his assertions about perception that appear in *Matter and Memory* (published eleven years earlier): "Perception, intellection, language so proceed [cinematographically] in general" (306). Likewise it seems appropriate to consider a related assertion he makes years later in *The Creative Mind* (1934) that thought—even that of his intuitive method of philosophy—"finally becomes lodged in *concepts* [i.e., abstractions] such as duration, qualitative or heterogeneous multiplicity, unconsciousness" (Henri Bergson, *The Creative Mind* [New York: Citadel Press, 2002], 35; my emphasis). In that same book, Bergson returns to the metaphor of the cinematograph to describe again the "deficit" that inheres in our everyday manner of thinking—that is, our habits of language, common sense, and understanding (23). So while we might allow that physiologically perception functions as a process of distillation, which we

might experience as if there were running inside us a cinematograph, the fact is that Bergson's cinematographic metaphor in *Creative Evolution* actually refers to "ordinary knowledge" and not the neurophysiological states of the proto- and core selves (Damasio) that readily correspond to Bergson's body-as-image of *Matter and Memory*.

48. Bergson, *Matter and Memory*, 38.

49. Ibid.

50. Ibid., 25 (emphasis in original).

51. Bergson does wax more metaphorical at points, describing the body as an advancing boundary between the past and the future. Within the flux of time, the body is situated at the very point where the past—which is triggered or called up by the circumstances of the moment—expires in the unfolding of action in the present. It is a kind of experience that Brian Massumi refers to as "lived speculation" (Massumi, *Semblance and Event*, 86). Likewise, Bergson describes the body, in its being a matrix of neural synapses and pathways, as a conductor that transmits or inhibits movement (Bergson, *Matter and Memory*, 47, 48); it is a "*place of passage* of the movements received and thrown back, a hyphen, a connecting link between the things which act upon me and the things upon which I act" (Ibid., 151–52; emphasis in original). What these metaphors have in common is their insistence that the body is never neatly delineated; it is never its own discrete entity. Instead, what is underscored is that the body is an ongoing process of being in relation.

Informed by current neurophysiological research into brain plasticity, Catherine Malabou has recently critiqued Bergson's turn to the metaphors of telephone exchange and conductor. She asserts that the brain is better understood in terms of networks. At this point, I am less concerned about whether or not his are suitable tropes than with how such tropes reveal Bergson to have been invested in a neurophysiological theorization of perception. Catherine Malabou, *What Should We Do with Our Brain?* Perspectives in Continental Philosophy (New York: Fordham University Press, 2008), 33–37.

52. Antonio R. Damasio, *The Feeling of What Happens: Body and Emotion in the Making of Consciousness* (New York: Harcourt Brace, 1999), 154.

53. Damasio, *Self Comes to Mind*, 31.

54. Ibid.

55. Ibid., 36.

56. Damasio, *Feeling of What Happens*, 154.

57. Ibid., 159.

58. Ibid., 154.

59. Ibid.

60. Ibid., 160.

61. It is worth making a distinction between feeling and emotion. As Damasio explains in *The Feeling of What Happens*, emotion is the emotive state of the biological organism; it refers to "complicated collections of chemical and neural responses, forming a pattern" (51). Feeling, on the other hand, refers to "the private, mental experience of an emotion" (42). Any reaction, felt or not, understood or not, is biologically—that is, emotively—informed. For example, in response to some sensory stimulus (e.g., a prick of a needle applied to a finger), chemical molecules are sent to the bloodstream, where they act on the receptors in the cells of tissues, and electrochemical signals move along neuron pathways, acting on other neurons and on muscular fibers or organs. The result is "a global change in the state of the organism" (67) whereby organs and muscles respond and move accordingly (e.g., sudden retraction of the finger). Consider the response elicited when a text or other message vibrates its arrival: we reach for our device—without concerted thought. Such changes to the overall state of the organism are not consciously felt. Rather, they signal the body's integral connectedness with its surroundings. In order for an emotion to be known, changes activated by the emotion must be imaged, and the core consciousness, which produces the images that allow for a feeling of knowing, must attend to the entire set of phenomena (see 68).

62. Damasio, *Feeling of What Happens*, 43.

63. Ibid., 89.

64. Massumi, *Semblance and Event*, 44 (emphasis in original).

65. Damasio, *Self Comes to Mind*, 100.

66. It is interesting to note, here, that Damasio cites T. S. Eliot, who actually attended Bergson's lectures at the Collège de France. He finds that Eliot aptly communicates the ephemeral materiality of the moment of core consciousness: in *The Four Quartets*, Eliot writes, "You are the music while the music lasts" (quoted in Damasio, *Feeling of What Happens*, 172). The point Damasio wishes to emphasize is that this "feeling essence of our sense of self" (171) is a knowing that is not yet known as such, because we are not separated or abstracted from it because we are not yet autobiographical, that is, not yet rearticulated with the memory objects comprising our autobiographical record.

67. I am referring to Bergson's inverted cone. In diagramming the becoming of "my present," Bergson deploys an inverted and horizontally cross-sectioned

cone in order to emphasize the temporality of perceptual consciousness. At its apex, point S, my body experiences contact with an ever-evolving present, plane P. Point S advances across plane P but not simply unidirectionally, linearly, or teleologically; this is not a historical, forward movement. My successive pasts striate into the increasingly expanding horizontal cross sections constituting the inverted cone. In a moment of memory, my body-as-image is the site of a constellation between the immediacy of my present in its unfolding and the activation of some slice of my ever-accreting pasts.

68. See Heidi Rae Cooley, "It's All About the Fit: The Hand, the Mobile Screenic Device, and Tactile Vision," *Journal of Visual Culture* 3, no. 2 (August 2004): 133–55.

69. I thank Greg Wilsbacher for providing the approximate measure, based on a Kodak Cine K on display at USC's Moving Image Research Collections.

70. Mizuko Ito, "Camera Phones Changing the Definition of Picture-Worthy," *Japan Media Review* (29 August 2003), http://www.ojr.org.

71. See Daniel Palmer, "iPhone Photography: Mediating Visions of Social Space," in Hjorth, Burgess, and Richardson, *Studying Mobile Media*, 85–97; and Chris Chesher, "Between Image and Information: The iPhone Camera in the History of Photography," in Hjorth, Burgess, and Richardson, *Studying Mobile Media*, 98–117.

72. In *Matter and Memory*, Bergson offers the keyboard as a metaphor to explain the affects of an object on perception: "The external object executes at once its harmony of a thousand notes, the calling forth in a definite order, and a single moment, a great multitude of elementary sensations corresponding to all the points of the sensory center concerned" (129).

73. Damasio, *Feeling of What Happens*, 171 (emphasis in original).

74. Ibid., 183.

75. Ibid. I am suggesting that the camera phone image redoubles the perceptual image. As such, it is a different kind of perceptual slice, one that introduces the photographic point of view that Bergson says reduces consciousness and thus generates the "intensified sense of knowing" that I discuss in the next paragraph.

76. Two points regarding the nonverbal inferences responsible for activating the chain of events leading to responsive action bear repeating. First, these nonverbal inferences are nonverbal, that is, they precede a spoken "I." Second, they are the product of a complex articulation of neurobiological processes, involving the changing biological state of the body as catalyzed by a causative object that may be internal or external to the organism and the "nonverbal

vocabulary of body signals [neural patterns, images, and maps]" (Damasio, *Feeling of What Happens*, 31).

77. See Cooley, "It's All About the Fit."

78. Of course, not every thumbnail image, text, or mobile update or announcement is a product of such an impulse to respond to a causative object. It is in fact the case that some persons, who do not embrace the spirit of these media, fret about who will see their posts and how they will be perceived; they are more self-conscious and deliberate in their use of technologies. The point I want to underscore here is that many experience a particular kind of relation with their devices by virtue of their device's design philosophy.

79. Anne Friedberg, *The Virtual Window: From Alberti to Microsoft* (Cambridge, MA: MIT Press, 2006). See also Roland Barthes, *Camera Lucida: Reflections on Photography*, 1st American ed. (New York: Hill and Wang, 1981).

80. For more on "selfie," see http://www.urbandictionary.com.

81. My use of "cut off" refers to the Derridean notion of citationality, the quality of "produc[ing] effects beyond" an originary context of signification. See Jacques Derrida, "Signature, Event, Context," *Margins of Philosophy* (1982): 307–30, http://www.stanford.edu; and Jacques Derrida, "Grafts: A Return to Overcasting [Retour Au Surjet]," in *Dissemination*, trans. Barbara Johnson, 355–58 (Chicago: University of Chicago Press, 1981).

82. Public figures who find themselves in trouble for inappropriate—lewd, racist, and so on—content underscore this point. For example, the 2012 Olympics in London witnessed two athletes—Swiss soccer player Michel Morganella and the Greek triple jumper Voula Papachristou—expelled for tweeting racist comments directed at other Olympic athletes/teams. In such instances, it becomes clear that self-expression may not always be as self-aware as it might or ought to be. For one account of these events, see Josh Wolford, "Swiss Athlete from Olympics for Racist Tweet," WebProNews, 31 July 2012, http://www .webpronews.com.

83. For Peirce, a sign is the "phenomenal manifestation" of cognition (Charles S. Peirce and James Hoopes, *Peirce on Signs: Writings on Semiotic* [Chapel Hill: University of North Carolina Press, 1991], 68). It is the effect of the "growing process" of cognition; it denotes the happening of thought.

84. Peirce and Hoopes, *Peirce on Signs*, 71.

85. Ibid.

86. Ibid., 72.

87. Ibid.

88. Ibid., 71.

89. Ibid. This is not to say there is no meaning in thought. It is to reconsider how thought achieves meaning—or how thought means.

90. Ibid.

91. Ibid.

92. Ibid., 68 (emphasis in original).

93. Ibid.

94. Ibid., 67.

95. "Tweeting" refers to a broader practice of mobile updating that social-networking services in conjunction with portable and networked devices enable.

96. In the essay "I Phone, I Learn," Anne Balsamo refers to the iPhone as a "meme machine." See Anne Balsamo, "I Phone, I Learn," in Snickars and Vonderau, *Moving Data*, 251–64.

97. Charles Sanders Peirce, *The Essential Peirce: Selected Philosophical Writings*, ed. Nathan Houser and Christian Kloesel, vol. 2 (Bloomington: Indiana University Press, 1998), 391.

98. Ibid., 390.

CHAPTER THREE. "LOCATION, LOCATION, LOCATION"

"Location, location, location" is an oft-used idiomatic expression in real estate. It refers to the importance of location (i.e., of a house). I deploy it here to underscore the importance of where-ness and attention to place in the mobile present. As the subtitle suggests, we now expect to be able to place and access both persons and information—and at the click of a button or the swipe of a touch screen. In this regard, "findability" becomes crucial for underscoring the relation between location (e.g., of a person, an asset, etc.) and navigation (i.e., among various persons, assets, etc.).

1. Michel Foucault, "About the Beginning of the Hermeneutics of the Self: Two Lectures at Dartmouth," *Political Theory* 21, no. 2 (May 1993): 198–227; Michel Foucault, Frédéric Gros, François Ewald, and Alessandro Fontana, *The Hermeneutics of the Subject: Lectures at the Collège de France, 1981–1982* (New York: Palgrave Macmillan, 2005); and Michel Foucault, *The History of Sexuality*, 1st American ed. (New York: Pantheon, 1978).

2. Noam Cohen, "It's Tracking Your Every Move and You May Not Even Know It," *New York Times*, 26 March 2011, http://www.nytimes.com.

3. See Sense Networks, home page, http://www.sensenetworks.com.

4. And it requires that we do nothing because our devices, if they are on,

transmit a changing set of coordinates in time to our movements and pauses.

5. See Peter Morville, *Ambient Findability* (Beijing: O'Reilly, 2005).

6. Recall controversy over Apple's inclusion of the "consolidated.db" file in iOS 4 iPhones and iPad 3Gs. As discussed by Alasdair Allan and Pete Warden in a YouTube video embedded at http://radar.oreilly.com/2011/04/apple-location -tracking.html, the file secretly stores data regarding the device's location (using cell phone towers and Wi-Fi access points). Also recorded is the device's ID along with a time stamp. This data persists through backups and restores. While the data is unencrypted, Allan and Warden indicate that there is no evidence that it leaves "your person." See Alasdair Allan, "Got an iPhone or 3g iPad? Apple Is Recording Your Moves," O'Reilly Radar: Insight, Analysis, and Research about Emerging Technologies, 20 April 2011, last updated 27 April 2011, http://radar .oreilly.com.

7. More recently, Daniel Palmer has noted the recent emergence of "reality mining" as an "antidote to the corporate dominance of data mining" (Palmer, "iPhone Photography," 94). This more euphemistic take on our routine proliferation of data belies the fact that we actively and unceasingly participate in a project of governance that mobilizes techniques of findability in order to manage the various "bodies" that are always in motion. See Hjorth, Burgess, and Richardson, *Studying Mobile Media*, 85–97.

8. Trendwatching.com, "Life Caching," 2004, http://www.trendwatching .com.

9. Ibid. (my emphasis).

10. Mike Hanlon, "SenseCam: The Black Box Flight Recorder for Human Beings," Gizmag, 31 August 2006, http://www.gizmag.com.

11. To reiterate, Nixon hailed from Augusta, Georgia, which aptly explains the inclination to document Augustas of all sorts.

12. Here, it is important to distinguish between two kinds of metadata: one, the user-generated keyword tag, and two, the device-encoded geotag (i.e., coordinates). The first sort might not be "encoded into an image file as metadata"; metadata might associate the keyword tag in a database, for example. The second sort is a part of the metadata of the image file—it was put there by the device.

13. Tags are a kind of metadata that serve as navigational mechanisms for finding like, that is, statistically relevant, instances. They provide a means of linking to various thumbnails within an individual participant's photostream as well as to those uploaded by members of the broader Flickr user group.

14. A 2009 Flickr search returned these results.

15. Increasingly, such devices are being equipped with the capability to encode information regarding Bluetooth environments, events from the phone's calendar, and any combination of names, tags, or descriptions a user might append. Moreover, work is being done that will ensure that shared images are encoded with metadata for environmental factors (temperature and barometric pressure) and biological data (body temperature, heart beat, and pulse). I first became aware of these possibilities at a PICS (Pervasive Image Capture and Sharing) workshop for Ubicomp 2005 in Tokyo. See the session notes at http://www.spasojevic.org/pics/session_3.htm. See also Marc Davis et al., "Mm2: Mobile Media Metadata for Media Sharing," in *CHI 2005*, 1335–38 (Portland, OR: ACM Press, 2007).

16. Palmer argues that the "iPhone signals a shift in thinking about photographs as being primarily about representation to thinking about photographs as information" (Palmer, "iPhone Photography," 90).

17. Allan Sekula, "The Body and the Archive," *October* 39 (Winter 1986): 9. John Tagg makes a similar point. See John Tagg, *The Burden of Representation: Essays on Photographies and Histories* (Amherst: University of Massachusetts Press, 1988), 66–102.

18. Sekula, "The Body and the Archive," 9n13.

19. Sekula notes that in the mid-1850s, the camera was valued for its "metrical accuracy": "exact mathematical data could be extracted [from the photographic image]" (ibid., 17).

20. Ibid., 16, 17. While Galton promoted composite portraiture of, for example, the criminal type, Bertillon imagined a system of criminal identification, which used a filing system for organizing fiche [cards] in order to identify a particular criminal (17). Both uses of photography demonstrate the photograph to be an extension of the Benthamite jail cell. In which case, the photograph as such operates according to the same panoptic principle that aims to regulate and contain (so-called) deviant bodies.

21. Although, here, we might think about how the increase in citizen journalism has produced newsworthy coverage and evidence of all sorts of events.

22. In chapter 1, I offer a more comprehensive discussion of the computational logic underpinning data management. In particular, I cite the Traveling Salesman Problem as a heuristic approach to latent semantic indexing (LSI)] and, by extension, singular value decomposition (SVD).

23. Kate Crawford is among those who do not privilege visibility. A scholar of journalism and media research, Crawford draws on iPhone's filiation with iPod in order to approach the device as a "listening station." She contends that sound is a better trope than vision for thinking about management: the iPhone "listens

to users" (213). She shifts "tuning in" to "listening in" as an emerging behavior defining iPhone practice: "Regular 'listening in'" is about "checking the activity of [various] feeds," for example, Facebook, Twitter, e-mail, and so forth (219). See Kate Crawford, "Four Ways of Listening with an iPhone: From Sound and Network Listening to Biometric Data and Geolocative Tracking," in Hjorth, Burgess, and Richardson, *Studying Mobile Media*, 213–28.

24. Geert Lovink, "Blogging: The Nihilist Impulse," *Eurozine*, 2 January 2007, http://www.eurozine.com. As early as 1995, Mark Poster used the term "superpanopticon" to draw attention to the mechanisms of surveillance operating through computerized databases. If the Panopticon produced an interiorized subjectivity through a self-discipline and a self-scrutiny that enacted an always-present threat of being observed, then the superpanopticon, as Poster describes it, disperses subjectivity through the subject's willingness to make visible as public record her or his private transactions. Lovink and Poster share an important insight in this regard: people have grown accustomed to a type of "visibility" that entails less a self-disciplining fear of being seen than a habituation to sharing one's data traces. See Mark Poster, *The Second Media Age* (Cambridge, UK: Polity, 1995).

25. For Rose, the "calculable person" is a person "whose individuality is no longer ineffable, unique, and beyond knowledge, but can be known, mapped, calibrated, evaluated, quantified, predicted, and managed" by means of the person's commitment to processes of self-understanding and self-improvement. This involves not abstraction but stabilization—a subtle but distinct difference. As Rose explains, "Persons are ephemeral, shifting," so the work of self-recording along with, for example, routine visits to doctor's appointments and compliance with other institutional protocols involving data accomplishes "a way of rendering the mobile and confusing [i.e., individual persons] . . . into a cognizable field [i.e., a population]" (106). By committing to practices of self-understanding and self-improvement, the person delivers herself or himself into two dimensions via personal details and history; through processes of inscription, "complexities of actuality" are (made) knowable and calculable—and, subsequently, predictable. See Nikolas Rose, *Inventing Ourselves: Psychology, Power, and Personhood* (Cambridge: Cambridge University Press, 1998).

26. Crawford, "Four Ways of Listening," 221.

27. Ibid., 222.

28. Morville, *Ambient Findability*, 9.

29. Foucault, "About the Beginning," 204.

30. Ibid.

31. See Michel Foucault, *The History of Sexuality*, vol. 1, *An Introduction* (New York: Vintage, 1990), 59.

32. Peirce and Hoopes, *Peirce on Signs*, 84.

33. Ibid.

34. Ibid.

35. Ibid.

36. Ibid.

37. Ibid.

38. Ibid., 75.

39. Ibid.

40. Ibid., 76.

41. Peirce, *Collected Papers*, 334. Importantly, Peirce's account accords with Antonio Damasio's point that brain circuitry is imprinted with body structures and functions acquired by an organism early in development and that such imprinting allows for the generation of persistent patterns of activity.

42. Daniel Palmer and Chris Chesher discuss the aesthetic particularities of mobile (iPhone) phone photography. See Palmer, "iPhone Photography"; and Chris Chesher, "Between Image and Information: The iPhone Camera in the History of Photography," in Hjorth, Burgess, and Richardson, *Studying Mobile Media*, 98–117.

43. I use "deeper" here in the sense of intensity, insofar as imaging occurs at the neurophysiological level of subjecthood.

44. Increasingly, scholars of film, media, and related humanities-oriented studies are turning their attention to data and data structures. English scholars use text-mining strategies to parse vast quantities of literary objects in order to identify previously undetected patterns and relationships across a canon, a particular oeuvre, or various repositories. In the case of film and media studies disciplines, interest has tended to favor examples of visual materials that demonstrate a prescience for what is called "database aesthetics." Typically cited examples include Dziga Vertov's 1929 city symphony film *Man with a Movie Camera* and the works of Ray and Charles Eames (e.g., their 1959 multiscreen installation *Glimpses of the USA* exhibited at the American National Exhibition in Moscow). For those who espouse databases as a medium for aesthetic practice, computation and data frequently become artifacts of a self-expression that belongs to an artist or some ensemble thereof. Media artists, likewise, use the term "database aesthetics" to describe creative practice that explores the conditions

of "information overflow" (Victoria Vesna, *Database Aesthetics: Art in the Age of Information Overflow*, Electronic Mediations 20 [Minneapolis: University of Minnesota Press, 2007], ix). See also Marsha Kinder, "Narrative Equivocations between Movies and Games," in *The New Media Book*, ed. Dan Harries, 119–32 (London: British Film Institute, 2002); Lev Manovich, *The Language of New Media* (Cambridge, MA: MIT Press, 2002); and Tara McPherson, "Beyond Formalism: Thoughts on New Media and Race in Post–World War II Culture" (conference paper, University of Washington, Seattle, 14 February 2003).

45. Espen J. Aarseth, "Introduction: Ergodic Literature," in *Cybertext: Perspectives on Ergodic Literature*, 1–23 (Baltimore: Johns Hopkins University Press, 1997).

46. Gene Smith, *Tagging: People-Powered Metadata for the Social Web* (Berkeley, CA: New Riders, 2008), 82.

47. Ibid.

48. In this context, expressivity emerges as a more complex transaction. Beyond any one user or community of users, it involves a corporately financed software program (e.g., Ludicorp, which established Flickr in 2002) that is a result of various decisions made by programmers. (And beyond that, a business model [e.g., Yahoo! acquired Flickr in 2005] that governs and maintains the site). The software programmer who designs an algorithm for identifying and establishing links among tags informs any one person's aesthetics of expressivity by the very choices that person (the programmer) makes regarding how the algorithm "expresses" itself. The algorithm responsible for the associations established among tagged assets on a site like Flickr is not without its art. Fundamental to what might be termed an algorithm's aesthetics, that is, its manner of expressing, is the simplicity and clarity of its code and the efficiency and accuracy of its performance. These attributes comprise what computer scientists refer to as "elegance." Concerned with the manner or style of approach to both the design of data structures and the effective management of elements (newly inputted as well as recently deleted), elegance materializes by means of anticipatory thinking and heuristic reasoning—both functionalities of "computational thinking," more broadly understood. See Jeannette M. Wing, "Computational Thinking," *Communications of the ACM* 49, no. 3 (2006): 33–35.

49. At the same time, the film invokes two distinct temporalities, two linear sequences that collide: the time of the screening (i.e., the spectator's present) and the time of the "journey," or road trip, to various Augustas.

50. In this, *The Augustas* has something in common with Dziga Vertov's *Man*

with a Movie Camera; Vertov's rhythmic use of montage and superimposition organizes sequences of images according the structure of a single day (morning, midday, and evening) in a Russian city.

51. For Foucault, *askēsis*, or a training of oneself, serves as a model for a *rapport a soi*. In a 1983 interview, he describes this training as a " 'citational' practice," by means of which one strives to "establish as adequate and as perfect a relationship of oneself to oneself as possible" (274). It is an ongoing "work" of self-making, wherein one attends carefully to what one has heard, read, and learned each day. In this labor of self-awareness, one is always in relation to others. Foucault indicates that it is a work in which one's relationship to oneself "intersects" with the relationships one has with "others and the world"—both population and milieu. What's more, any "truth," that is, knowledge of the world, cannot be arrived at without this labor of relation, for truth is not a consequence of some sort of evidentiary knowledge out there but a knowledge that materializes through the very self-awareness one practices—a self-awareness that is situated in the world. Michel Foucault and Paul Rabinow, *Ethics: Subjectivity and Truth; The Essential Works of Foucault, 1954–1984* (New York: New Press, 1997).

52. But also, the "case" of Augusta points to the fact that expressivity has to do with materialities of medium: here, celluloid frames and digital files. Here we can see most clearly the expressiveness Foucault and others do not consider— precisely because they are attempting to explain a dominant mode of self-record. Even as they might acknowledge that how people speak of themselves depends on the affordances of a given technology, they overlook that the medium, too—be it a page or .doc file, a photograph or .jpg file—"speaks." Nixon's *The Augustas* makes this poignantly clear: both person and medium express. While we are given to imagine that Nixon selected shots, framings, and sequences of Augustas to edit in combination, the celluloid, which bears the photographic index of each Augusta, expresses by way of its deterioration. As one screens the reel, one cannot but notice what registers visually as wrinkles and water spots, stretchings, and discolorations; one cannot but notice the jittery instability of the image as a whole. The Nixon reel expresses its materiality through the visible evidence of its decomposition. Even as the reel has been preserved, trace residues of mold, water damage, serve to remind us of the veritable uncertainty of any instance of expression. (A 2009 National Film Preservation Fund grant funded the preservation of Scott Nixon's *The Augustas*.) And the same applies to digital assets of all varieties, including those appearing as thumbnails in photostreams. Such images are almost always "down-rezed" versions of an original file—not to

mention the loss of data as a result of any cropping or scaling applied to make images "fit" in their tidy series. No digital object is free from the threat of data loss or corruption, and a thumbnail image is, perhaps, almost by definition data loss. This is why those who oversee digital repositories spend so much time, energy, and money identifying sustainability plans, digitization standards, selection and metadata guidelines, and preservation protocols: to ensure findability and accessibility.

CHAPTER FOUR. SECURED MOBILITIES

1. Chun, *Control and Freedom*. More recently, Chun has asserted that cycles of obsolescence and renewal function to perpetuate a project of programmability. See also Wendy Hui Kyong Chun, *Programmed Visions: Software and Memory*, Software Studies (Cambridge, MA: MIT Press, 2011).

2. The commercial aired one time during the third quarter of the 1984 Super Bowl game.

3. As a whole, the ad text reads, "Today, we celebrate the first glorious anniversary of the information purification directives. We have created, for the first time in all history, a garden of pure ideology—where each worker may bloom, secure from the pests purveying contradictory truths. Our unification of thoughts is more powerful a weapon than any fleet or army on earth. We are one people, with one will, one resolve, one cause. Our enemies shall talk themselves to death, and we will bury them with their own confusion. We shall prevail!"

4. Her difference continues to be underscored through cinematography and editing. At one point, the camera frames the gray masses as individuals. One face wears a breathing apparatus that covers nose and mouth. Another dons glasses. But then we return to a shot of the line of marching bodies presented in close-ups and medium close-ups of fragmented body parts. In a particularly poignant shot, a close-up of feet pounding against the grating punctuates the voice-over's invocation of "ideology." In contrast to the athlete's singularity, we are invited to recognize the norm.

5. I cite another Apple advertising campaign (ca. 1997).

6. Kunkel, *AppleDesign*, 21.

7. Of interest is that Apple's version of Orwell's panoptic society is not particularly invested in the visible. While the visual is foregrounded—screens abound—sight and being seen do not seem to be as important. Of course, it's apparent that someone is "watching," because troops pursue the rogue hammer-

wielding runner. But vision is not emphasized: the uniformly seated bodies stare blankly at a monumental image of a talking head that requires bifocals.

8. While others have made similar observations regarding the status of visibility in governance, Grusin's is most suited to my argument. Among those others, we might recall that Gilles Deleuze, particularly in his short essays on "control societies," famously qualifies the model of panoptic power by asserting the ceaseless and ever-shifting (i.e., "modulating") character of power, describing control as "free-floating" and constantly changing, as "short term" but at the same time "continuous and unbounded" (Deleuze, "Postscript on Control Societies," in *Negotiations, 1972–1990*, 177–82 [New York Columbia University Press, 1995], 181). Deleuze helps us to imagine the contemporary functioning of power according to a different principle than the architectural-panoptic model that he treats as antecedent. More concretely, sociologist David Lyon, historian Mark Poster, and media theorist Wendy Chun have produced accounts of governance specific to the late twentieth and early twenty-first centuries. In more recent mobilities research, Kate Crawford has proposed "eavesdropping" as a means to think about the work of tracking. See David Lyon, *The Electronic Eye: The Rise of Surveillance Society* (Minneapolis: University of Minnesota Press, 1994); David Lyon, *Surveillance as Social Sorting: Privacy, Risk and Digital Discrimination* (London: Routledge, 2003); Poster, *Second Media Age*; Chun, *Control and Freedom*; and Crawford, "Four Ways of Listening."

9. In chapter 3, we considered the work of GPS-enabled mobile devices, but one might also think in terms of radio frequency identification (RFID) technologies that serve to keep track of inventories of, for example, animals, consumer goods, and vehicular movements. Here, it's important to make a distinction. RFID tags are location specific and require scanners that are on-site. RFID technologies "look" for movements within and across particular facilities but not at the global scale of GPS, which takes advantage of satellite technology.

10. Michel Foucault, "The Eye of Power," trans. Colin Gordon, Leo Marshall, John Mepham, and Kate Soper, in *Power/Knowledge: Selected Interviews and Other Writings, 1972–1977*, ed. Colin Gordon, 146–65 (New York: Pantheon, 1980), 152. As interpreted by Foucault, Rousseau's "transparent society" imagines a society that is "visible and legible in all its parts," wherein each individual should be able to see the "whole of society" (152). Of value is personal opinion—which would counter wrongdoing. For Foucault, Rousseau and Bentham are both overlapping and complementary, figures of a both/and (Boolean) variety.

11. Taking a page from Peirce, we might observe that even if, semiotically,

an opinion is imagined as symbolic exchange—a matter of reading, writing, speaking, and listening—symbols are not easily disentangle form the icons and indices that make them interpretable.

12. Jean M. Converse explains that while population counts are at least two thousand years old, those that have been developed in the twentieth century have more explicitly functioned as instruments for "viewing mass populations" as "social facts, political publics, and economic markets" (Jean M. Converse, *Survey Research in United States: Roots and Emergence, 1890–1960* [Berkeley: University of California Press, 1987], 1).

13. Foucault, "Eye of Power," 152.

14. This is not to say that Foucault abandons the Panopticon as a metaphor for power. His conceptualization of security remains limited by its persistent valuation of surveillance that implicitly privileges sight and understands governance as principally concerned with the visual order of things. Even as he emphasizes the quantifying, data-generating aspects of managing populations and ensuring circulations, his reliance on the "dispositif" of the Panopticon, which never escapes its etymological roots ("all seeing"), serves always to return power to the domain of the visual and the reliably effective work of an omnipresent gaze. Given historical context, this is not in itself surprising. At the time of the lectures at the Collège de France on biopolitics (1975–79), real-world surveillance operations must have seemed primarily visual: security cameras, video images, banks of CCTV screens, photo identification, and so forth. The Internet-equipped personal computer (with its trails of "cookies") had yet to enter the home, and the mobile phone prototype was the size and heft of a brick (and, thus, not very portable). But in the context of lighter, less cumbersome technologies, technologies that are mobile and likely always "on" and in hand, we ought to rethink the aptness of the formulation "visibility is a trap" as a way of understanding contemporary governance.

15. Michel Foucault, *Security, Territory, Population: Lectures at the Collège de France, 1977–1978*, 2004, trans. Graham Burchell (New York: Palgrave MacMillan, 2007), 65.

16. Michel Foucault, *The Birth of Biopolitics: Lectures at the Collège de France, 1978–79*, trans. Graham Burchell, ed. Michel Senellart (Basingstoke, UK: Palgrave Macmillan, 2008), 54, 55.

17. Foucault, *Security, Territory, Population*, 65.

18. Ibid., 13, 64. Foucault defines circulation as "movement, exchange, and contact, as form of dispersion, and also as form of distribution" (64). As I will

discuss in the next section, he introduces the Roman camp as a model for the design of towns in northern Europe beginning in the late sixteenth through the early seventeenth centuries in his 11 January 1978 lecture (15). As a form, the Roman camp epitomizes flexibility.

19. Foucault, *Security, Territory, Population*, 20.

20. Ibid.

21. Ibid., 21.

22. Ibid., 46–47.

23. Ibid., 46.

24. Foucault's consistent example for how security operates within a milieu is inoculation. Here, a disease, such as polio, is used against itself to check, limit, or regulate contagion. The point is not to eradicate the disease but to keep it "within socially and economically acceptable limits and around an average that will be considered optimal for a given social functioning" (Foucault, *Security, Territory, Population*, 5). The 2009 H1N1 virus outbreak offers a case in point: neither eradication nor cure was the aim of any initiative to address the virus and its transmission and global circulation. Instead, authorities worldwide focused on managing the threat: ceaseless biomonitoring at airports, continuous reports and updates regarding the virus (symptoms, sites of greatest risk, and mutations), health advisories urging vaccination, and ubiquitous dispensers filled with hand sanitizer.

25. Foucault, *Security, Territory, Population*, 66.

26. Ibid.

27. Ibid., 57.

28. Ibid., 15.

29. Ibid., 17.

30. Ibid.

31. Ibid., 20.

32. Lawrence Keppie, *The Making of the Roman Army: From Republic to Empire* (Norman: University of Oklahoma Press, 1984), 38.

33. Ibid.

34. Ibid., 37.

35. Ibid., 36.

36. For example, see David Darling, "Roman Camp," The Worlds of David Darling, 1999, http://www.daviddarling.info.

37. Diane Favro, *The Urban Image of Augustan Rome* (Cambridge: Cambridge University Press, 2008), 111. Although Favro does not undertake a Foucauldian

analysis of urban reorganization of Augustan Rome, her terms seem to invite such an approach. In addition to describing urban rule as "care," Favro writes of "maintenance" as the logic underwriting Augustus's aims, and "fitness" to describe its effects. Moreover, she describes Augustus as being committed to the "functioning of Rome," which required increased circulation of all sorts: "Ancient Rome was a consuming, not a producing, city. Access was essential. Roads, streets, and the river had to be maintained to in order to ensure the movement of comestibles, building materials, tourists, and troops" (111). That her archeologically informed description of Augustan Rome translates into Foucauldian terms not only underscores the viability of his use of the Roman camp as a model for schematizing governance but also suggests there may be more to the Roman precedent than Foucault himself proposes.

38. Favro, *Urban Image*, 140.

39. Ibid., 144.

40. Ibid., 153.

41. Ibid., 156.

42. Ibid., 134.

43. Ibid., 135.

44. Ibid.

45. Ibid., 139.

46. Jason Konig and Tim Whitmarsh, eds., *Ordering Knowledge in the Roman Empire* (Cambridge: Cambridge University Press, 2007), 30.

47. Ibid., 10.

48. Ibid., 30.

49. Ibid.

50. Ibid., 34.

51. In this regard, Konig and Whitmarsh agree with Trevor Murphy, who identifies the encyclopedia to be of Roman invention even as it is a product of "the Roman encounter with Greek ideals of all-embracing education . . . and dependent on the territorial and intellectual ambitions of a unified empire" (quoted in ibid., 10).

52. Konig and Whitmarsh, *Ordering Knowledge*, 34.

53. Ibid., 35.

54. Ibid., 25.

55. Ibid., 28.

56. Ibid., 29.

57. Konig and Whitmarsh conclude that the Roman Empire made empire and

archive coterminous, even synonymous: that which is "archival" is "imperial" and vice versa. However, they are careful to clarify that Roman Empire as imperial endeavor was significantly different from its modern European iterations. The administrative strategies of the Roman Empire were less interventionist. The editors note the "relatively light touch" of Roman rule (ibid., 6), culturally speaking, insofar as cultural production was not explicitly deployed as a tool of empire or justification for imperial domination (as in the case of the British Empire).

58. Rheingold, *Smart Mobs*.

59. Ibid., xiii.

60. Ibid., 190.

61. Clive Thompson, "The Year in Ideas: Smart Mobs," *New York Times*, 15 December 2002.

62. Raymond Williams offers a slight variation on the term "mob." In *Keywords*, he contextualizes the term in relation to "masses." While he notes its etymological ties to mobile vulgus, he does not contrast "mobility" and "nobility." He explains that by the nineteenth century, the term had acquired a more specific usage, referring to "a particular unruly crowd rather than a general condition." In his account, "mass" and then "the masses" came to refer to the general condition. Raymond Williams, "Masses," in *Keywords: A Vocabulary of Culture and Society*, 192–97 (New York: Oxford University Press, 1983), 193.

63. Peter Linebaugh illuminates the history of this change in *The Many-Headed Hydra: Sailors, Slaves, Commoners, and the Hidden History of the Revolutionary Atlantic* (Boston: Beacon, 2000). He observes that before 1747 or so the mob was regularly described (e.g., by merchants, in newspaper accounts, etc.) as "disorderly," particularly in terms of its capacity for "motion and commotion" (211). Those who constituted the mob in the colonies posed a destabilizing and, therefore, menacing force to capitalism (and more generally, empire). Nevertheless, they were pivotal to imagining conditions of possibility for revolutionary movement in America. By 1747, the diversity of the mob required a broader understanding of a Lockeian humanism that underpinned notions of rights and liberty. In response, there came pronouncements regarding the natural rights and the rights of man" (216). To include the diverse, un-English mob in the revolution required that the disorderly be incorporated into the new national order as citizen-individuals with natural rights. Such inclusion also made the unwieldy mob accountable as a population—subject to and objects of governance. See also Gustave Le Bon, *The Crowd: A Study of the Popular*

Mind, 1896 (Kitchener, ON: Batoche, 2001); Arthur Schopenhauer, *Parerga and Paralipomena: Philosophical Essays by Arthur Schopenhauer*, trans. E. F. J. Payne (Oxford: Oxford University Press, 1974); Siegfried Kracauer, *The Mass Ornament: Weimar Essays*, 1963 trans. Thomas Levin (Cambridge, MA: Harvard University Press, 1995); and Gertud Kock, *Siegfried Kracauer: An Introduction* (Princeton, NJ: Princeton University Press, 2000).

64. He identifies this shift in governmental reason with the rise of the market as "an agency of veridiction" (Foucault, *Birth of Biopolitics*, 33), wherein prices "constitute a standard of truth" (32). The market, as a "set of rules," establishes what "can be described to be true or false" (35). Under these conditions, government must adhere to the principle of political economy that, Foucault notes, "revealed the existence of phenomena, processes, and regularities that necessarily occur as a result of intelligible mechanisms" (15). The question to ask is one not of natural rights but of "the naturalness specific to the practice of government itself." That government has a nature means that there is "something that runs under, through, and in the exercise of governmentality" (16). And effective, or successful, governance always respects this nature; that is, it governs "just enough" (17). In other words, government must be responsive to the spontaneity of the market's "natural mechanisms" (31). And while there's also a naturalness accorded individuals, it is so to the degree that "their longevity, health, and ways of conducting themselves have complex and tangled relationships with these economic processes" (22n).

65. Foucault, *Birth of Biopolitics*, 37.

66. Ibid., 43.

67. Ibid., 45.

68. In particular, rulers of Tunisia, Egypt, Libya, and Yemen were ousted. Other protests have occurred in Algeria, Syria, Iraq, Kuwait, Morocco, and the Sudan, as well as Lebanon, Mauritania, Oman, Saudi Arabia, Djibouti, and the Western Sahara. More recently, social protests have taken place in the Palestinian Authority.

69. Thomas Sander, "Twitter, Facebook and YouTube's Role in Arab Spring (Middle East) Uprisings," 26 January 2011, updated 27 March 2013, http://socialcapital.wordpress.com.

70. Henry Jenkins, *Textual Poachers: Television Fans and Participatory Culture*, Studies in Culture and Communication (New York: Routledge, 1992). Jenkins initially coined the term "participatory culture" to characterize user-generated content typical of fan communities. In *Spreadable Media*, Jenkins and coauthors Sam Ford and Joshua Green return to the term as a means of thinking about how

networks of people shape the circulation of media artifacts. In this regard, they share a familiar optimism that informs grassroots efforts and notions of collective agency, such as Rheingold's "smart mobs." Henry Jenkins, Sam Ford, and Joshua Green, *Spreadable Media: Creating Value and Meaning in a Networked Culture*, Postmillennial Pop (New York: New York University Press, 2013).

71. Thompson, "The Year in Ideas."

72. Jussi Parikka provides an account for how we might interpret insect and animal metaphors, such as swarms and packs, as functioning to ensure biopolitical enterprise even as they are suggestive of the kind of radical (i.e., "headless") politics that Rheingold attributes to the mobile many (43). In *Insect Media: An Archaeology of Animals and Technology*, he describes how, historically, insects and animals have long provided a means to conceptualize social formations (in Western culture), communicating both an image of neatly executed organization and threatening force. But how these figures function as discursive formations shifts in the early twentieth century as the centrality of Fordist principles underpinning industry gives way to "new mathematical ideas" (45) that deal with questions of emergence (e.g., the traveling salesman problem). References to social insects likewise change. No longer simply an ideal model for conceptualizing social organization according to hierarchy and taxonomy (e.g., of individual units), such phenomena also offer an image of "the social" as an ongoing, emergent process involving shifting variables (e.g., age, race, gender, medical history, genetic predispositions, education, income, location of residence, and niche interests—any of which might be tracked across a population). We cannot think these interpretations of social insects apart; we never have. Jussi Parikka, *Insect Media: An Archaeology of Animals and Technology*, Posthumanities (Minneapolis: University of Minnesota Press, 2010).

CONCLUSION

1. Foucault and Rabinow, *Ethics*, 255.

2. Peirce, *Collected Papers*, 73 (5.113).

3. Apel, *Charles S. Peirce*, 96.

4. Bergson, *Creative Mind*, 109.

5. Foucault and Rabinow, *Ethics*, 261.

6. Jeffrey T. Nealon likewise notes this shift in Foucault's oeuvre. Jeffrey T. Nealon, *Foucault beyond Foucault: Power and Its Intensifications since 1984* (Stanford, CA: Stanford University Press, 2008).

7. By 1980, Foucault had turned his attention to the "care of the self," identifying it as the principle by which subjects might constitute or fashion themselves. Instead of deploying technologies of self that instantiate a subject beholden to practices of self-sacrifice and self-renunciation such as confession (which seeks to unearth hidden truths), this *rapport a soi* would take bios as the "material" for an aesthetic existence. Foucault contends that art should be a matter not simply of objects but of life itself. Living ethically means living artfully.

8. Foucault, "About the Beginning." Foucault's early 1980s lectures take a similar line of inquiry. See Foucault et al., *Hermeneutics of the Subject*; Michel Foucault, *The Government of Self and Others* (Houndmills, UK: Palgrave Macmillan, 2010); and Michel Foucault, *The Courage of the Truth (the Government of Self and Others II): Lectures at the Collège de France, 1983–1984*, trans. Graham Burchell, ed. Frederic Gros (Houndmills, UK: Palgrave Macmillan, 2011).

9. Foucault and Rabinow, *Ethics*, 260.

10. Deleuze and Boyman, *Pure Immanence*; Guattari, *Three Ecologies*; Jacques Derrida and Anne Dufourmantelle, *Of Hospitality*, Cultural Memory in the Present (Stanford, CA: Stanford University Press, 2000).

11. Massumi, *Semblance and Event*, 57, 80.

12. Grosz, *Chaos, Territory, Art*, 76.

13. Mark B. N. Hansen, *New Philosophy for New Media* (Cambridge, MA: MIT Press, 2004). In "Foucault and Media: A Missed Encounter?" Hansen turns to Foucault's notion of refusal. Not juridical as is the case with resistance, refusal occurs at the level of the body, a body that "is coupled, both actually and virtually, with the environment" (506). Moreover, refusal in the context of media technologies, such as television and Facebook, might take the form of a kind of creativity—or creative relation—across a population. In combination, haptic aesthetics and refusal are suggestive of the kind of habit change Peirce proposes. Mark B. N. Hansen, "Foucault and Media: A Missed Encounter?" *South Atlantic Quarterly* 111, no. 3 (Summer 2012): 497–528.

14. "Intra-action" is to be distinguished from "interaction." While the latter term "presumes the prior existence of independent entities or relata," the former specifies the "ontological inseparability/entanglement of intra-acting 'agencies.'" Barad, *Meeting the Universe Halfway*, 39, 135.

15. Roberto Esposito, *Bíos: Biopolitics and Philosophy*, Posthumanities (Minneapolis: University of Minnesota Press, 2008).

16. Protevi, *Political Affect*, 35.

17. Protevi, *Political Affect*, 35–36. Also worth noting, in this regard, is Jeffrey T. Nealon's parsing of Foucault's ethics as "the transformative power of the common, the everyday, and the mundane" (*Foucault beyond Foucault*, 78).

18. Rita Raley, *Tactical Media*, Electronic Mediations (Minneapolis: University of Minnesota Press, 2009), 1.

19. Rafael Lozano-Hemmer, "*Amodal Suspension*: Relational Architecture 8," 2003, http://www.amodal.net/intro.html.

20. In fact, ten thousand unique instances of participation (from ninety-four distinct countries) were archived and made searchable (although the search function seems to have been deactivated). Lozano-Hemmer, "*Amodal Suspension*."

21. See John Craig Freeman and Mark Skwarek, *Border Memorial: Frontera de los Muertos*, 2012, http://bordermemorial.wordpress.com/border-memorial -frontera-de-los-muertos.

22. The Transborder Immigrant Tool (2007–) offers a complementary but differently oriented perspective of the desert between the U.S. and Mexico. The project uses recycled, repurposed GPS-enabled phones to identify, locate, and direct migrant users to water stations that punctuate the border region. Instead of offering a real-time view of already failed crossings, it endeavors to ensure such crossings succeed in the present. Developed by the Electronic Disturbance Theater and b.a.n.g. lab/CalLit at the University of California, San Diego, the project points to a kind of aesthetic of media practice to which Augusta App aspires—albeit on a less politically interventionist scale and with a different audience, or population, in mind. I thank Tony Stagliano for providing details regarding this project. See Bordermachines.net, "From Lines to Territories: Ricardo Dominguez, Bang.Labs, and the Transborder Immigrant Tool," accessed 7 April 2013, http://www.bordermachines.net/transborder2.html.

23. See the *Oxford English Dictionary*, s.v. "artwork," accessed 4 June 2013, http://www.oed.com.

BIBLIOGRAPHY

Aarseth, Espen J. "Introduction: Ergodic Literature." In *Cybertext: Perspectives on Ergodic Literature*, 1–23. Baltimore: Johns Hopkins University Press, 1997.

Akrich, Madeleine. "The De-Scription of Technical Objects." In *Shaping Technology/Building Society: Studies in Sociotechnical Change*, edited by Wiebe E. Bijker and John Law, 205–24. Cambridge, MA: MIT Press, 1992.

Allan, Alasdair. "Got an iPhone or 3g iPad? Apple Is Recording Your Moves." O'Reilly Radar: Insight, Analysis, and Research about Emerging Technologies, 20 April 2011. Last updated 27 April 2011. http://radar.oreilly.com.

Apel, Karl-Otto. *Charles S. Peirce: From Pragmatism to Pragmaticism*. 1981. Translated by John Michale Krois. New York: Humanity Books, 1995.

Balsamo, Anne. *Designing Culture: The Technological Imagination at Work*. Durham, NC: Duke University Press, 2011.

———. "I Phone, I Learn." In *Moving Data: The iPhone and the Future of Media*, edited by Pelle Snickars and Patrick Vonderau, 251–64. New York: Columbia University Press, 2012.

Barad, Karen Michelle. *Meeting the Universe Halfway: Quantum Physics and the Entanglement of Matter and Meaning*. Durham, NC: Duke University Press, 2007.

Barthes, Roland. *Camera Lucida: Reflections on Photography*. 1st American ed. New York: Hill and Wang, 1981.

Bejjani, Fadi J., and Johan M. F. Landsmeer. "Biomechanics of the Hand." In *Basic

Biomechanics of the Musculoskeletal System, edited by Margareta Nordin and Victor H. Frankel, 275–303. 2nd ed. Philadelphia: Lea and Febiger, 1989.

Bergson, Henri. *Creative Evolution*. Mineola, NY: Dover, 1998.

———. *The Creative Mind*. New York: Citadel Press, 2002.

———. *Matter and Memory*. New York: Zone Books, 1988.

Berry, Michael J. *Science and Technology in the USSR*. Longman Guide to World Science and Technology. Burnt Mill, UK: Longman, 1988.

Berry, Michael J. A., and Gordon Linoff. *Data Mining Techniques: For Marketing, Sales, and Customer Relationship Management*. 3rd ed. Indianapolis: Wiley, 2011.

Block, Ryan. "Live from Macworld 2007: Steve Jobs Keynote." Engadget, 9 January 2007. http://www.engadget.com.

Bogost, Ian. *Persuasive Games: The Expressive Power of Videogames*. Cambridge, MA: MIT Press, 2007.

Bordermachines.net. "From Lines to Territories: Ricardo Dominguez, Bang.Labs, and the Transborder Immigrant Tool." Accessed 7 April 2013. http://www .bordermachines.net/transborder2.html.

Boyle, Casey. "Abundant Rhetoric: Memory, Media, and the Multiplicity of Composition." PhD diss., University of South Carolina, 2011.

Buchholz, B., and T. J. Armstrong. "A Kinematic Model of the Human Hand to Evaluate Its Prehensile Capabilities." *Journal of Biomechanics* 25, no. 2 (1992): 149–62.

Buell, Duncan. *Algorithms and Data Structures Using Java*. Boston: Jones and Bartlett, 2013.

Buell, Duncan A., and Heidi Rae Cooley. "Critical Interactives: Improving Public Understanding of Institutional Policy." *Bulletin of Science, Technology, and Society* 32, no. 6 (December 2012): 489–96.

Büscher, Monika, John Urry, and Katian Witchger. *Mobile Methods*. Abingdon, UK: Routledge, 2011.

Cariou, Marie. "Bergson: Keyboards of Forgetting," translated by Melissa McMahon. In *The New Bergson*, edited by John Mullarkey, 99–117. Manchester, UK: Manchester University Press, 1999.

Certeau, Michel de. *The Practice of Everyday Life*. Berkeley: University of California Press, 1984.

Chesher, Chris. "Between Image and Information: The iPhone Camera in the History of Photography." In *Studying Mobile Media: Cultural Technologies, Mobile Communication, and the iPhone*, edited by Larissa Hjorth, Jean Burgess,

and Ingrid Richardson, 98–117. Routledge Research in Cultural and Media Studies. New York: Routledge, 2012.

Chun, Wendy. *Control and Freedom: Power and Paranoia in the Age of Fiber Optics*. Cambridge, MA: MIT Press, 2006.

Chun, Wendy Hui Kyong. *Programmed Visions: Software and Memory*. Software Studies. Cambridge, MA: MIT Press, 2011.

Cohen, Noam. "It's Tracking Your Every Move and You May Not Even Know It." *New York Times*, 26 March 2011. http://www.nytimes.com.

Converse, Jean M. *Survey Research in United States: Roots and Emergence, 1890–1960*. Berkeley: University of California Press, 1987.

Cook, William J. *In Pursuit of the Traveling Salesman: Mathematics at the Limits of Computation*. Princeton, NJ: Princeton University Press, 2012.

Cooley, Heidi Rae. "It's All About the Fit: The Hand, the Mobile Screenic Device, and Tactile Vision." *Journal of Visual Culture* 3, no. 2 (August 2004): 133–55.

Crawford, Kate. "Four Ways of Listening with an iPhone: From Sound and Network Listening to Biometric Data and Geolocative Tracking." In *Studying Mobile Media: Cultural Technologies, Mobile Communication, and the iPhone*, edited by Larissa Hjorth, Jean Burgess, and Ingrid Richardson, 213–28. Routledge Research in Cultural and Media Studies. New York: Routledge, 2012.

Cresswell, Tim. *On the Move: Mobility in the Modern Western World*. New York: Routledge, 2006.

Damasio, Antonio R. *The Feeling of What Happens: Body and Emotion in the Making of Consciousness*. New York: Harcourt Brace, 1999.

———. *Self Comes to Mind: Constructing the Conscious Brain*. New York: Pantheon, 2010.

Darling, David. "Roman Camp." The Worlds of David Darling. 1999. http://www.daviddarling.info.

Davis, Marc, et al. "Mm2: Mobile Media Metadata for Media Sharing." In *CHI 2005*, 1335–38. Portland, OR: ACM Press, 2007.

Debord, Guy. *Society of the Spectacle*. Detroit: Black & Red, 1970.

Deleuze, Gilles. "Postscript on Control Societies." In *Negotiations, 1972–1990*, 177–82. New York Columbia University Press, 1995.

Deleuze, Gilles, and Anne Boyman. *Pure Immanence: Essays on a Life*. New York: Zone Books, 2001.

Delprete, Piero G. "Revision and Typification of Brazilian Augusta (Rubiacae,

Rondeletieae), with Ecological Observations on the Riverine Vegetation of the Cerrado and Atlantic Forests." *Brittonia* 49, no. 4 (1997): 487–97.

Denso Wave. "QR Code.Com." Accessed 30 March 2013. http://www.qrcode .com.

Derrida, Jacques. "Grafts: A Return to Overcasting [Retour Au Surjet]." In *Dissemination*, translated by Barbara Johnson, 355–58. Chicago: University of Chicago Press, 1981.

———. "Signature, Event, Context." *Margins of Philosophy* (1982): 307–30. http://www.stanford.edu.

Derrida, Jacques, and Anne Dufourmantelle. *Of Hospitality*. Cultural Memory in the Present. Stanford, CA: Stanford University Press, 2000.

Diaz, Jesus. "1960s Braun Products Hold the Secrets to Apple's Future." *Gizmodo: The Gadget Blog*, 14 January 2008. http://gizmodo.com.

Dourish, Paul, and Genevieve Bell. *Divining a Digital Future: Mess and Mythology in Ubiquitous Computing*. Cambridge, MA: MIT Press, 2011.

Elliott, Anthony, and John Urry. *Mobile Lives*. London: Routledge, 2010.

Esposito, Roberto. *Bíos: Biopolitics and Philosophy*. Posthumanities. Minneapolis: University of Minnesota Press, 2008.

Farman, Jason. *Mobile Interface Theory: Embodied Space and Locative Media*. New York: Routledge, 2012.

Favro, Diane. *The Urban Image of Augustan Rome*. 1996. Cambridge: Cambridge University Press, 2008.

Flanagan, Mary. *Critical Play: Radical Game Design*. Cambridge, MA: MIT Press, 2009.

Foucault, Michel. "About the Beginning of the Hermeneutics of the Self: Two Lectures at Dartmouth." *Political Theory* 21, no. 2 (May 1993): 198–227.

———. *The Birth of Biopolitics: Lectures at the Collège de France, 1978–79*. Translated by Graham Burchell. Edited by Michel Senellart. Basingstoke, UK: Palgrave Macmillan, 2008.

———. *The Courage of the Truth (the Government of Self and Others II): Lectures at the Collège de France, 1983–1984*. Translated by Graham Burchell. Edited by Frederic Gros. Houndmills, UK: Palgrave Macmillan, 2011.

———. "The Eye of Power." Translated by Colin Gordon, Leo Marshall, John Mepham, and Kate Soper. In *Power/Knowledge: Selected Interviews and Other Writings, 1972–1977*. 1972. Edited by Colin Gordon, 146–65. New York: Pantheon, 1980.

———. *The Government of Self and Others*. Houndmills, UK: Palgrave Macmillan, 2010.

———. *The History of Sexuality*. 1st American ed. New York: Pantheon, 1978.

———. *The History of Sexuality*. Vol. 1, *An Introduction*. New York: Vintage, 1990.

———. *Security, Territory, Population: Lectures at the Collège de France, 1977–1978*. 2004. Translated by Graham Burchell. New York: Palgrave MacMillan, 2007.

Foucault, Michel, and Paul Rabinow. *Ethics: Subjectivity and Truth; The Essential Works of Foucault, 1954–1984*. New York: New Press, 1997.

Foucault, Michel, Frédéric Gros, François Ewald, and Alessandro Fontana. *The Hermeneutics of the Subject: Lectures at the Collège de France, 1981–1982*. New York: Palgrave Macmillan, 2005.

Freeman, John Craig, and Mark Skwarek. *Border Memorial: Frontera de los Muertos*. 2012. http://bordermemorial.wordpress.com/border-memorial -frontera-de-los-muertos.

Friedberg, Anne. *The Virtual Window: From Alberti to Microsoft*. Cambridge, MA: MIT Press, 2006.

Fuchs, Christian. "A Contribution to the Critique of the Political Economy of Google." *Fast Capitalism* 8 (2011). http://www.fastcapitalism.com.

Galloway, Alexander R. *Protocol: How Control Exists after Decentralization*. Leonardo Book Series. Cambridge, MA: MIT Press, 2004.

Galloway, Alexander R., and Eugene Thacker. *The Exploit: A Theory of Networks*. Electronic Mediations 21. Minneapolis: University of Minnesota Press, 2007.

Goggin, Gerard. *Cell Phone Culture: Mobile Technology in Everyday Life*. London: Routledge, 2006.

———. *Global Mobile Media*. Abingdon, UK: Routledge, 2011.

Gordon, Eric, and Adriana de Souza e Silva. *Net Locality: Why Location Matters in a Networked World*. Chichester, UK: Wiley-Blackwell, 2011.

Grosz, E. A. *Chaos, Territory, Art: Deleuze and the Framing of the Earth*. Wellek Library Lectures in Critical Theory. New York: Columbia University Press, 2008.

———. *Time Travels: Feminism, Nature, Power*. Next Wave: New Directions in Women's Studies. Durham, NC: Duke University Press, 2005.

Grosz, Elizabeth. "The Thing." In *Architecture from the Outside: Essays on Virtual and Real Space*, 167–83. Cambridge, MA: MIT Press, 2001.

Grusin, Richard A. *Premediation: Affect and Mediality after 9/11*. Basingstoke, UK: Palgrave Macmillan, 2010.

Guattari, Félix. *The Three Ecologies*. London: Athlone, 2000.

Guerlac, Susan. *Thinking in Time: An Introduction to Henri Bergson*. Ithaca, NY: Cornell University Press, 2006.

Halavais, Alexander M. Campbell. *Search Engine Society*. Digital Media and Society Series. Cambridge, UK: Polity, 2009.

Hanlon, Mike. "SenseCam: The Black Box Flight Recorder for Human Beings." *Gizmag*, 31 August 2006. http://www.gizmag.com.

Hansen, Mark B. N. "Foucault and Media: A Missed Encounter?" *South Atlantic Quarterly* 111, no. 3 (Summer 2012): 497–528.

———. *New Philosophy for New Media*. Cambridge, MA: MIT Press, 2004.

Hjorth, Larissa, Jean Burgess, and Ingrid Richardson. *Studying Mobile Media: Cultural Technologies, Mobile Communication, and the iPhone*. Routledge Research in Cultural and Media Studies. New York: Routledge, 2012.

Ito, Mizuko. "Camera Phones Changing the Definition of Picture-Worthy." *Japan Media Review* (29 August 2003). http://www.ojr.org.

Ito, Mizuko, Daisuke Okabe, and Misa Matsuda, eds. *Personal, Portable, Pedestrian: Mobile Phones in Japanese Life*. Cambridge, MA: MIT Press, 2005.

Jenkins, Henry. *Textual Poachers: Television Fans and Participatory Culture*. Studies in Culture and Communication. New York: Routledge, 1992.

Jenkins, Henry, Sam Ford, and Joshua Green. *Spreadable Media: Creating Value and Meaning in a Networked Culture*. Postmillennial Pop. New York: New York University Press, 2013.

Kaplan, Caren. "Transporting the Subject: Technologies of Mobility and Location in the Era of Globalization." *PMLA* 117, no. 1 (2002): 32–42.

Keppie, Lawrence. *The Making of the Roman Army: From Republic to Empire*. Norman: University of Oklahoma Press, 1984.

Kinder, Marsha. "Narrative Equivocations between Movies and Games." In *The New Media Book*, edited by Dan Harries, 119–32. London: British Film Institute, 2002.

Kock, Gertud. *Siegfried Kracauer: An Introduction*. Princeton, NJ: Princeton University Press, 2000.

Konig, Jason, and Tim Whitmarsh, eds. *Ordering Knowledge in the Roman Empire*. Cambridge: Cambridge University Press, 2007.

Koskinen, Ilpo Kalevi. *Mobile Multimedia in Action*. New Brunswick, NJ: Transaction Publishers, 2007.

Kracauer, Siegfried. *The Mass Ornament: Weimar Essays*. 1963. Translated by Thomas Levin. Cambridge, MA: Harvard University Press, 1995.

Kunkel, Paul. *AppleDesign: The Work of the Apple Industrial Design Group*. New York: Graphis, 1997.

———. *Digital Dreams: The Work of the Sony Design Center*. New York: Universe Publishing, 1999.

Langville, Amy N., and C. D. Meyer. *Google's Pagerank and Beyond: The Science of Search Engine Rankings*. Princeton, NJ: Princeton University Press, 2006. Kindle edition.

Latour, Bruno. "Where Are the Missing Masses? The Sociology of a Few Mundane Artifacts." In *Shaping Technology/Building Society: Studies in Sociotechnical Change*, edited by Wiebe E. Bijker and John Law, 225–58. Cambridge, MA: MIT Press, 1992.

Le Bon, Gustave. *The Crowd: A Study of the Popular Mind*. 1896. Kitchener, ON: Batoche, 2001.

Lefebvre, Henri. *The Urban Revolution*. Translated by Robert Bononno. Minneapolis: University of Minnesota Press, 2003.

Lima, Manuel. *Visual Complexity: Mapping Patterns of Information*. New York: Princeton Architectural Press, 2011.

Linebaugh, Peter. *The Many-Headed Hydra: Sailors, Slaves, Commoners, and the Hidden History of the Revolutionary Atlantic*. Boston: Beacon, 2000.

Lovink, Geert. "Blogging: The Nihilist Impulse." Eurozine, 2 January 2007. http://www.eurozine.com.

Lozano-Hemmer, Rafael. "*Amodal Suspension*: Relational Architecture 8." 2003. http://www.amodal.net/intro.html.

Lupton, Ellen, and Julia Lupton. *Design Your Life: The Pleasures and Perils of Everyday Things*. New York: St. Martin's Griffin, 2009.

Lupton, Ellen, and Jennifer Tobias. *Skin: Surface, Substance, and Design*. New York: Princeton Architectural Press, 2002.

Lyon, David. *The Electronic Eye: The Rise of Surveillance Society*. Minneapolis: University of Minnesota Press, 1994.

———. *Surveillance as Social Sorting: Privacy, Risk and Digital Discrimination*. London: Routledge, 2003.

Mager, Astrid. "Algorithmic Ideology." *Information, Communication, and Society* 15, no. 5 (2012): 769–87.

Malabou, Catherine. *What Should We Do with Our Brain?* Perspectives in Continental Philosophy. New York: Fordham University Press, 2008.

Manovich, Lev. "The Back of Our Devices Looks Better Than the Front of Anyone Else's: On Apple and Interface Design." In *Moving Data: The iPhone and the Future of Media*, edited by Pelle Snickars and Patrick Vonderau, 278–86. New York: Columbia University Press, 2012.

———. *The Language of New Media*. Cambridge, MA: MIT Press, 2002.

Massumi, Brian. *Semblance and Event: Activist Philosophy and the Occurrent Arts*. Technologies of Lived Abstraction. Cambridge, MA: MIT Press, 2011.

McPherson, Tara. "Beyond Formalism: Thoughts on New Media and Race in Post–World War II Culture." Conference paper, University of Washington, Seattle, 14 February 2003.

Moore, F. C. T. *Bergson: Thinking Backwards*. Cambridge: Cambridge University Press, 1996.

Morville, Peter. *Ambient Findability*. Beijing: O'Reilly, 2005.

Nealon, Jeffrey T. *Foucault beyond Foucault: Power and Its Intensifications since 1984*. Stanford, CA: Stanford University Press, 2008.

Norman, Donald A. *The Design of Everyday Things*. New York: Doubleday, 1990.

Palmer, Daniel. "iPhone Photography: Mediating Visions of Social Space." In *Studying Mobile Media: Cultural Technologies, Mobile Communication, and the iPhone*, edited by Larissa Hjorth, Jean Burgess, and Ingrid Richardson, 85–97. Routledge Research in Cultural and Media Studies. New York: Routledge, 2012.

Papanek, Victor J. *Design for the Real World: Human Ecology and Social Change*. New York: Bantam, 1973.

Parikka, Jussi. *Insect Media: An Archaeology of Animals and Technology*. Posthumanities. Minneapolis: University of Minnesota Press, 2010.

Parks, Lisa. *Cultures in Orbit: Satellites and the Televisual*. Console-Ing Passions. Durham, NC: Duke University Press, 2005.

———. "Zeroing In: Overhead Imagery, Infrastructure Ruins, and Datalands in Afghanistan and Iraq." In *Communication Matters: Materialist Approaches to Media, Mobility and Networks*, edited by Jeremy Packer and Stephen B. Crofts Wiley, 78–92. Shaping Inquiry in Culture, Communication and Media Studies. London: Routledge, 2012.

Peirce, Charles S. *Collected Papers of Charles Sanders Peirce*, edited by Charles Hartshorne and Paul Weiss. Vol. 5. Cambridge, MA: Harvard University Press, 1934.

———. *The Essential Peirce: Selected Philosophical Writings*, edited by Nathan Houser and Christian Kloesel. Vol. 2. Bloomington: Indiana University Press, 1998.

Peirce, Charles S., and James Hoopes. *Peirce on Signs: Writings on Semiotic*. Chapel Hill: University of North Carolina Press, 1991.

Poster, Mark. *The Second Media Age*. Cambridge, UK: Polity, 1995.

Protevi, John. *Political Affect: Connecting the Social and the Somatic*. Posthumanities. Minneapolis: University of Minnesota Press, 2009.

Raley, Rita. *Tactical Media*. Electronic Mediations. Minneapolis: University of Minnesota Press, 2009.

Rheingold, Howard. *Smart Mobs: The Next Social Revolution*. Cambridge, MA: Perseus, 2002.

Rodowick, David Norman. *Gilles Deleuze's Time Machine*. Post-Contemporary Interventions. Durham, NC: Duke University Press, 1997.

Rose, Nikolas. *Inventing Ourselves: Psychology, Power, and Personhood*. Cambridge: Cambridge University Press, 1998.

Sander, Thomas. "Twitter, Facebook and YouTube's Role in Arab Spring (Middle East) Uprisings." *Social Capital Blog*, 26 January 2011. Updated 27 March 2013. http://socialcapital.wordpress.com.

Schneider, Alexandra. "The iPhone as an Object of Knowledge." In *Moving Data: The iPhone and the Future of Media*, edited by Pelle Snickars and Patrick Vonderau, 49–60. New York: Columbia University Press, 2012.

Schopenhauer, Arthur. *Parerga and Paralipomena: Philosophical Essays by Arthur Schopenhauer*. Translated by E. F. J. Payne. Oxford: Oxford University Press, 1974.

Searle, John R. "Proper Names." *Mind* 67, no. 266 (1958): 166–73.

Sekula, Allan. "The Body and the Archive." *October* 39 (Winter 1986): 3–64.

Sheller, Mimi. "Mobility." *Sociopedia.isa* (2011). http://www.sagepub.net.

Silva, Adriana de Souza e, and Daniel M. Sutko, eds. *Digital Cityscapes: Merging Digital and Urban Playspaces*. Digital Formations. New York: Peter Lang, 2009.

Simpson, Mark. *Trafficking Subjects: The Politics of Mobility in Nineteenth-Century America*. Minneapolis: University of Minneapolis Press, 2005.

Smith, Gene. *Tagging: People-Powered Metadata for the Social Web*. Berkeley, CA: New Riders, 2008.

Snickars, Pelle, and Patrick Vonderau, eds. *Moving Data: The iPhone and the Future of Media*. New York: Columbia University Press, 2012.

Tagg, John. *The Burden of Representation: Essays on Photographies and Histories*. Amherst: University of Massachusetts Press, 1988.

Thacker, Eugene. *Biomedia*. Electronic Mediations. Minneapolis: University of Minnesota Press, 2004.

———. "Nomos, Nosos and Bios." *Culture Machine* 7 (2005). http://www.culturemachine.net.

Thompson, Clive. "The Year in Ideas: Smart Mobs." *New York Times*, 15 December 2002.

Trendwatching.com. "Life Caching." 2004. http://www.trendwatching.com.

Urry, John. *Mobilities*. Cambridge, UK: Polity, 2007.

———. *Sociology beyond Societies: Mobilities of the 21st Century*. London: Routledge, 2000.

Verhoeff, Nanna. *Mobile Screens: The Visual Regime of Navigation*. Mediamatters. Amsterdam: Amsterdam University Press, 2012.

Vesna, Victoria. *Database Aesthetics: Art in the Age of Information Overflow*. Electronic Mediations 20. Minneapolis: University of Minnesota Press, 2007.

Wasik, Bill. "What Is Big Think?" Big Think, 2 July 2009. http://bigthink.com.

Williams, Raymond. "Masses." In *Keywords: A Vocabulary of Culture and Society*, 192–97. New York: Oxford University Press, 1983.

Wilson, Frank R. *The Hand: How Its Use Shapes the Brain, Language, and Human Culture*. New York: Vintage, 1998.

Wing, Jeannette M. "Computational Thinking." *Communications of the ACM* 49, no. 3 (2006): 33–35.

Wolford, Josh. "Swiss Athlete from Olympics for Racist Tweet." WebProNews, 31 July 2012. http://www.webpronews.com.

INDEX

Panopticon, 63, 79–80, 84–85, 142n24, 148n14

Papenek, Victor J., 31

Parks, Lisa, xxvii

Peirce, Charles Sanders, xxix, xxxiii, xxxv, 18–21, 25, 29, 38, 40, 47–54, 58, 64, 67–69, 75–76, 107, 109, 138n83, 143n41, 147n11, 154n13

perception, xxvii, xxxii, 26, 38–42, 47, 49, 69, 134n47, 135n51, 137n72

performance art, 111

performative cartography, xxvi, 132n19

performative intra-action, 108

perpetual present, 42, 49

persistent alertness, 45

persistent awareness, 44

personal awareness, 45

personal inflection, 72

personal perspective, 46

photograph, 54, 56, 63, 75, 114, 145n52

photographed place, 113

photographic image, 60, 65

physical manageability, 27

pinch, 17, 25, 31, 49

pinging, 58

plane composition, 108

political affect, 109

politics of ourselves, 106–7

popularity, xxxiii, 14–15, 127n29, 128n32

population management, xxviii, 8, 17, 97

population managers, xvii

portability, xxv, 27, 37

pouvoir, 84

power geometries, xxvi

power relation, 34–35

predictive model, 33

premediate, xxvii

Princess Augusta, 117n5

principle of organization, xxii

procedural rhetoric, 6, 124n13, 125n15

processes of cognition, 25, 107

processes of inference, 43

process of interpretation, 49

process of relation, 47, 135n51

productive regulation, xxviii

programmability, xxvii, 146n1

Protevi, John, xxxv, 109

proximity, xxvi, 14, 16, 127n28, 128n33, 129n46

psychic attachment, 28

public landscape, 110

public opinion, 84–85, 93, 97

pure immanence, 107

purity, 31

QR code, xxxii, 1–4

query histories, 7

query module, 14

quotidian practice, 17

Raley, Rita, xxxi, 109–10

Rams, Dieter, 30

range of options, 28

recordability, 66

reflective self, 41

regularity, xxxiii

regulatory process, 72, 108

repetition, xxix, xxxi, 20, 65, 69–70, 75, 92

resonant loop, 44